774. 71

D1351578

WATERFORD CITY AND COUNTY
WITHDRAWN
LIBRARIES

WATERFORD CITY AND COUNTY
WITHDRAWN
LIBRARY

Light in the
Landscape

A Photographer's Year

WATERFORD CITY AND COUNTY
WITHDRAWN
LIBRARIES

Light in the Landscape

A Photographer's Year

Peter Watson

WATERFORD CITY LIBRARY	
244174 2	
L B C	930100
	E40.73

GUILD OF MASTER CRAFTSMAN PUBLICATIONS

First published 2001 by
Guild of Master Craftsman Publications Ltd,
166 High Street, Lewes,
East Sussex, BN7 1XU

Copyright in the Work © Guild of Master
Craftsman Publications Ltd
Text and photographs copyright
© Peter Watson

ISBN 1 86108 209 6
A catalogue record of this book is available
from the British Library

All rights reserved

The right of Peter Watson to be identified
as the author of this work has been
asserted in accordance with the Copyright
Designs and Patents Act 1988,
Sections 77 and 78.

No part of this publication may be
reproduced, stored in a retrieval system, or
transmitted in any form or by any means
without the prior permission of the
publisher and copyright owner.

The Publishers and author can accept no
legal responsibility for any consequences
arising from the application of
information, advice or instructions
given in this publication.

Designed by Fineline Studios
Typeface: Foundry

Colour origination by
Viscan Graphics (Singapore)
Printed and bound by Kyodo
Printing (Singapore) under the supervision
of MRM Graphics, Winslow,
Buckinghamshire, UK

Acknowledgements

My thanks go out to Alistair Kerr at
BZ Photolab for services rendered way
above the call of duty; the team at
CA Design & Print Ltd for their expertise,
help and patience; Jayne Davies for her
unfailing support and assistance and for
her frequent assessments of the
quality of sky; Stephanie Horner and
Lindy Dunlop of Guild of Master
Craftsman Publications Ltd for their
enthusiasm and invaluable contribution;
my wife Susie and daughters Hayley and
Sophie for their encouragement
(anything to get me out of the house!);
and to David Bingle for his moral
support. (Dave, thank you; I dedicate the
picture on page 124 to you.)

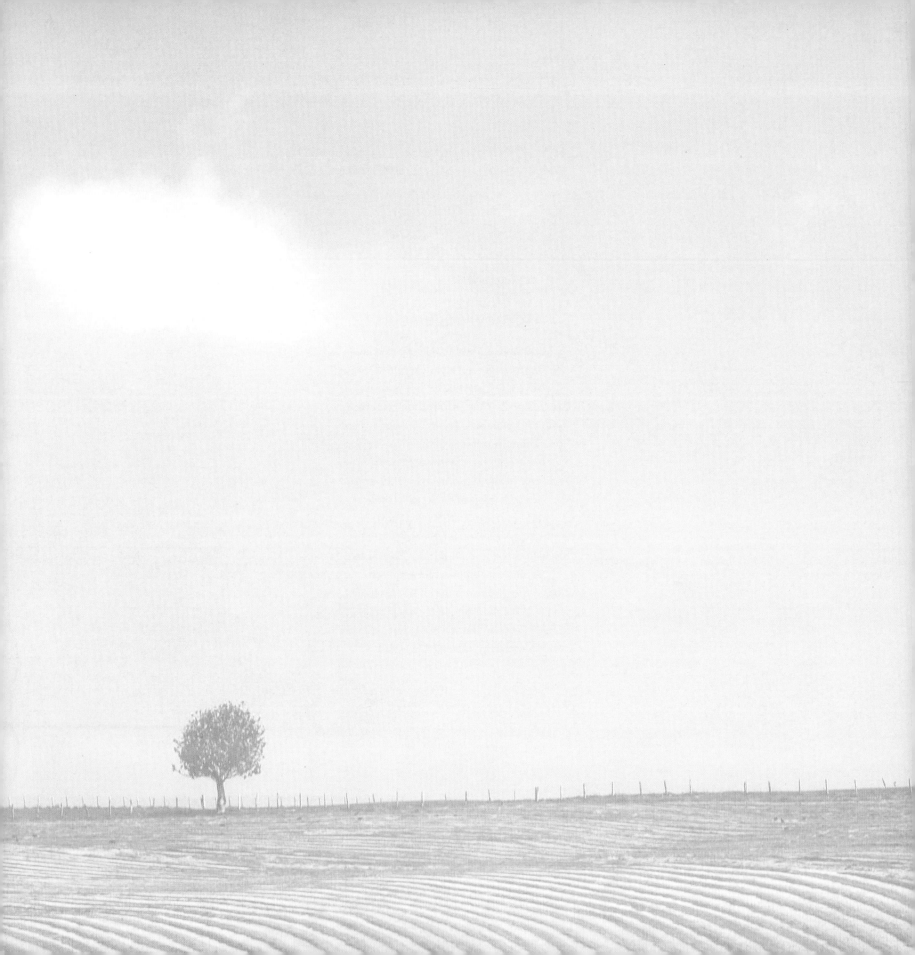

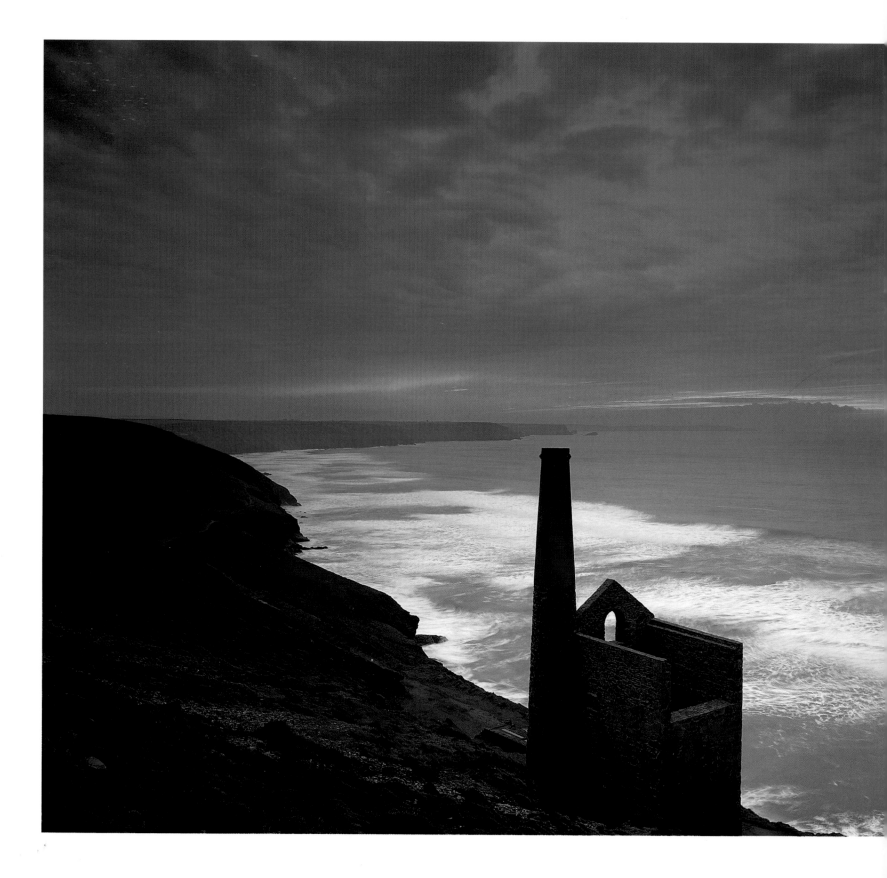

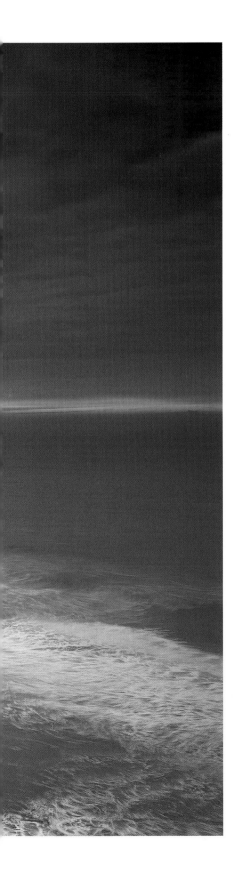

introduction

I must confess that I find landscape photography in particular to be quite fascinating, indeed compulsive. I think it has something to do with the vastness of the subject – for it does cover, literally, the entire world – coupled with the lack of control we have over it. Photographing it is immensely challenging and at the same time so very rewarding.

Imagine a world without any visual information. A world void of pictures, a world where communication is restricted to speech and the written word. Imagine this and the power, indeed miracle, of photography becomes apparent, for surely it is a miracle that a single moment in time – a tiny fraction of a second – can be frozen, captured and then seen by millions; the living landscape preserved forever for others to enjoy. This is the power of photography, the product of a unique combination of art and science which dates back over 150 years.

From those early, revolutionary days of the daguerreotype we have progressed to the point where high quality and chemical-free digital images have now become commonplace. I believe such progress does not threaten the existence of the photograph *per se*; I think photography will endure in the way painting has, despite the emergence of new art forms and technologies.

The scale and variety of subject matter is so vast that it can be overwhelming. However, it is not *what* you photograph that matters, it is *when*. I believe, and I hope you will also discover, that every part of the landscape – every mountain, every field, every tree – has its time, a moment of glory when a particular feature excels itself, demanding, and deserving, to be photographed and preserved for our lasting enjoyment. It is for this reason that successful landscapes result from the photographer being in the right place at the right time, being able to watch, wait and choose the moment.

The challenge facing the photographer is to interpret and capture the landscape in such a way that the viewer's reaction to it is instinctive. For the viewer to respond with emotion to the sight of a photograph it follows that the photographer must have responded emotionally to the sight of the landscape.

Wheal Coates, Cornwall
Tachihara 5 x 4in with 150mm lens, Fuji Provia [ISO 100], 1/2sec at f/22½, 0.6 grey grad

Emotion should not, however, be allowed to dominate the actual picture-taking process; this should always be undertaken in a disciplined and methodical manner. However breathtaking a scene might be, the question must always be asked, 'Should I wait or should I return?' Only recently I was waiting, camera on tripod, for the light to play over the landscape in a particular way. Attracted by the tripod, people wandered over, pointed their camera more or less where mine was pointing and took a photograph. Theirs would have been of a similar view but taken in a different light, using a different lens and probably with no filter to darken the sky. And nobody had waited for the moment. Nobody had appreciated the potential of what lay before them.

Although this is a guide to landscape photography in which lighting, exposure, composition and many other aspects of the subject are comprehensively covered, the main purpose of this book is to portray the unique beauty of Britain. My aim is to enthuse, to inspire creative photography, and to encourage you to venture into the countryside and discover the variety and distinctive character of Britain's landscape.

Throughout this book I have attempted to illustrate, by example, the extensive and varied nature of the photographic opportunities that occur throughout the year, across the length and breadth of Britain. Such opportunities are unique to Britain, due no doubt to the combination

of diverse landscape and somewhat erratic weather. Together they produce moments of pure magic, the equal of anything to be found anywhere in the world.

Unfortunately, Britain's unreliable climate shows no more allegiance to photography than it does to any other outdoor activity. Disappointing and frustrating experiences regularly occur and these must be accepted philosophically. To succeed under such conditions the photographer must not only tolerate inclement weather but must also learn how to use it to advantage and make the most of the creative opportunities it can provide. Add patience, perseverance and enthusiasm to a philosophical approach and the profile of the successful photographer begins to emerge.

Then – and this is most important – there is the development of the observing, seeing, eye and, essentially, the gaining of an appreciation and understanding of light. Light is the photographer's raw material. It is infinitely more important than the type of film, camera or lens. Learn to use light creatively. Apply it to your film, your canvas, with the panache of an impressionist painter, but always exercise care and precision and pay painstaking attention to detail. These are the creative aspects of photography and they present a far greater challenge to the novice than do the more finite technical areas such as shutter speed, aperture and depth of field. Master them and your landscapes will bring you lasting joy and

pleasure – and possibly recognition. This book will, I hope, provide the stimulus.

Turning now to the photographs, I selected them to show the varied nature of Britain's landscape, how its appearance changes throughout the year and how you can successfully capture the essence of its many guises. The pictures also illustrate the many specific artistic and practical aspects of landscape photography that you are likely to encounter and explain, by example, how to overcome obstacles and thrive, whatever the conditions.

I deliberated for some time over which photographs to include here. There were many others I could have used but the six I finally selected all share a common and appropriate theme; for different reasons they all say to me 'The Moment'.

The photograph of Wheal Coates on page 1 is, I think, a most appropriate opening picture. I was nearing the end of a week's stay in Cornwall during a cold and wet February, with little to show for my time there. The combination of gale force winds, hail and rain proved to be a formidable obstacle to picture taking. With just two days left and the sky a monotonous pale grey, I had decided that the best approach would be to choose a location on the north-west coast and remain there until (hopefully) conditions improved. Wheal Coates (a well-known, disused tin mine) seemed to offer potential. I imagined that if the sun broke through the clouds, even for a fleeting moment, a dramatic backlit

photograph might be possible. (See the picture of Bickerton, Cheshire, on page 54, as an example of this.) Failing that, there was always the chance that the clouds would clear sufficiently by the end of the day to produce an attractive evening sky.

On the first day there was nothing. A blanket of cloud covered the sky, with not the faintest suggestion of the sun breaking through. Such occasions try one's patience but it is important not to give up: you can guarantee that within minutes of you doing so the picture you had been waiting for will materialize.

Initially, the following day (now my last in Cornwall) proved no better. By mid-afternoon I was contemplating delaying my departure to enable me to return at dawn the next day, reasoning that a third visit must produce something.

I was becoming resigned to making this third trip to the National Trust car park (which was, after two days, becoming a little tedious), when I noticed a trace of detail developing in the cloud. At last – and by now it was 4.30pm – there was a glimmer of hope. A hint of marble was becoming apparent in the sky immediately above me. Tiny veins, no more than gossamer threads, were becoming evident. It was a slow process but there was, without doubt, a transition taking place. Now it was a race against time: there was barely an hour of daylight left. I checked and double-checked everything, including composition and

focusing. My spirit level told me the horizon was straight . . . everything was ready. It now depended on the sky.

The minutes ticked by. The sky was still improving but the improvement was too slow and the light was fading rapidly. My heart began to sink. I had virtually given up hope when, with perhaps 10 minutes of daylight left, a faint glow appeared on the horizon. Barely noticeable at first, it quickly grew to become a bright pink splash above the sea. For the first time in

two days I was looking at something I wanted to photograph. Five minutes later the light faded but that didn't matter. Waiting for two days ensured that I was in the right place for those critical minutes and I got my picture. The week had not been one of my most productive periods but I was not complaining: I was in the right place when the moment arrived.

By contrast, the photograph below required no waiting. I first noticed this sweeping view on an overcast and wet

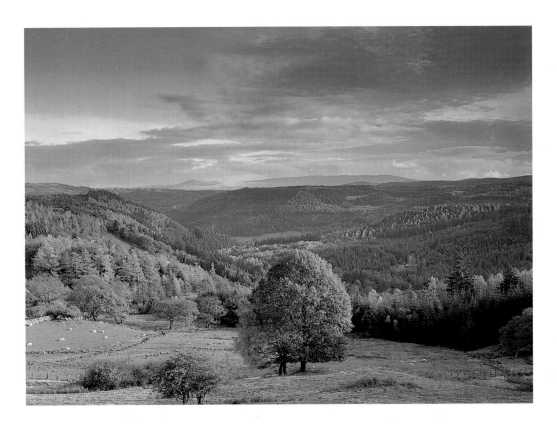

Gwydyr Forest, Snowdonia
Tachihara 5 x 4in with semi-wideangle lens, Fuji Provia [ISO 100], 1sec at f/32, 81B and 0.6 grey grad

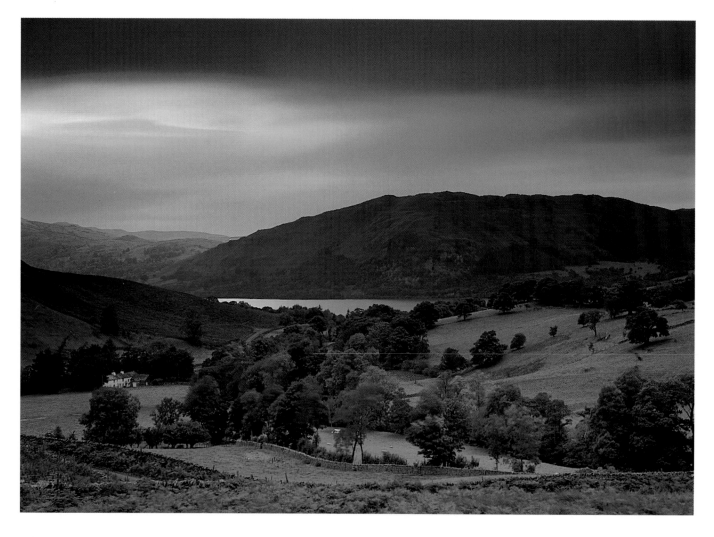

Ullswater, The Lake District

Tachihara 5 x 4in with 150mm lens, Fuji Provia [ISO 100], 1/2sec at f/22, 0.6 grey grad

day. Although I couldn't take the picture on that occasion I was at least able to compose it in my viewfinder and take a compass reading.

I was facing south which was perfect as it meant that the sun would be to my right during late afternoon. The low sidelighting this would produce would be ideal for the big open view, and the sunlight's warmth at this time of day would enhance the colour of the turning

leaves. A few days later the weather improved and I returned, set up my camera and took half a dozen exposures in little more than five minutes.

Now, when I look at the photograph of Gwydyr Forest, I realize how fortunate I was to have returned at the time I did – the sky and lighting could not have been better. I would normally expect to have to wait or even return a number of times to find conditions like these, but this time

I was lucky. Thankfully the picture-taking process is not always that easy – how boring that would be.

The heaven-sent opportunity which Ullswater kindly presented me came as a complete surprise. I had just taken the picture near Threlkeld (see page 143) and had, I thought, finished for the day. Returning to my cottage I was stopped in my tracks by the fluorescent light that was shimmering on the lake's surface.

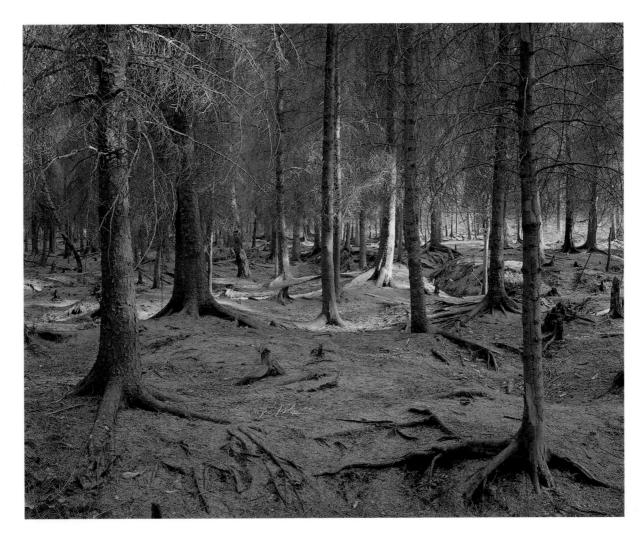

Delamere Forest, Cheshire
Tachihara 5 x 4in with 150mm lens, Fuji Provia [ISO 100], 1/2sec at f/32, 81C

The effect was particularly striking and was further emphasized by the sombre gloom which surrounded these two isolated bright spots.

Without delay I set up my camera, fitted a 150mm lens, read the exposure, reduced the brightness of the sky with a neutral, grey graduated filter, and managed to take just two pictures. The light then suddenly faded taking, photographically speaking, Ullswater with it.

Twenty minutes earlier I had not even contemplated such a photograph. Although I had been in the vicinity for much of the day there had been no clue, no sneak preview, of what was to unfold before me. This time it was the unexpected which provided the day's most memorable moment.

This picture of Delamere Forest is a photograph which is special to me because of its sentimental value but I hope

it can also be appreciated for its visual appeal. This was one of the earliest landscapes that I felt I had systematically conceived, planned and executed. The picture is particularly satisfying to me because the photograph looks exactly as I had envisaged the forest might look in optimum lighting. I had attempted to visualize how low sidelighting would reveal the unusual undulation of the ground whilst, at the same time, a shaded and subdued foreground would allow

5

those marvellous tree roots their due prominence, free from any distracting highlights. Finally, I hoped that the perfect lighting conditions would produce a highlight in the clearance behind the trees: this would attract the eye and take the viewer through the picture and, therefore, on a walk through the forest.

You can imagine my delight, when returning a few months later at what I had guessed to be the right time of day and year, at finding the forest appearing just as I had imagined. Within minutes I had taken my photograph and immediately took the film to be processed.

The results, fortunately, met my most optimistic expectations. The satisfaction and confidence – the sheer elation – gained from seeing the final image is a feeling I will never forget.

It was from that moment that I was determined, come what may, to become a professional photographer. I had discovered the power of photography. (That original photograph was taken in 35mm format. The picture here is one I took on a later occasion using 5 x 4in film.)

A tame fox accompanied me as I strolled along the lakeside on the evening that I took this photograph of Loch Fyne. Having chosen a suitable position I set up my camera and waited for the sun to set.

It was a halcyon moment. With precision timing the new moon revealed itself in the twilit sky as the fading sun, required elsewhere, dipped below the distant mountains. The silence and stillness were absolute, the breathing of the fox the only sound which kept me in touch with reality. It was an effort to stop gazing and remind myself why I was there. I still hear the silence every time I look at this picture.

Brimstage is a tiny village situated close to where I live on the Wirral Peninsula. Although attractive and in a pleasant rural location, it is not the village but a single row of trees in an adjoining field which beckons me.

I regularly visit this field. Never have I seen its appearance repeated, so I include the picture on page 8 to demonstrate the *when* principle rather than the *what*. The countryside is emblazoned with anonymous, and often neglected, features.

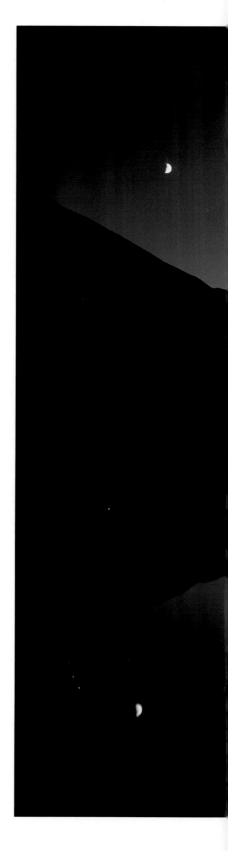

Loch Fyne, Argyllshire
Tachihara 5 x 4in with wideangle lens, Fuji Provia [ISO 100], 5 seconds at f/22, 81C and 0.6 grey grad

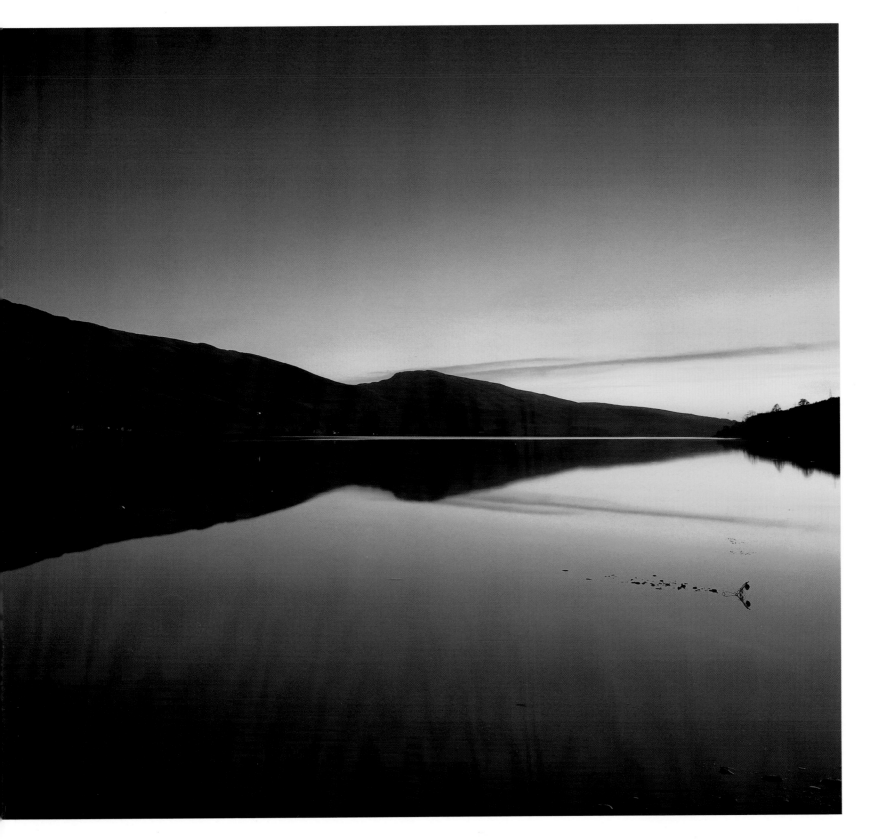

Near Brimstage, The Wirral Peninsula
Tachihara 5 x 4in with wideangle lens, Fuji Provia [ISO 100], 1/4sec at f/22½, 81C and 0.3 grey grad

Bereft of a grandiose appearance, their hidden potential remains untapped. Discover for yourself a piece of landcape which you feel has something to offer, then visit it regularly at different times of the day and year. Be patient. Persevere. One day the ordinary will look extra-ordinary and you will be there just at that moment to photograph it. So, here are just a few examples of some of my pictures which are special to me. Throughout this book there are many more, of both well- and little-known sites. Producing this publication has given me great pleasure, prompting me to relive the experiences and emotions I felt when taking each photograph. I hope you can share in these experiences, receive a glimpse of and, above all, be inspired to photograph, the unique and majestic splendour of Britain's landscape.

the right approach

and conventional photography. So, whatever equipment you use, it is you who will be creating the photograph. Learn the skills, adopt the right approach and your photography will bring you lasting enjoyment.

digital or film?

If you are buying for the first time or replacing old equipment, then you have a number of decisions to make. The first and most fundamental is whether to choose digital or conventional film.

The falling price of digital cameras now makes them worthy of serious consideration, particularly for sports and news coverage applications where speed and ease of picture transmission are more important than image resolution.

However, where picture quality is the main concern – and in landscape photography it is the *only* concern – film still has the edge and should therefore be your choice.

At some point digital cameras may replace film altogether (although this is by no means certain), but new technology will not replace the photographer's creative skill. Distinctive pictures originate in the photographer's eye; this is the art of photography. Science may evolve but the art remains. The techniques described throughout this book apply to both digital

the basic equipment

The list is relatively short: a reliable camera, a small range of lenses, an exposure meter, a handful of filters and a tripod. A compass and a map of the area that you are photographing will also be very useful. And that's it. You do not need an array of expensive, gimmick-laden equipment. Success cannot be bought – you will achieve this through your own efforts.

camera

Assuming you are using film, you will need a simple but sturdy camera. Features such as autofocus and motor drive are no help when photographing the landscape. If you already have a camera which has these automatic functions that's fine, there is no need to change it, you can simply use it in manual mode.

If you are buying a new (or used) camera, choose a basic, manual model which takes interchangeable lenses and which has a removable back (see Polaroid back, page 10). However, before you buy you do have another important decision to make. You need to choose, carefully, the size of film you are going to use.

So, APS, 35mm, medium format or large format? The choice can be a dilemma for the landscape photographer. The larger the film size, the finer the image resolution and this should be a consideration if you intend to make enlargements of your pictures. However, an increase in film size brings with it a corresponding increase in bulk and weight and this should not be ignored: equipment becomes heavier as the day progresses and can become a hindrance if you are climbing or trekking across rough terrain.

The majority of photographers prefer medium format (available in 6 x 9cm, 6 x 7cm, 6 x 6cm and 6 x 4.5cm), as it provides an ideal combination of relatively large image size and portability. I use large format in 5 x 4in because – and this may sound perverse – of its cumbersome size and slow method of operation. Being forced to work at a slow pace imposes discipline and creates thinking time and this has changed, for the better I believe, my approach to photography. (Large-format film is available in 5 x 4in, 5 x 7in and 10 x 8in.)

If large format sounds tempting then I would advise that you approach it with caution. Borrow or hire the equipment and use it extensively before committing yourself. It doesn't suit everybody and you need to be certain before you buy.

lenses

Whatever size camera you use you will need to be able to vary the focal length of the lens. A zoom lens with a wideangle capability will be perfectly adequate as long as you use it correctly (see pages 142/3). Alternatively, you could use a range of, say, three fixed focal length lenses – a wideangle, a standard and a short telephoto – which will cope with most situations you are likely to encounter. The precise focal lengths will depend on your film size. Your local dealer will be able to demonstrate these for you.

exposure meter

Not surprisingly, accurate exposure of film depends on accurate measurement of light. If your camera has a built-in meter, this will be good enough. A preferable method, however, is to use a hand-held meter with a spotreading capability. This will enable you to take exposure readings of different parts of the landscape and sky and is very useful in enabling you to judge by how much, if at all, you need to darken the sky with a filter.

Polaroid back

A Polaroid back is commonly used by most professional photographers, and should not be considered a luxury item.

The ability to see a Polaroid of your photograph is an essential part of the picture-taking process (see page 11). Most medium-format and all large-format cameras have a removable back, but check with your dealer before you buy.

filters

Filters are an important tool and are discussed throughout the book. You don't need many: a warm-up (81B or C), a polarizer and a grey graduated. This latter filter is used to reduce the brightness of the sky and is available in a range of densities. They are neutral in colour, their only role being to absorb excess light.

tripod

Last but not least we come to the tripod. This is, I must emphasize, an essential piece of equipment. If you have any thoughts that you will be able to manage without one, then I urge you to reconsider. Creative photography requires thought, patience and observation. Give your camera to someone else – your tripod – while you do the thinking. Buy a strong, sturdy model (a lightweight tripod is liable to introduce more camera shake than it will prevent) and use it every time you use your camera. Also, for ease of camera movement on the tripod, you will find that a ball-and-socket head is a very useful accessory.

techniques to achieve quality

Picture quality is of critical importance. Nothing less than a pin-sharp image, free of camera shake and in perfect focus from front to back, will do. The only way to achieve such quality (assuming you are using a conventional rather than a digital camera) is to use a slow, fine-grain film, a good tripod, a small aperture and usually, as a consequence of this, a long shutter speed. Because you are using a tripod this should not be a problem and you should have no difficulty in adopting these practices as your standard method of working. The only drawback, from time to time, is wind, which can either shake the camera or blur leaves and grasses. This, however, is merely an occasional nuisance; it can usually be overcome with patience and should not adversely affect the overall standard of your photography.

A film with a speed of no more than ISO 100 will have a fine-grain emulsion and will be capable of producing sharp images with good colour saturation. To achieve maximum sharpness use the smallest possible aperture, f/32 or even f/45 or f/64 if your lens stops down this far. This is particularly important when you include close foreground objects in your picture, as you will need maximum depth of field. As a result of using such small apertures it will often be necessary to make exposures of 1/2 or 1sec or longer, hence the need for a sturdy tripod.

Depth of field – the distance from front to back which is in sharp focus in a photograph – is affected by:

the focal length of the lens;
the aperture size; and
the focusing distance.

A wideangle lens stopped down to its smallest aperture will, if focused correctly, produce a depth of field that stretches from 3 or 4ft (1–1.2m) in front of the camera, all the way to infinity. To achieve this you must focus several feet beyond the close foreground as depth of field extends both forwards and backwards. The point of focus which produces maximum depth of field is known as the hyperfocal distance. If your camera has a depth of field preview button you can actually see what is in focus at any given aperture. However, it is not essential that you have such a facility because, with a little practice, you should be able to gauge the hyperfocal distance with reasonable accuracy. Also, it is worth remembering that the smaller the aperture, the greater the tolerance for error in this respect.

Another very important practice, and one that I recommend you adopt as part of your everyday technique, is the taking of a

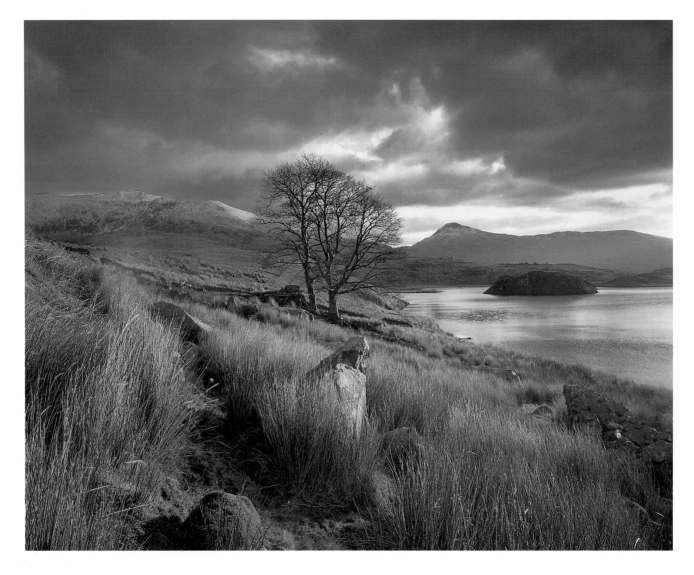

Llyn Dywarchen, Snowdonia
Tachihara 5 x 4in with wideangle lens, Fuji Provia, ISO 100, 1 sec at f/32, 81C. 0.6 grey grad and polarizer

Polaroid. This is a step which should never be missed. Viewing a sample of the picture before taking the real photograph enables you to check composition, exposure and the brightness of the sky (ie, the extent to which the sky should be darkened by the use of a grey graduated filter). It can sometimes be tempting to overlook the use of a Polaroid and, indeed, the speed of events will occasionally dictate that you have to take your picture with the utmost haste. The benefit of a sneak preview has therefore to be sacrificed in order not to miss the fleeting moment, but this should always be the exception. Not only will a Polaroid help to prevent many disappointments, it will have a measurable, positive effect on the quality of your pictures. I encourage you to make its use a habit.

Perfect sharpness and perfect stillness were achieved by using a solid tripod, a small aperture and careful focusing. It was also necessary to wait for the breeze to drop to avoid the long grasses becoming blurred.

artistic use of light and the landscape

Light is your precious raw material. How you use it and control it will, above everything else, have a direct and often dramatic effect on the quality of your photographs. Learn to live it, breathe it, appreciate it and, above all, learn to use it correctly. Ultimately, your photography will stand or fall because of it. So, how do we make the best use of light?

Start by looking; not just at the landscape but at the light falling on it. Choose somewhere within easy travelling distance and visit the same place at different times of day and in different lighting conditions. Observe how the appearance of the landscape changes as a result of how it is lit. Sometimes the effect will be dramatic, sometimes it will be subtle, perhaps no more than a quiet, intangible nuance of something different. Always, however, there will be a change and you will never see the same picture twice.

Soft, diffused light from a cloudy sky will have a softening effect on the landscape, with flat, subdued colours being prominent. Sunlight will have the opposite effect, the precise appearance depending on its strength and direction and the amount of cloud present. Low sunlight during early morning/late evening will reveal undulations and textures and this will be further enhanced when the sun is positioned to one side of the camera. The same scene under a midday sun will look completely different, the contours and textures will have disappeared to be replaced by shadows which are shorter but stronger.

Look also at the effect of broken cloud. On a breezy day watch how the play of light across the landscape produces fleeting moments of perfection as different features are highlighted and lifted out of their surroundings. Just watch and wait and absorb the effects, it will be time very well spent.

Backlighting can be a very beautiful light. The effect of shadows stretching towards the camera across a translucent landscape can be breathtaking but great care needs to be taken. Avoid harsh sunlight and be aware of the possibility of lens flare; sunlight falling directly onto the camera lens will cause this and it should be avoided at all costs. Forests and woodland can look stunning when backlit, particularly in autumn, and they also provide a natural canopy which can eliminate the risk of flare.

The quality of light, you will discover, is infinitely variable. Spend time getting to know the many effects it can create – it will repay you a thousand times over.

january

Although winters have recently become milder, there are still frequent snowfalls on high ground. There may be no sign of snow at sea level but at a height of 1000ft (300m) or so the landscape can become transformed. Search out suitable places in advance, keep a shortlist and follow the weather forecasts.

If the weather is overcast and the lighting flat, woodland and forests provide an opportunity for creative photography. They should not be ignored in winter; small but interesting details, normally hidden by greenery, can make excellent close-up subjects. Look also for breaks in the clouds — shafts of sunlight can transform a winter scene.

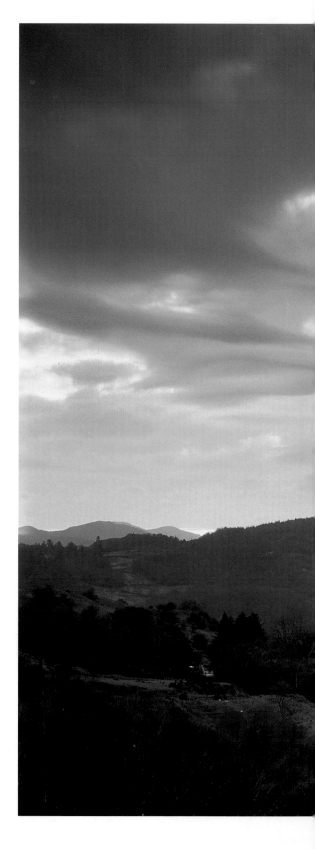

Although taken in the depths of winter, this tranquil scene was just as it appears in the photograph – a calm and peaceful end to a midwinter's day. Grey and cloudy as it is, the sky is not depressing, indeed I rather think it contributes to the beauty and serenity of the picture.

The weight of the sky and the darkness of the foreground encourage the viewer's attention towards the lake and mountains and to those lovely variations of warm, muted colours to be found amongst them.

After a period of waiting the clouds opened momentarily to produce a vivid highlight on the lake. This was worth waiting for. The bright splash of water brings the picture alive, it acts as a focal point and, being the photograph's only highlight, emphasizes the calm mood and tranquillity of the winter landscape.

Very often these special moments go unnoticed. Spend a number of afternoons sky watching and you will discover that winter is not always bleak and miserable. The day can often end spectacularly, briefly perhaps, but long enough to photograph it.

Don't be deterred by cloudy skies. If the cloud structure is interesting and varied and not just a featureless grey, then the final half hour or so of daylight is always worth watching closely. Do venture out at this time of year – seek and you will find.

To ensure that detail was retained in the darkest parts of the picture, a grey graduated filter was used to bring the sky down to the brightness level of the landscape. This enabled the entire scene to be photographed within the limited latitude of colour reversal film and, consequently, the highlights and shadows were reproduced without loss of detail.

Take care with exposure. Automatic TTL metering will overexpose this type of picture, particularly when a grey graduated filter is used. Automatic readings should therefore be adjusted to reduce exposure by approximately 1 stop. For safety, bracket the exposure in one-third or half-stop steps.

Llyn Gwynant, Snowdonia
Tachihara 5 x 4in with 150mm lens, Fuji Provia [ISO 100], 4 seconds at f/16, 81C and 0.6 grey grad

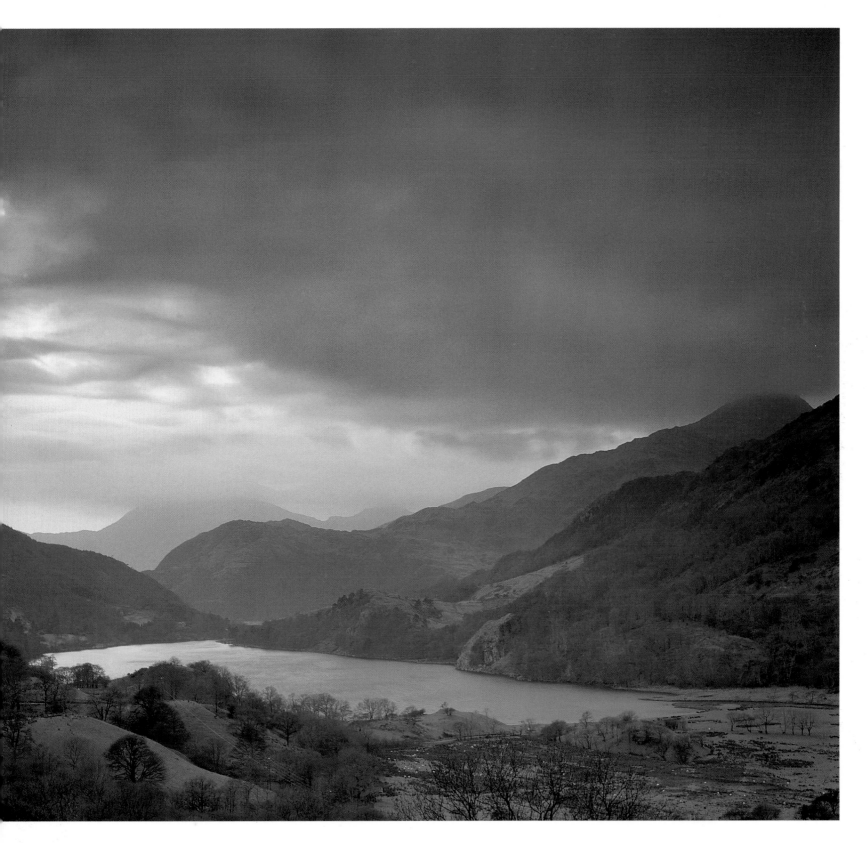

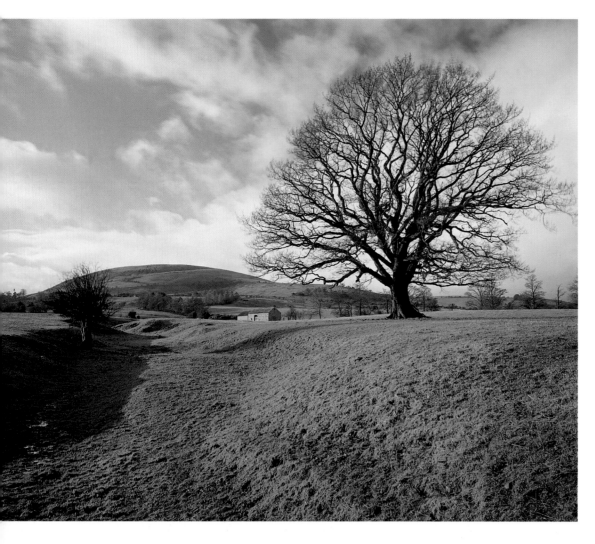

West of Watermillock, The Lake District
Tachihara 5 x 4in with wideangle lens, Fuji Velvia [ISO 50], 1sec at f/22, polarizer

Always consider the lighting conditions. The sun was low in the sky to the left and this created those essential shadows.

Trees should not be ignored in the winter months: their leaves often conceal interesting shapes and patterns.

Driving along a minor road in the Lake District, I was attracted by the shape and solitude of an isolated tree protruding above a hedge, which partly obscured my vision. It is always worth investigating any location which has potential, so I stopped and continued on foot along a conveniently situated path. With every step I sensed that potential was turning to reality. There was indeed a photograph here and the conditions were ideal for it to be taken at that very moment.

For a landscape photograph to work, the individual elements must combine well. Here the tree is a dominant and attractive feature, but that alone does not make the picture. The fall of the land to the left of the tree creates a natural avenue along the landscape and this line of vision is further strengthened by the shadow and water on the lower ground. The viewer quite naturally 'travels' along this avenue, pauses at the tree, continues on to the farm building and finally to the distant hills. The picture therefore takes the viewer on a pleasant walk through the countryside, and what better purpose could a photograph serve?

The combination of the undulating land, the tree, the farm building (this is an essential element because it gives the picture depth and scale), and the hills in the background all work together to produce a structured and satisfying whole. Successful photography comes from observing elements within the landscape and visualizing how they might appear when viewed as a picture. It was observation, not technical skill or electronic gadgetry, which created this photograph.

An 81B warm-up filter was used. Without it the picture would have looked a little cold and grey.

The use of a polarizing filter reduces the light reflected off the damp stones in the foreground and strengthens their colour. It also deepens the shadow on the barn which accentuates the drama in the picture.

My brief spell in the Lake District was proving to be productive. Tuesday morning found me in the right place at just the right time to enjoy, and photograph, this dramatically lit piece of rugged Cumbrian landscape. Again I was initially attracted by a single object, this time a solitary barn, bathed in light and standing resplendent in its surrounding terrain.

Whilst this and the preceding photograph are similar in some respects, in others they are quite different. This time there is no gentle stroll in the countryside, it is rather more of a scramble, a hike over rocks, fences, hills and mountains.

This is a dramatic piece of landscape and it should therefore be dramatically lit. Imagine this picture as a bright and breezy scene, softly lit with blue sky and white clouds. It would fail.

The mood and lighting of a photograph should be appropriate to the nature of the

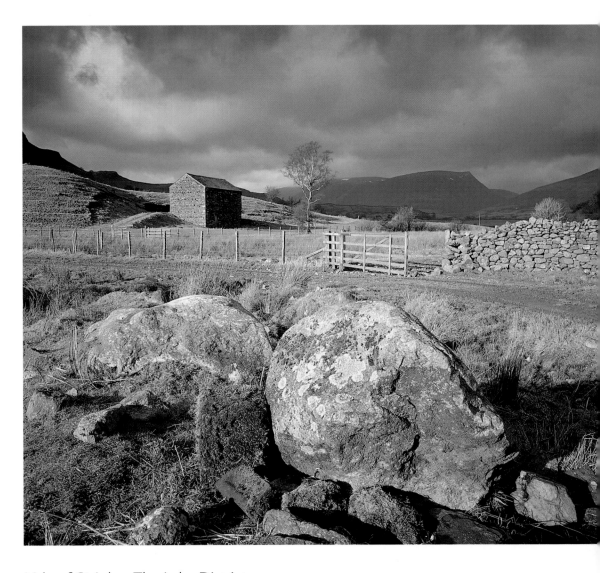

Vale of St John, The Lake District
Tachihara 5 x 4in with wideangle lens, Fuji Velvia [ISO 50], 1sec at f/32, 0.3 grey grad, 81B and polarizer

landscape it depicts. That single barn, sandwiched between a visually strong foreground and sky, must be harshly lit.

Without the contrasting highlight and shadow falling on it, the little building would vanish, lost in all that was happening all around it. The barn is the key to this picture; lose it and you lose the photograph.

When you find a group of objects that you think have the making of a photograph, devote time to their arrangement; attempt to create depth within a balanced composition.

A bland sky is, for this picture, preferable. A cloud pattern would merely have distracted from the arrangement on the ground and would have brought nothing but confusion to the photograph. (This is the exception to the rule. For the majority of pictures, a strong cloud formation is desirable.)

Peckforton, Cheshire
Tachihara 5 x 4in with wideangle lens, Fuji Velvia [ISO 50], 2 seconds at f/45, 81B and polarizer (half polarized)

I think that every photographer has, at some time, been attracted by the symmetrical curves and repetitive pattern of bales of hay scattered over recently combined fields. I have also been drawn towards them. I sensed there was a picture somewhere among the bales and trees in this rolling Cheshire field and after an hour or so of experimenting (there were many options), I finally arrived at this composition.

By this time the sun had almost reached the horizon but fortunately the sky was completely clear with no low cloud to impair the quality of light. The low sidelighting was essential to the success of this photograph and the sun's position had to be considered as the picture was being built. The lighting gives the picture depth because of the shadows cast in the harvester's tracks as they taper away over the brow of the hill.

The other effect of the directional lighting is the solid, three-dimensional appearance it gives to the bales.

The picture therefore consists of cylindrical bales and flat, two-dimensional trees. The arrangement works because the main tree, whilst dominated in size by the bale in the foreground, is in a visually stronger position, being higher and to the right of centre. It draws the eye to and then beyond the horizon and is the cornerstone of the composition. The result is a balanced, apparently carefully arranged photograph.

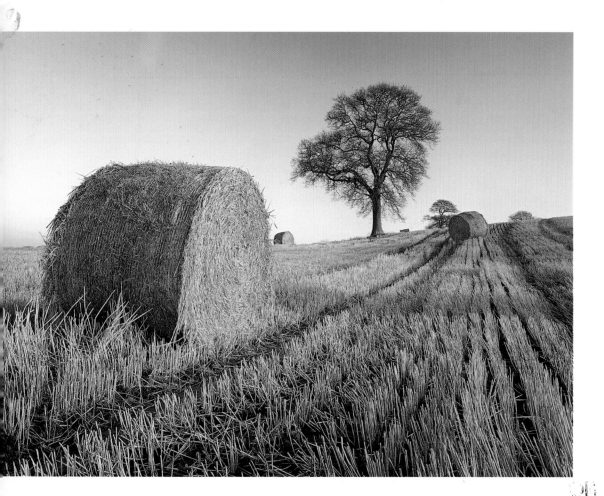

MUNICIPAL LIBRARY

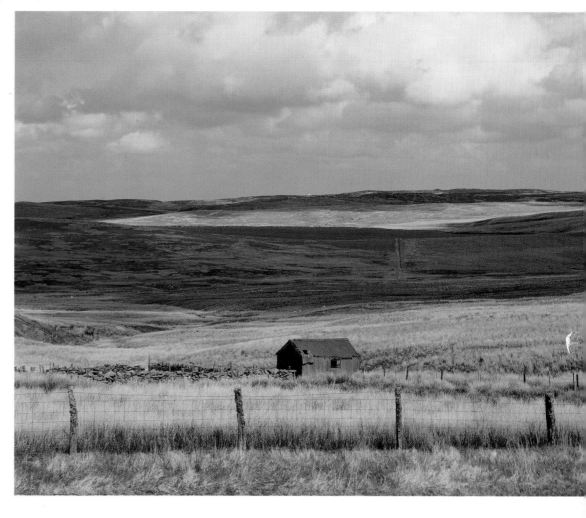

It took me some time (longer than it should, I must admit) to arrive at this composition. I had experimented with various horizon levels (one-third sky, two-thirds sky or somewhere in between), differing relative positions of hut and lake, and finally various focal lengths.

It eventually became obvious that the elements could be placed symmetrically. I realized that the hut could be centrally positioned between the fence posts, which in turn could be spaced equally across the frame. The lake could also take a central position to reinforce the symmetry.

On its own this arrangement does not, however, produce a sufficiently strong image. Light, as always, has a role to play. This time it continues the pattern of horizontal stripes which has become partly established by the bottom strip of green and the adjacent straw-coloured grass. There is a relatively large expanse of sky (the position of the horizon being determined by the structure of the rest of the photograph). It is a pity that the sky does not contribute to the symmetrical theme because the picture would have been stronger still had it contained a cloud pattern which reflected the landscape below. The photograph, therefore, is not perfect, but nevertheless I find it aesthetically satisfying. It seems to capture the spirit of this haunting corner of Wales.

Denbigh Moor, Denbighshire
Tachihara 5 x 4in with short telephoto lens, Fuji Provia [ISO 100], 1sec at f/32, 81C and polarizer

However strong the composition, ask yourself if it could be further improved in different lighting conditions. Look critically at every aspect of the landscape and try, if possible, to improve on reality through the creative use of light.

Strong, oblique lighting emphasizes the shape and presence of the barn.

A polarizing filter was used and this has taken the reflected highlight off the lake's surface but has darkened it to such an extent that it has become lost in the background. The use of the polarizer was, on this occasion, a mistake.

WATERFORD

NO

MUNICIPAL LIBRARY

This snow-capped piece of Tyrolean terrain is in fact the Lake District. What a graphic example of the beauty and diversity of the British landscape.

I took the photograph below initially, preferring the bigger view which included the small tree in the foreground and the distant group of trees to the right.

Although I liked this arrangement (and still do) I was not totally convinced. My instincts told me that concentrating on the main subject – the evergreen trees – would add more to the picture than would be lost. I suspect that, had the deciduous trees been in leaf, I would have been satisfied with the original composition. As it is, I do prefer the second picture.

In addition to these differences in composition, there is something else which separates the two pictures – the use of an 81B warm-up filter.

The warming filters are the yellowish 81 series (with 81 the weakest, followed by the progressively stronger 81A, B, C, D and E). They are used to compensate for a

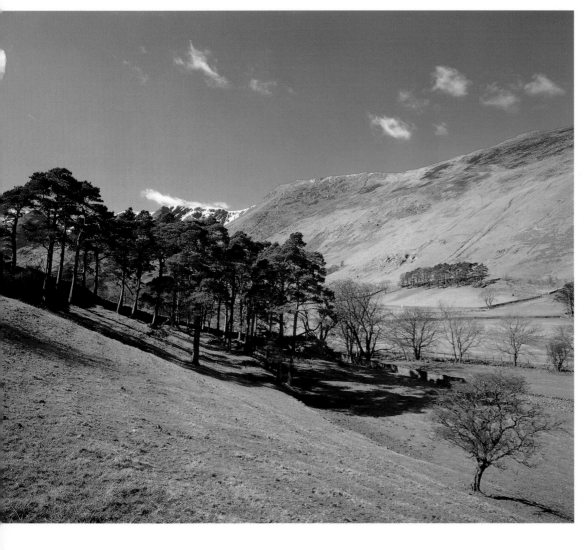

Near Patterdale, Cumbria
Tachihara 5 x 4in with wideangle lens,
Fuji Provia [ISO 100], 1/2sec at f/22, 81B
and polarizer (half polarized)

blue cast which is often present, in varying degrees, in daylight. They can also be used to enhance colour by adding warmth to the picture. Like any filter they should not be used indiscriminately and the rule, as always, is that under-use is infinitely preferable to over-use. There is also an 85 series of filters which are more orange than yellow. The 85A is an

effective filter to use when photographing autumn leaves but generally I find them too extreme for everyday use.

If you compare both photographs, the use of a warming filter becomes apparent. Whilst it improves the colour of the valley in the first picture it would have been quite wrong to have used it to warm the

photograph below. This picture exudes Alpine freshness. It speaks of a crisp, clear, dew-soaked valley, cold and bracing but in its own way also warm and welcoming. Tweaking of colour is quite unnecessary here. Those rich, green leaves are quite splendid; they convey the Alpine theme perfectly and should be allowed to remain just as they are.

Warm-up filters, if used with care and sensitivity, can produce very pleasing results, but beware when photographing a predominantly green landscape: it is likely to become discoloured if a filter stronger than an 81A or B is used.

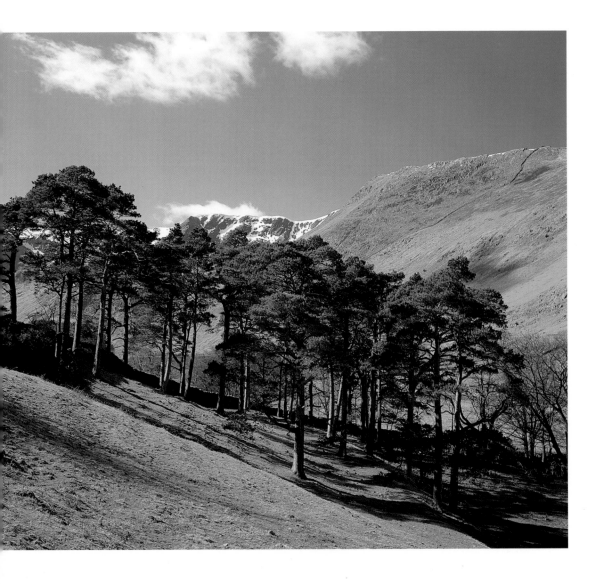

Near Patterdale, Cumbria
Tachihara 5 x 4in with 150mm lens,
Fuji Provia [ISO 100] 1/2sec at f/22½,
polarizer (half polarized)

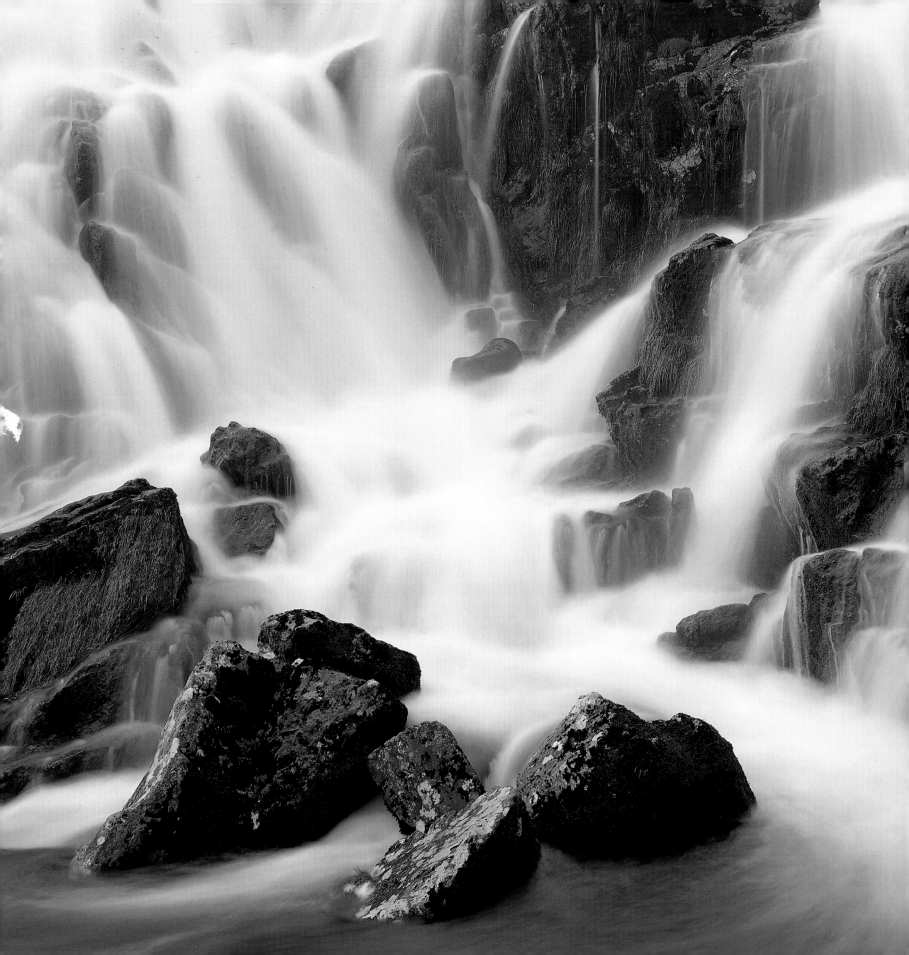

Waterfalls are a consistently popular subject and we are fortunate to live in a country whose landscape is adorned with many spectacular examples. Some are well known while others, like the one pictured here, are tucked away anonymously, well off the beaten track. This fine example of cascading waters can be quite magnificent after a downpour, yet despite this it receives few visitors (and even fewer photographers, I would guess).

Exposure was based on a shutter speed of two seconds. Depending on the force and direction of the water, exposures between a half and four seconds will normally be required to adequately express movement. Too short a shutter speed will give water jagged edges while an exposure that is too long will cause a stream or waterfall to resemble a foam bath. To be certain of obtaining a pleasing result, take several exposures using different shutter speeds (remembering of course to adjust your lens aperture accordingly). In time your instincts will tell you which exposure to use and you will not have to bracket so widely.

I discovered this waterfall by scouring a map of the area. The Ordnance Survey Landranger maps have a scale of 1:50,000 which is equivalent to $1\frac{1}{4}$in to a mile (1cm to 0.5km). These maps are a godsend. All the topographical features and details you are likely to need are shown, including streams and waterfalls. Study them closely and look for features which could be of interest (isolated buildings, lakes, and tree groups are always worth investigating). Used properly, your maps will take you to new and interesting places and also prevent a lot of fruitless searching.

Avoid including water in your exposure reading. The brilliant white appearance of fast-flowing water will cause the photograph to be underexposed.

Sunlight should also be avoided. Soft, diffused light from an overcast sky will give the best results.

Near Bala, Gwynedd
Tachihara 5 x 4in with 150mm lens, Fuji Provia [ISO 100], 2 seconds at f/45

february

This is the time to visit popular tourist towns and villages. Busy resorts, out of season, are free of the summer crowds and overt signs of commercialism and it is in this state that they reveal their true character. Well-known beauty spots and attractions can be photographed in original ways by using lighting and seasonal weather to strong effect. Without the people and traffic and the familiar clear blue sky, your photographs should look vastly superior to the ubiquitous picture-postcard image. Don't be deterred by bad weather. The rain has to stop some time and you only need a few seconds of the right conditions to take a memorable photograph.

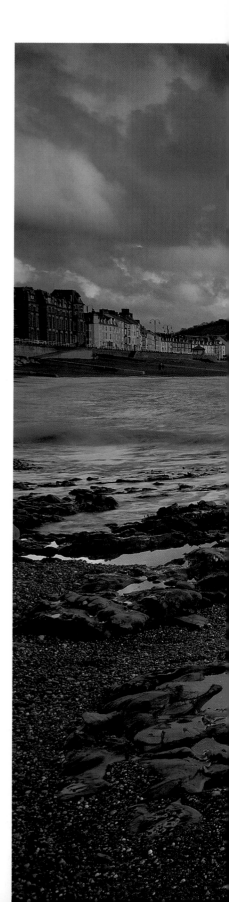

Approaching Aberystwyth from the A44 takes you through its centre and on towards the seafront. A right turn then suddenly brings to view the majestic splendour of the town's crescent-shaped, Victorian promenade. A sweeping curve of tall, imposing, colour-washed hotels embrace Cardigan Bay to form an image evocative of bygone days: seaside Britain at its finest, but don't look too closely.

When faced with an impressive view, the instinctive reaction is to photograph it exactly as it appears. Unfortunately this will, almost without exception, be a mistake. Unless you are extremely careful, a photograph of any resort town will include features which will detract from the image you are trying to create: traffic,

people, litter, buildings in the course of renovation, buildings needing renovation – the list goes on and on. To avoid disappointment you need to think not about what to *include*, but what to *exclude*. You're not trying to capture reality; your objective is to produce a clinically clean, flawless picture.

Take your time. Investigate. Look for high viewpoints or, perhaps, find an interesting foreground which flows into the picture. Consider photographing the scene at the beginning or the end of the day. There will be fewer people around at those times and the subdued light of dawn or dusk can be useful in concealing unattractive features which would be more prominent during daylight.

This was taken from the northern end of the promenade. It was not the most obvious viewpoint but I was attracted by the extensive, rocky foreground. In terms of size, Aberystwyth itself makes only a small contribution to the picture, but, being the brightest part, it is still the focal point. The muted foreground and the weighty sky (which was darkened by a 0.9 ND graduated filter) contribute to this by enveloping the town. This also draws attention to the sunlit promenade and sets the town in its wider, very attractive environment.

Aberystwyth, Dyfed
Tachihara 5 x 4in with wideangle lens, Fuji Provia [ISO 100], 2 seconds at f/32, 81C and 0.9 grey grad

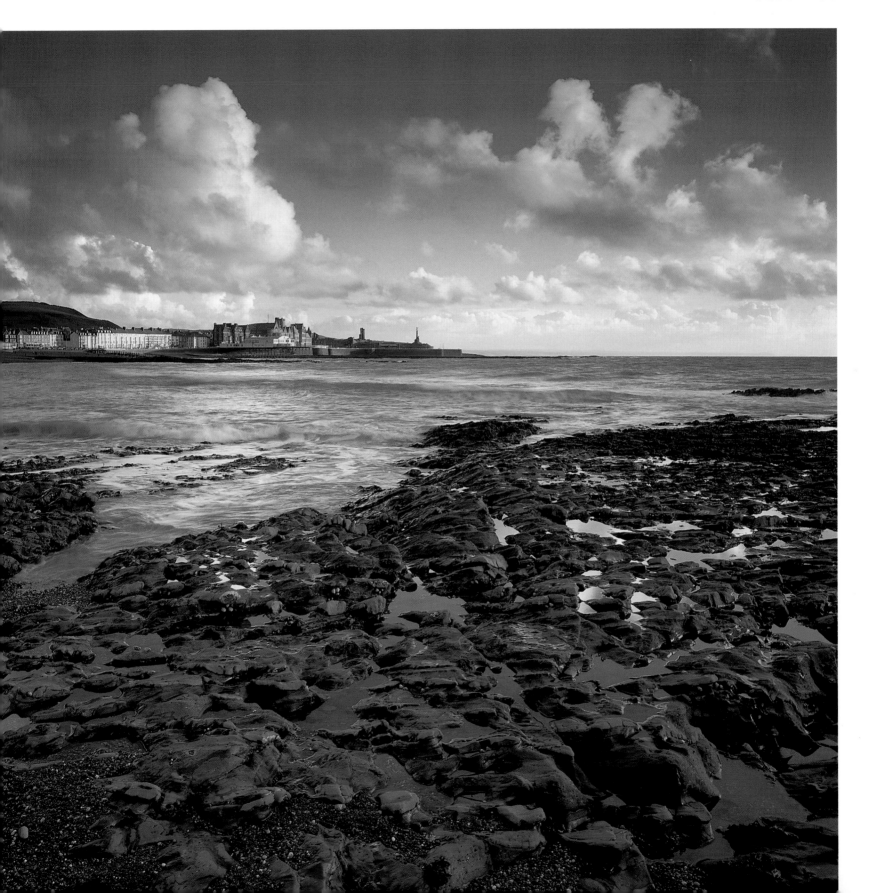

Can there be a more depressing start to a photographer's day than to awake to the deafening sound of hail and rain crashing against the windows? It need not be so as there are two certainties with this country's weather: one, it is capricious and two, however bad the conditions, at some point they will improve. The quality of light can change both quickly and dramatically, particularly in stormy weather, and the brave photographer who ventures out will often be rewarded with stunning pictures which would be unobtainable in fine conditions.

Never give up. Inclement weather is as much a part of Britain's landscape as its mountains, rivers and valleys; it should be considered a photographic opportunity, not regarded as an obstacle.

On this day the rain did relent, finally stopping late in the afternoon. The sky, however, was a dull, featureless grey, the lighting was flat and the wind prevailed. I therefore headed for a waterfall that I had found on the map. Waterfalls photograph well in overcast lighting and the heavy rain would have swollen the rivers and streams and produced, I hoped, a powerful and gushing cascade.

The route took me along a remote track towards an isolated barn and on to those lovely, colourful dry-stone walls. They alone seemed to brighten the entire landscape. The subdued lighting revealed perfectly the stones' subtle variations of colour. The day, which had started so unpromisingly, was, after all, proving productive. I was fortunate on this occasion: shortly afterwards the weather deteriorated again and forced me to discontinue my journey to the waterfall. That is now for another day.

Near Stonethwaite, The Lake District
Tachihara 5 x 4in with wideangle lens, Fuji Velvia [ISO 50], 2 seconds at f/32, 81C and polarizer

The sky is weak. It could have been improved by using a grey graduated filter but this would also have darkened the top of the hillside and its use would have been obvious.

The forecast had not been encouraging. Sleet and gales were expected later in the morning so the answer was to rise early, before the weather deteriorated. It is common knowledge that a dawn sky frequently looks attractive but not always appreciated that the most striking cloud formations often occur during unsettled or stormy conditions. Changeable weather should therefore be greeted with enthusiasm, not despondency.

Here the dawning of a new day has brought with it an air of tranquil serenity but the soft, pastel colours and calm water conspire to deceive. Minutes later the dawn glow faded, to be replaced by rain-filled clouds and a stiffening, icy breeze. Despite (or, more accurately, because of) the stormy weather, the day was to prove productive; the rain would stop and start, sunlight would flicker across the mountains and clouds would roll by in constantly changing formations. This is the type of weather from which great pictures are born. Brave the conditions, persevere and you will reap the rewards.

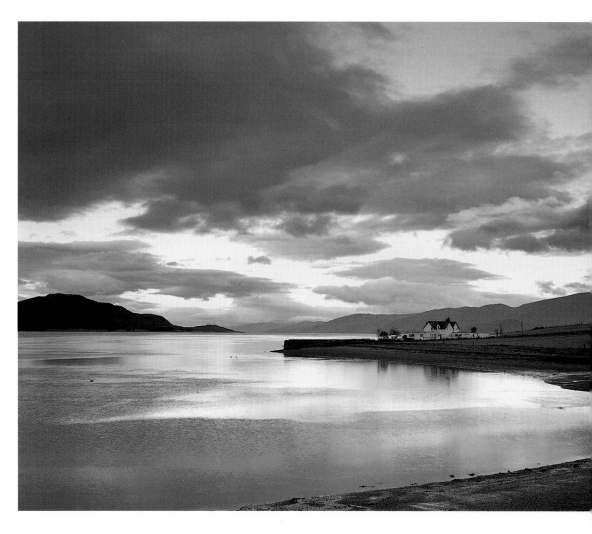

Loch Linnhe, The Scottish Highlands
Tachihara 5 x 4in with 150mm lens, Fuji Provia [ISO 100], 1/2sec at f/32, 81C and 0.6 grey grad

Do rise early. Although it can be unpredictable, dawn lighting creates effects which occur at no other time of day and they can be a photographer's delight.

The lochside cottage brings scale and perspective to the picture and is the cornerstone around which the photograph is constructed. Look out for isolated objects (trees are useful): they often provide the opportunity to create an original picture and should not be ignored.

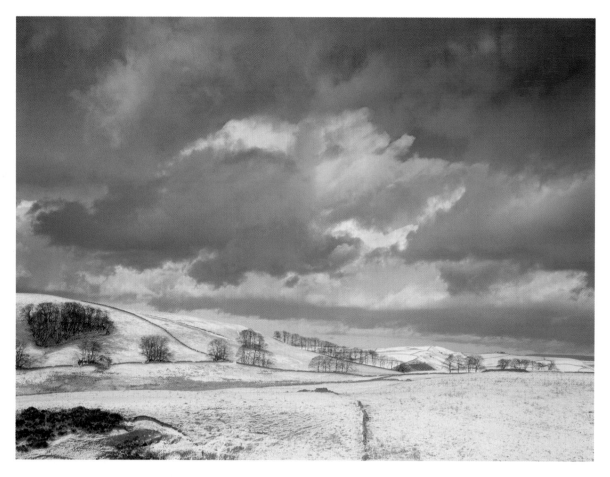

West of Buxton, The Peak District
Tachihara 5 x 4in with wideangle lens, Fuji Provia [ISO 100], 1/30sec at f/22, 81B and 0.3 grey grad

In this book there are a number of photographs which show more sky than land. Sometimes the horizon may be just a fraction below the centre of the picture, other times it might be much lower.

A photograph might easily consist of nine-tenths sky and one-tenth land and work well, making a striking and memorable image. Conversely, there are photographs which include just a tiny strip of sky, with the horizon placed very close to the top of the frame. So, what are the guidelines? The positioning of the horizon is a much debated subject and there is no rigid formula which should be adopted. The rule of thirds (ie, placing the horizon one-third or two-thirds up from the bottom of the picture) is an acceptable starting point but should be used as a guide only; like any rule it should never be slavishly followed.

The quality of the sky, the arrangement of the landscape beneath it, the position of clouds and, of course, the theme of the photograph are the relevant factors which should be used to determine where the horizon is placed.

When photographing snow, beware of a cold blue cast, which can make a picture look uninviting. An 81A or B filter will eliminate this and bring a warm glow to your snow scenes.

It is easy to underexpose snow. Exposure meters are calibrated to produce mid-grey tones. It will therefore be necessary to increase exposure by one to two apertures.

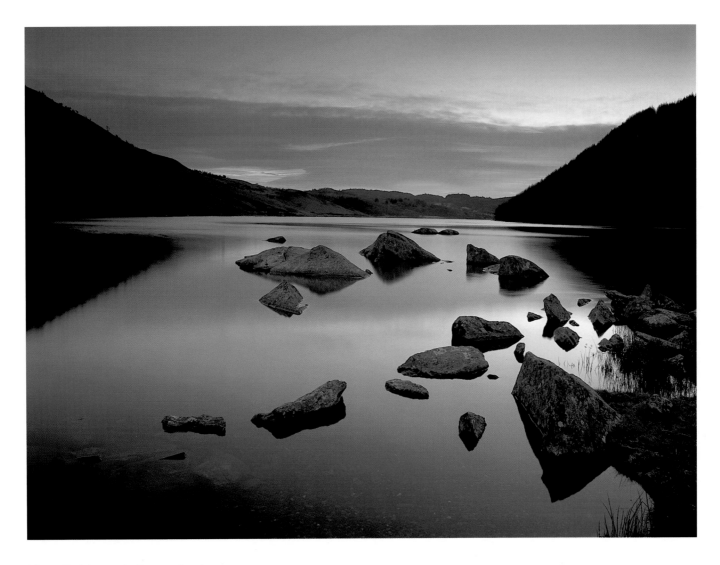

Llyn Geirionyd, Snowdonia
Tachihara 5 x 4in with wideangle lens, Fuji Provia [ISO 100], 5 seconds at f/32, 81C and 0.6 grey grad

You may sometimes find it necessary to choose a central position; though often frowned upon, I don't hesitate to place the horizon in the middle of a picture if this makes the strongest composition, as in the photograph on page 1. The horizon had to be placed centrally. If I had raised or lowered it, the picture would have been weakened as a result – and most people would not consciously notice this central position unless it was pointed out.

In the photograph opposite, there was only one possible arrangement. The combination of one-third land and two-thirds sky reflects the visual strength of these two elements. The snow-covered landscape has a role to play and enough should be included to enable it to make its presence felt, but undoubtedly it is the sky which is the more interesting. This is a skyscape rather than a landscape and it should be photographed as such.

In the photograph above it is, again, the sky which makes the picture, but this time the appeal lies in the reflected sky as much as the sky itself and the horizon must be placed near, but not too near, the top of the picture. A lower horizon would have weakened the drama created by the dark, forbidding water in the foreground, whilst a higher horizon would have tipped the balance: there would have been too much black and too little red, blue and purple.

Winter is an excellent time to visit Britain's coastal resorts and villages. As well as deserted beaches and quiet fishing ports, the short days enable the photographer to work at both dawn and dusk and, because of the low position of the sun, throughout the entire day.

I spent a week in Cornwall in late February expecting there to be very few holiday makers and hoping that the weather would, by this time, be offering at least a suggestion that spring was not that far away. This particular day, however, started badly – very badly (similar in many ways to my rain-soaked day in the Lake District described on page 30).

Not to be deterred, I ventured to the coast expecting to find it deserted on such a wet and windy winter's day. My optimism was justified: I did indeed have the place to myself and, thankfully, the clouds soon began to break. This invited sunshine and showers to vie for supremacy throughout the morning. These are the perfect conditions for a photographer because they produce an ever-changing and continually moving play of light across the landscape. Be patient on such occasions and you will experience some exquisite lighting effects.

Often it is the minimally lit landscape which is the most striking. Imagine for a moment that light was not free, that it had to be paid for along with your film and processing. If this was the case then it would, of course, be used more carefully and sparingly. There is no doubt in my mind that if light was not so freely and readily available, photography standards would improve.

Avoid lavishly lit landscapes. Wait for a particular feature which you find attractive to be lit in isolation from its surroundings.

In changing lighting conditions take as many pictures as your instinct tells you (this does not mean shooting an entire roll of film and hoping for the best). You may obtain a number of quite different, but equally successful, photographs.

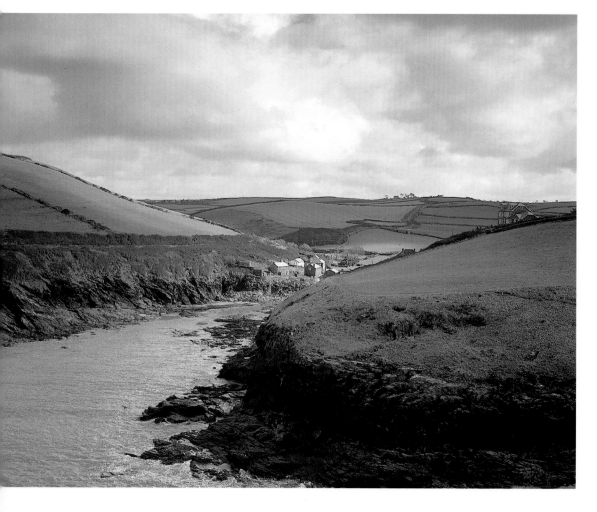

Portquin, Cornwall
Tachihara 5 x 4in with 150mm lens, Fuji Provia [ISO 100], 1/8sec at f/22, 81C and 0.6 grey grad

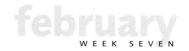

This picture of Port Isaac shows, I hope, the benefit of visiting resorts out of season. Despite it being Sunday afternoon, this popular village was almost deserted. I made a number of exposures using a 1 second shutter speed and not once did a passerby inadvertently wander into the picture. This, I can state from painful experience, would not be the case in the summer.

It was necessary to wait half an hour for the sun to disappear behind a cloud. The photograph is structured around a series of straight lines – a combination of horizontal, vertical and diagonal. Shadows would have conflicted with these lines. The introduction of contrasting light and shade would, therefore, have reduced the photograph to a confusing eyesore.

When photographing buildings, avoid tilting the camera upwards because the result will be converging parallel lines. This has happened here slightly and was careless of me, particularly as my camera has movements to compensate for this.

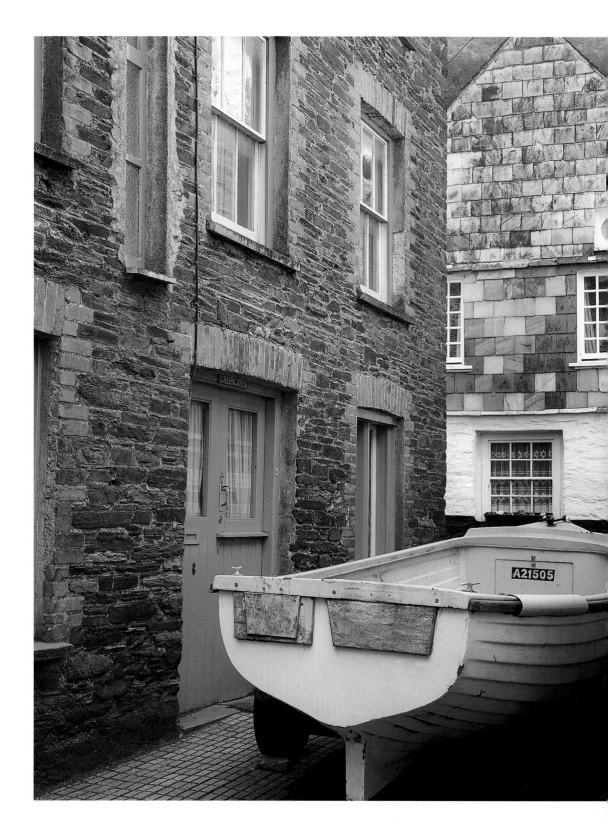

Port Isaac, Cornwall
*Tachihara 5 x 4in with 150mm lens,
Fuji Provia [ISO 100], 1sec at f/22*

A dull, overcast day is not, under most circumstances, appropriate weather for photographing big, open views. It is, however, the perfect lighting for close-up pictures, as both this and the photograph on page 37, I hope, demonstrate.

In this photo, muted but saturated colour combines with a vividly patterned tree bark to produce a bold image. This would not be improved by strong, directional lighting (it would, in fact, be spoilt by the introduction of highlights and shadows).

These minute landscapes are not uncommon. They exist in every forest but must be searched for with a critical eye. A casual glance will reveal nothing.

This picture was taken on a day which was totally unsuitable for most types of landscape photography, but, if the desire is strong, there will always be a picture to take.

Erdigg Forest, Clwyd
Tachihara 5 x 4in with 150mm lens, Fuji Velvia [ISO 50], 15 seconds at f/45, polarizer

Meols, The Wirral Peninsula
Tachihara 5 x 4in with 150mm lens, Fuji Velvia [ISO 50], 4 seconds at f/45, polarizer

When searching for a photograph you should always be aware of the possibility of there being a landscape hidden within the landscape. A tiny detail, insignificant to the casual observer, can, when isolated from its more dominant surroundings, become transformed and assume the perspective and impact of a large, open vista.

Here the simple combination of two distinct colours and the flowing lines of the rock face (which are so very important to the composition of the picture) caught my attention. I knew I had found the photograph I was seeking. All that was necessary, apart from deciding on the composition, was the careful removal of some surplus sand from the foliage.

Always remain vigilant. The most interesting photograph may be just inches away.

march

Conditions can be volatile and difficult to predict at this time of year, so be prepared for changeable, capricious weather. There can also be significant regional variations across the country, so follow the weather forecasts carefully but plan only one day at a time. (If you plan longer than this it becomes a gamble.) The landscape is now awakening from its winter hibernation. Early flowering shrubs, emerging foliage and spring flowers can make attractive subjects. This is also a convenient time for photographing as night falls. Brightly lit towns and cities photograph particularly well in the late afternoon/early evening.

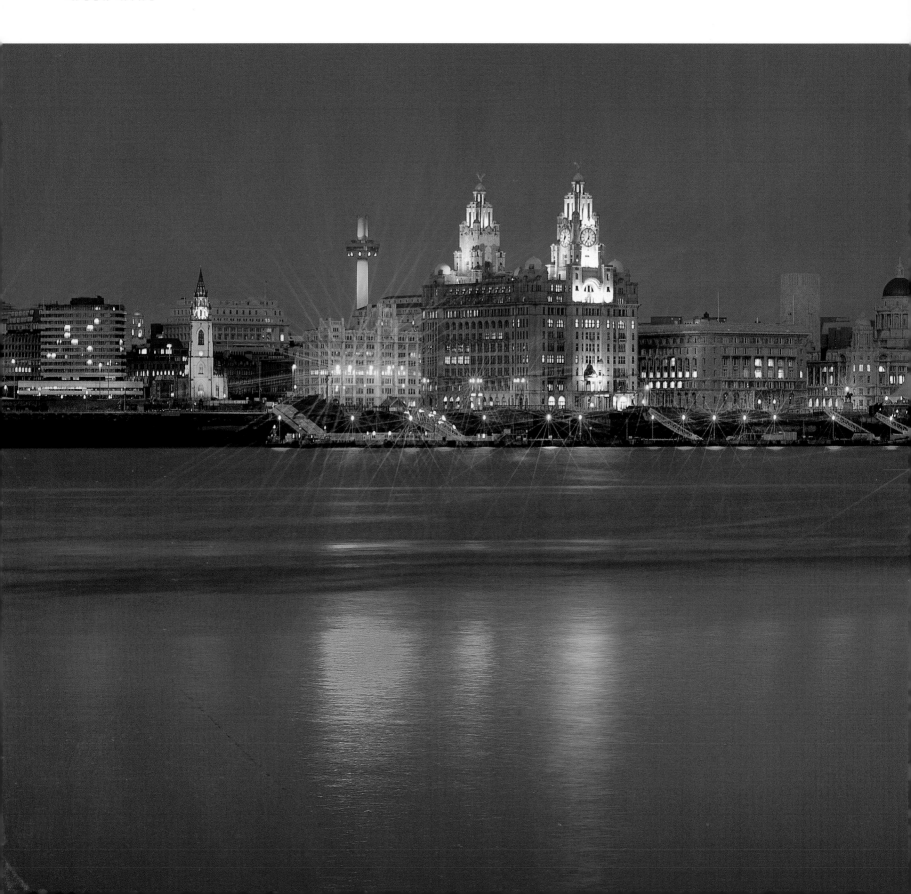

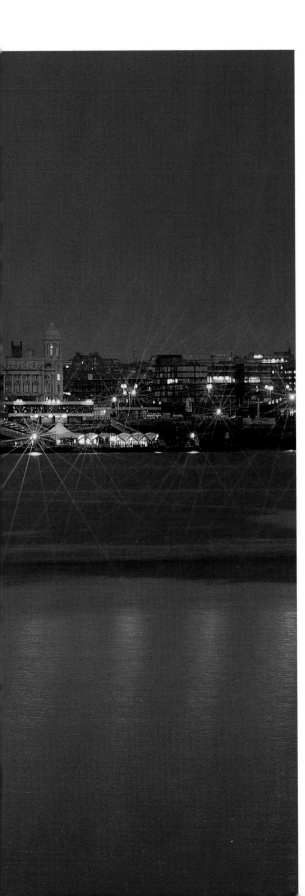

There is just one rule to remember if you intend to photograph at night – don't! Photograph instead at dusk when there is still some daylight left in the sky. The crystal clear, heavenly blue sky you see here would have become, if photographed just a little later, an inky black mass. This would have looked dull and contrasted too sharply with the illuminated buildings.

Light fades rapidly once the sun has set, so allow yourself plenty of time to choose your viewpoint and set up your camera and tripod. Ideally, you will either know the location well or have researched the best vantage point.

No filters should be used (there is, of course, no need to darken the sky) unless your intention is to produce star effects with the points of light as I have done here. If you decide to do this then I would suggest that you include only a small number of light sources as the effect can easily be overdone. As always, exercise restraint when using any filter.

When calculating exposure, ensure that no naked lights are included in your reading because the result will be an underexposed photograph. Measure only light reflected from the buildings – a spot meter is perfect for this – and always bracket your exposures in 1/2 stops.

Ensure that the camera is perfectly level, particularly when vertical or horizontal lines are included in the picture. Use a spirit level for absolute certainty.

The sky was perfectly clear when I took this photograph. Beware of cloud, which can reduce a dusk sky to a murky grey.

When using shutter speeds of several seconds or longer, it will be necessary to increase exposure to compensate for reciprocity failure. The increase required is likely to be in the region of a 1/2–one stop but your film guide notes should give specific advice.

When working in the dark you will need to be completely familiar with the operation of your camera. Practise at home with any new equipment until its handling becomes second nature to you.

Liverpool waterfront
Tachihara 5 x 4in with 150mm lens, Fuji Velvia [ISO 50], 60 seconds at f/16, starburst

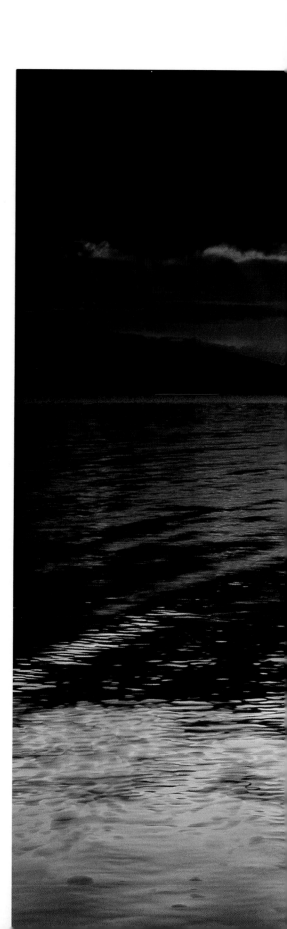

'Oh, that must be relaxing', is the reply I generally receive when I tell somebody what I do. Well, photographing the landscape can certainly be relaxing but, in reality, it is often just the opposite.

This picture of Loch Fyne, for example, was the end result of a frantic, final hour of daylight which I spent driving repeatedly up and down the same stretch of coastal road. There was no time to head for anywhere else. The sky was improving, but the light was fading, so I had to find a photograph somewhere along the shores of the loch.

Every quarter of a mile (250m) or so I would stop and clamber down the bank, often continuing over, around or through brambles – they weren't going to stop me – to find that elusive Highland image. There was no time to breathe in the tranquil atmosphere and certainly no time to allow myself to be wooed by the loch's seductive beauty. There was work to be done and it was becoming a race.

Finally, with the setting sun now a distant memory (in reality it had set only a few minutes earlier but at the time it seemed much longer), the rippled, textured surface of the loch delivered the answer to my prayers. So, the day ended successfully after all, but it had not been easy, and it had certainly not been relaxing.

It is not always frenetic and there are, of course, many times when it is possible to work slowly and enjoy the experience of watching and waiting for that special moment. But it is a fact that there are also many occasions when, if you are to avoid being left behind by the pace of what is happening all around you, you have to move, almost literally, with the speed of light.

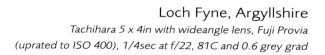

A relatively fast shutter speed was necessary to capture the detail on the water's surface. The 1/4 second exposure has softened the ripples slightly but has retained the texture. I would have preferred to use a 1/8 second exposure but I had already uprated the film from ISO 100 to 400 and did not want to push the film by more than two stops.

Loch Fyne, Argyllshire
Tachihara 5 x 4in with wideangle lens, Fuji Provia
(uprated to ISO 400), 1/4sec at f/22, 81C and 0.6 grey grad

I visit Lyn Gwynant often. There is, here, a quite marvellous combination of mountain, lake and sky. Places like this should be revered. I would encourage you to find somewhere similar and make it the subject of prolonged study; observe it at different times of day, in different seasons and in a variety of lighting conditions. Brave the elements. Do not be deterred by inclement weather – the best pictures often arise at the most unlikely moment.

It is an inescapable fact that success is directly linked to effort. Technical skill and creative flair, whilst admirable and indeed essential attributes, are wasted if they remain cocooned in esoteric isolation from the real world.

The reality of success is the acceptance of many tiresome necessities. These include rising early, returning late, making wasted journeys, making (sometimes many) return journeys, enduring many hours of waiting, endless hours of sky watching, and becoming cold, wet, tired and disappointed. But don't be deterred by this. You will also enjoy moments of sheer delight, magical moments which will remain with you forever. In comparison, the effort and disappointments will seem insignificant. Be prepared to make this effort, think positively and the balance will immediately tip in your favour.

This picture was the result of a week of daily visits to the lake. For six consecutive days I made the journey. The first five trips were fruitless but I knew it was just a matter of time. At the sixth attempt the variable elements of light, cloud and wind combined to enhance the lake's natural beauty to stunning effect, and through persistence, I was there to photograph it.

Llyn Gwynant, Snowdonia
Tachihara 5 x 4in with 150mm lens, Fuji Provia [ISO 100], 1sec at f/22, 81C and 0.9 grey grad

Don't accept second best. If you find a good location make the most of it; keep returning until you are satisfied that you have seen and photographed it in the best conditions possible.

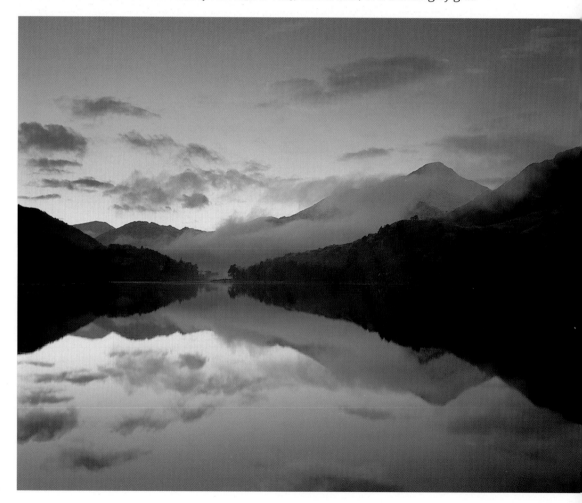

There are some places which invite you back again and again, each visit providing a different experience and a new discovery as the landscape teasingly reveals something about itself which it had previously kept hidden. The Snowdonia National Park is such a place. Every time I visit I invariably find something new to photograph. It is the sort of place to which one could easily devote an entire book, there being so much potential within it. Don't despair if North Wales lies beyond easy reach – there are areas with equal potential to be found all over Britain. They may not be on the scale of Snowdonia but they can still be the source of many exciting picture-taking opportunities.

Look for rural areas which have lakes and streams, a hilly or mountainous terrain and a mixture of deciduous and evergreen trees. Become familiar with an area, get to know it well, and visit it frequently. You will be rewarded.

When foreground plays a major role in a picture, endeavour to organize the composition so that the rest of the landscape flows away from it in one continuous sweep. If you can, find a position which gives you an uninterrupted view, free of any blind spots. This can often be achieved by adopting a high camera position which looks down onto and then beyond the foreground.

A lake doesn't always have to be perfectly still to look attractive. A nuance of a reflection can sometimes be an effective means of bringing water into a picture.

Llyn Cregennan, Snowdonia
Tachihara 5 x 4in with wideangle lens, Fuji Provia [ISO 100], 1/4sec at f/45, polarizer

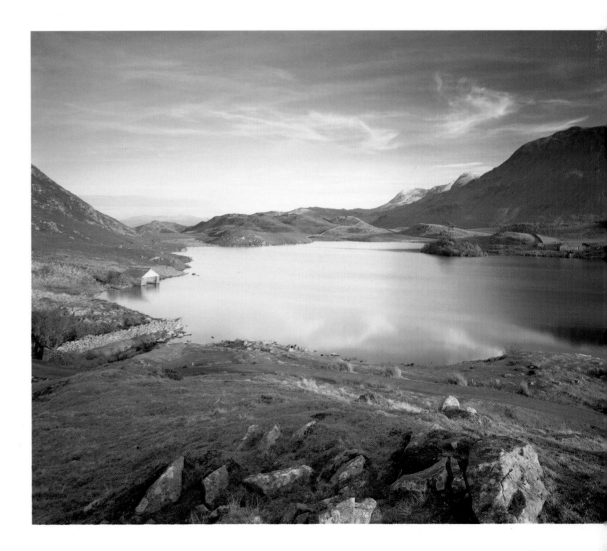

There I was, driving home, another day on the landscape over (I thought) when suddenly I was forced to come to a screeching and abrupt halt. Well, not forced exactly; most people would simply have continued their journey, but then most people would not have been compelled to investigate the beacon of light which, under normal circumstances, usually takes the appearance of a run-of-the-mill winding river.

My investigation over, there was no doubt about it; I simply had to photograph this marvellous river and sky. All I needed was something in the foreground. It was fortuitous that I didn't have to look far because the light was, by now, subdued. Therefore, to prevent those upright stones being reduced to a murky grey, I used fill-in flash to bring them closer to the brightness of the sky and river. I use flash only as a last resort because it can easily create as many problems as it solves. As a precaution, having calculated the exposure, I reduced the power of the flash unit by half. The result is that, whilst the artificial light has sufficiently brightened the stones, its presence is not in any way noticeable.

Flash is like a filter – its use should never be detected.

You would think that this picture had been taken with the addition of a sunset filter but in fact only a mild warm-up and a grey graduated filter were used. This demonstrates the natural colour which can be hidden in the sky. Often these unseen colours remain so because of overexposure. Reduce the brightness of the sky with a neutral grey filter and those latent colours will be brought to life. Here a high density filter was used and, on this occasion, proved too strong. A medium filter would have produced a slightly paler sky which would have looked more natural.

Near Talysarn, Gwynedd
Tachihara 5 x 4in with wideangle lens, Fuji Velvia[ISO 50], 1sec at f/32, 81B and 0.9 grey grad

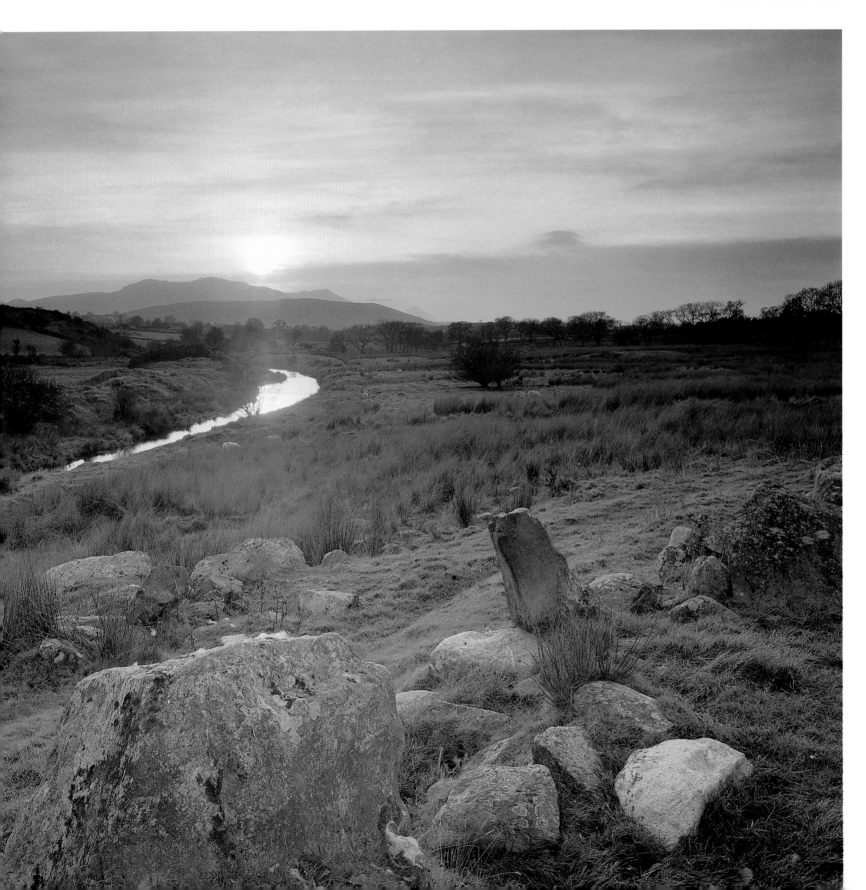

april

Vivid greens (and in some parts of the country, yellows) are the predominant colours at this time of year. Look for expanses of grasses or vegetation which display subtle variations of colour and texture, and fields of emerging crops which can produce strong graphic lines across the landscape. Appearances can change quickly in the spring; visit places which have potential at least once a week to ensure that you don't miss the optimum moment. Improve colour saturation by using a polarizing filter to reduce reflections from wet or dew-soaked fields, even on overcast days.

Near Tiverton, Devon
Tachihara 5 x 4in with short telephoto lens, Fuji Provia [ISO 100], 1/4sec at f/22½, 0.3 grey grad and polarizer

Britain's landscape is renowned for its rich topographical diversity. Sweeping coastlines skirt majestic mountains, rolling farmland mingles with open moorland and, as if all this wasn't enough, forests, lakes, rivers and streams bring their own array of visual highlights. These are the qualities which make the landscape such an irresistible object of attention. We photograph it but, somehow, are never satisfied; we keep coming back, time and time again, for more. Why is this?

Well, there is something else. Britain's landscape is also an intriguing blend of permanence and transience. There are the parts which have a reassuring, timeless predictability, the places where you know what you are going to find when you get there, your concern being only (!) the weather.

Then there is the unknown, the ever-changing landscape which we, as photographers, must share with others. This is the farmed, agricultural land which exists in a constant state of transition. The growing seasons bring with them shapes, patterns, textures and colours and these are as vital to the photographer as are the crops to the farmer. You never know what

you will find. Pictures appear and disappear, sometimes literally overnight, and it is this constantly changing appearance which is so compelling.

Devon is a fine example of rural farming activity at its most photogenic. There are also attractions of the permanent kind in its woodland, moors and coastline. It is a county rich in photographic opportunity and I always find a visit there to be a rewarding experience. This photograph was taken on my way home, having spent several days in the area to the west of Tiverton. I was fortunate because, having seen the field only the previous day – when it was raining – I had only this one opportunity to take the picture. The day got off to a wet start and it didn't look hopeful but, ever the optimist, I waited. Three hours later the sky cleared sufficiently for me to grab the image I wanted. I think the simple composition and the solid, distinct colours work well together. This is a graphic example of a photograph being created, not by me, the photographer, but as a by-product of the arable farming process. Spend time in areas of rural farmland and, with keen observation, you will discover images like this throughout the country.

Although it is a realistic picture, this is as much an abstract image. Look out for these patterns and arrangements as you drive along. They can suddenly appear without warning and are easily missed.

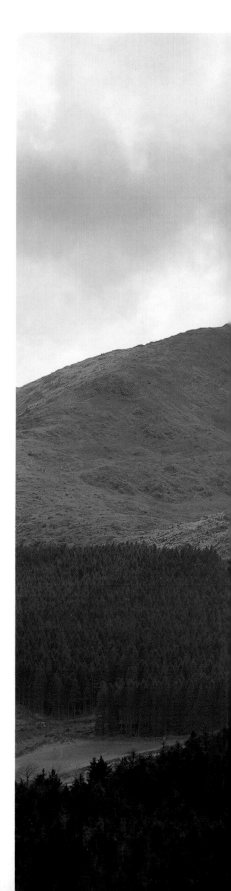

You will see that there is no foreground or middle distance in this photograph. It is a simple, two-dimensional image, but a sense of distance and scale still prevails. The trees and, critically, the isolated farm building, define the size and magnitude of the towering mountain, so it was vital that strong emphasis was given to that tiny barn standing in its bright green field. This could only be achieved by the use of light.

I had to wait for several hours for the clouds to produce a beam of sunlight on that specific part of the mountain face but there was no choice: the picture would not have worked without this spotlight effect. Those three hours or so of sky watching enabled the unmistakable and overwhelming scale and beauty of Snowdonia to be graphically brought into the photograph. This is no illusion, it is real, and of this the viewer is left in no doubt. This perception of scale has also introduced depth into the photograph, without the presence of foreground or middle distance.

All of this has been achieved by using the most effective tool available to the photographer – the creative and precise application of light.

The sky is weak and would have been improved by the use of a grey graduated filter, but the mountain peak would then also have darkened and this would have looked unnatural.

There is sunlight falling on the mountain just above the field. It is not as strong as the light on the barn but ideally it should not be there. When spotlighting a single object, there should be no other highlights in the picture.

Beddgelert Forest, Snowdonia
Tachihara 5 x 4in with short telephoto lens, Fuji Provia [ISO 100], 1/15sec at f/16½

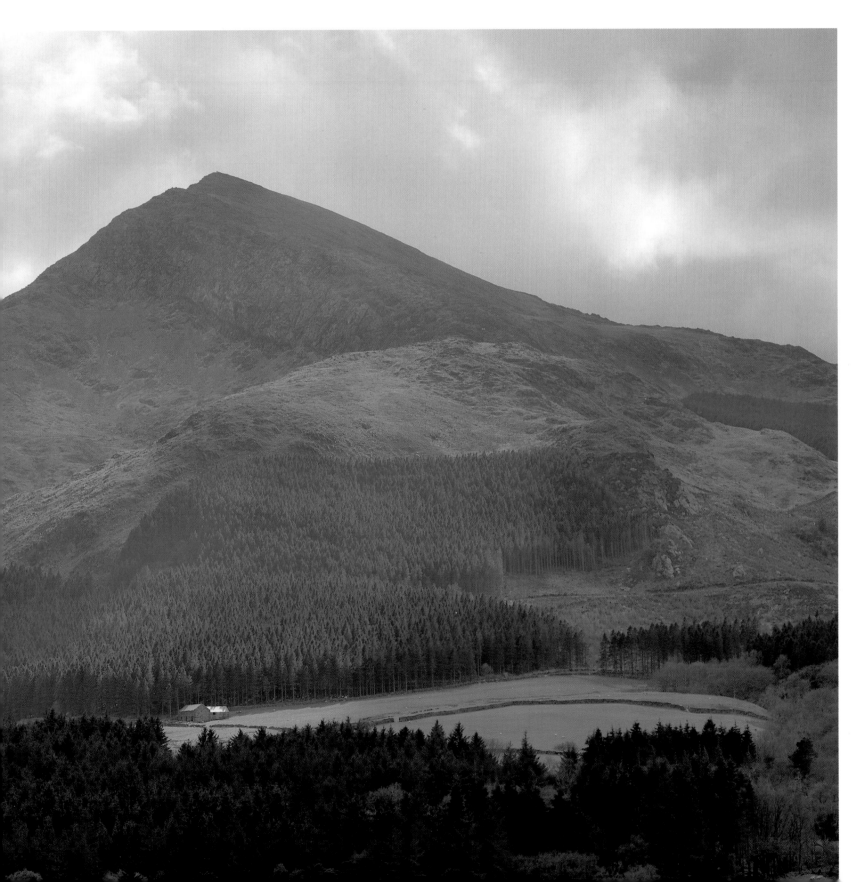

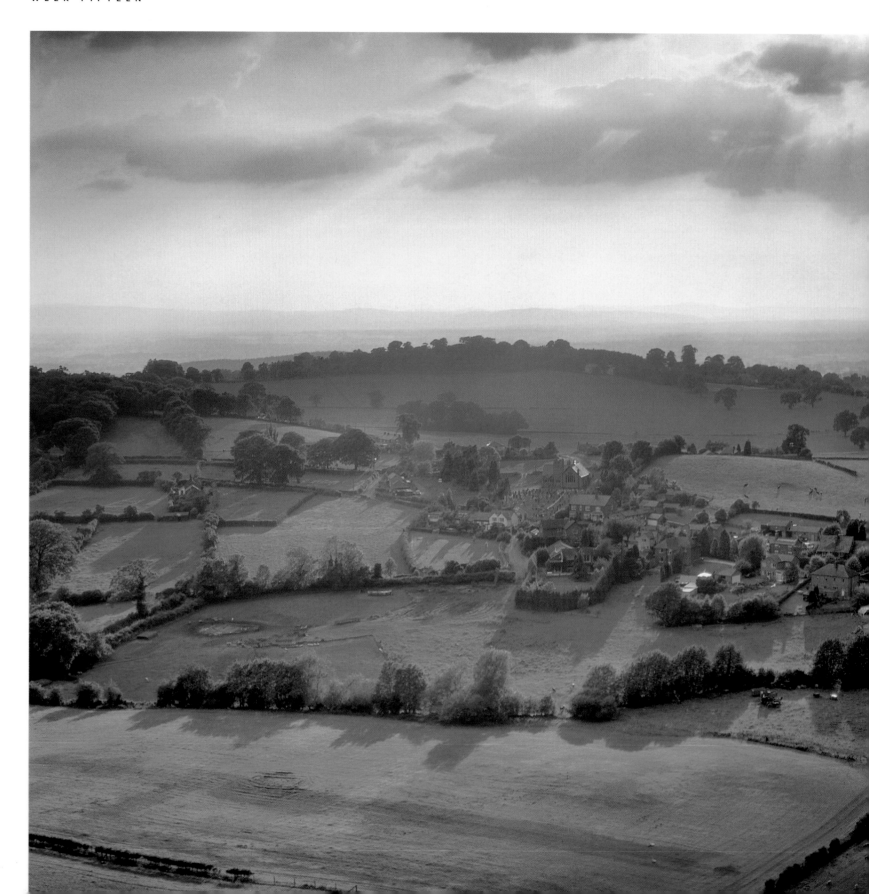

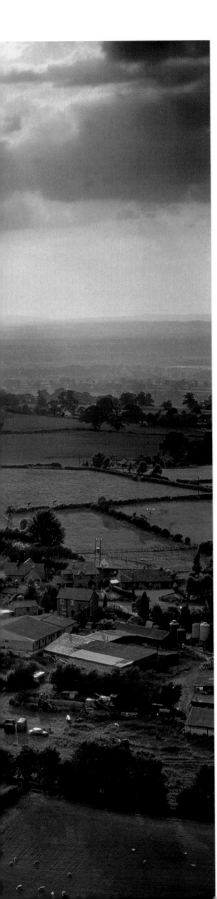

Bickerton Hill, Cheshire

Tachihara 5 x 4in with 150mm lens, Fuji Provia [ISO 100],
1/8sec at f/32, 0.9 grey grad

Photographing into the sun is often a recipe for disaster. The result is frequently lens flare and a jarring clash of highlights and shadows, but this is not always the case and it has the potential to provide an exquisite form of lighting.

Broken cloud and evening sunlight combine here to illuminate the landscape in a theatrical manner. This type of backlit photograph always looks striking, but do beware of flare which can only be avoided by waiting for the sun to be partially obscured by cloud.

Once everything is ready, it is then simply a matter of watching and waiting for the perfect moment as the light plays across the landscape. However, take care with your exposure reading. Point the meter at the landscape only and completely exclude the sky. Because it is backlit, the sky will be very bright and, if included in your reading, would cause your photograph to be underexposed.

A high viewpoint will enable you to point the camera downwards which can greatly reduce the risk of lens flare.

A polarizing filter is ineffective when pointing towards the sun. Almost certainly, the only filter you will need is a medium or high density, grey graduated, which will enable the detail in the sky to be recorded.

If depth of field allows, use a larger aperture to soften the effect of a graduated filter. Exercise restraint when using filters. Under-use is infinitely preferable to over-use.

To record a subject as a silhouette, take a meter reading of the sky and then expose for the sky only. If water is to be included in the photograph, there is likely to be a difference in exposure value between sky and water of about 1 stop. Use a light density, grey graduated filter to reduce the sky's brightness and base your meter reading on the water. For safety, bracket the exposure in 1/2-stop steps.

It would have been pointless taking these pictures had there been even a slight breeze. Perfect reflections occur only in perfect stillness.

The Albert Dock, Liverpool
Tachihara 5 x 4in with 150mm lens, Fuji Provia [ISO 100], 5 seconds at f/45, 81C and 0.6 grey grad

These two pictures were taken within 20 minutes of each other. In both cases a grey graduated filter was used to reduce the sky's brightness but in the photograph below it was too strong. Its presence is obvious and it weakens the picture. I should have used a lighter density filter and a softer graduation to give a less abrupt transition from light to dark.

I much prefer the picture to the right where the use of the filter is completely undetectable. The sky and water are in perfect balance, a single colour, a single element. For both pictures an 81C warm-up filter was also used but it had only a marginal effect. It is the sky's natural colour which has been reproduced, by careful exposure rather than by any form of manipulation.

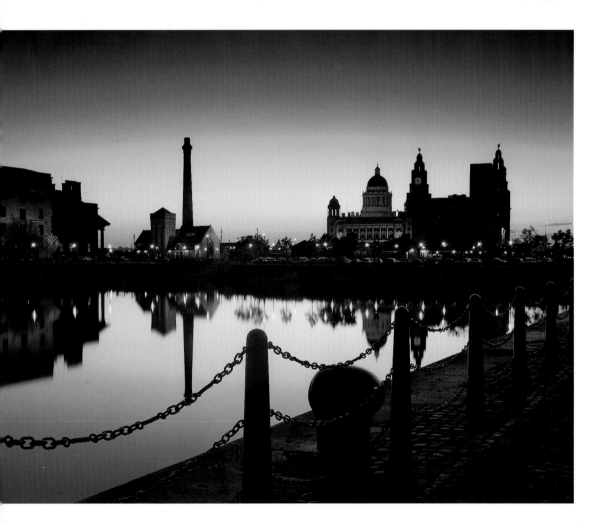

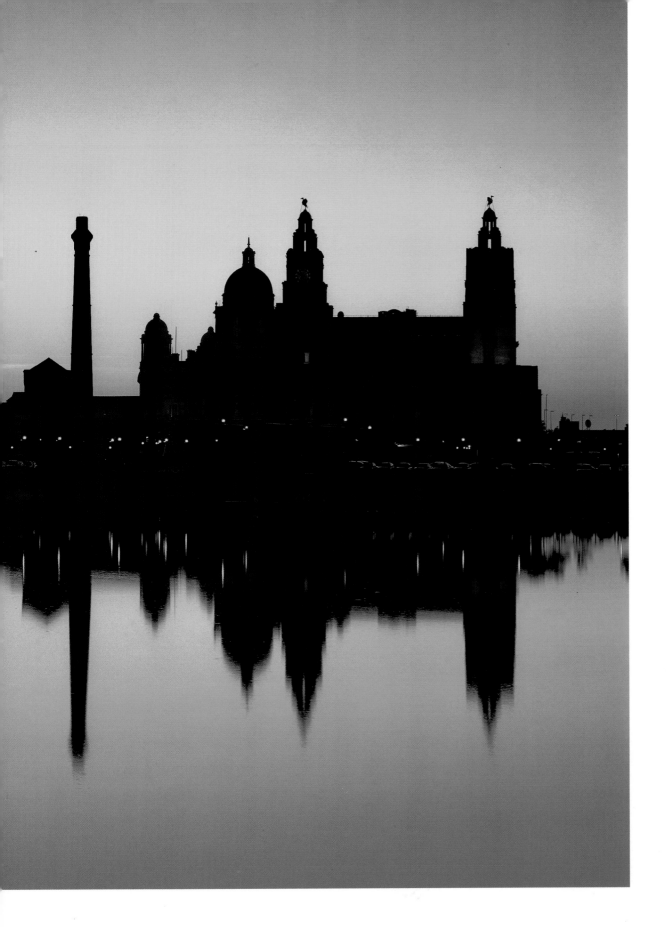

The Albert Dock, Liverpool
Tachihara 5 x 4in with short
telephoto lens, Fuji Provia
[ISO 100], 1sec at f/22^1/$_2$, 81C
and 0.3 grey grad

Fate plays a part in many photographs. My destination this day had been the rolling, crop-growing fields of Shropshire. The sky was looking attractive, and the forecast was fine. Everything seemed promising – for a while.

This day, I was to discover, was the day of the roadworks. Major repairs, which required the closure of the road and a circuitous detour through the centre of Wrexham, were being undertaken. The traffic was soon barely crawling. Stop, start, stop, start, stop, start. This wasn't

what I had planned. The sky was going to waste and I wanted to be out there, on the landscape.

Abandoning my journey to Shropshire, I followed a minor, traffic-free road which took me into an anonymous hinterland to the east of Wrexham. A photographer's paradise it was not, but the contour lines on my map told me that the terrain wasn't completely flat. There is always possibility in gently rolling countryside, so off I went in search of potential photographs.

Near Wrexham, North Wales
Tachihara 5 x 4in with wideangle lens, Fuji Provia [ISO 100], 1/2sec at f/32, 81C,
0.3 grey grad and polarizer

Fate had played its hand. The landscape, although not of a grandiose appearance, had a subtle, understated charm. Gentle sweeps and curves mingled with flowing, graphic lines while richly textured surfaces created strong patterns across the undulating hills. There were pictures to be found here. Not as immediately obvious as, for example, a vivid field of oil-seed rape, but they were there, tucked away in the nooks and crannies, waiting to be teased out.

There is a lesson to be learned from this. But for the roadworks, I would not have considered this part of the country. I would have, quite wrongly, assumed that its seemingly nondescript appearance had nothing to offer the photographer. Such casual dismissal is wrong. Keep an open mind (and an open eye). In the right conditions, photographs will often appear in the unlikeliest of places.

Images like this are a by-product of arable crop growing. They come and go with the changing seasons so it pays to make regular visits to this type of farmland.

North of Stow-on-the-Wold, The Cotswolds
Tachihara 5 x 4in with 150mm lens, Fuji Velvia [ISO 50], 1/4sec at f/22, 0.3 grey grad and polarizer

Little Rissington, Great Rissington, Upper Slaughter, Lower Slaughter, Little Barrington, Great Barrington; you know before you look at a map what you will find in the Cotswolds – the village names give it away. Possibly nowhere else in England is there such a concentration of timeless towns and villages sheltered by an equally timeless rolling landscape. For the tourist it is pretty; to the photographer it is much, much more.

Photographs appear fleetingly then disappear as the light plays across the landscape. Set up your camera on days of broken cloud, then watch as hidden undulations reveal themselves under the varying combinations of light and shade. It can be fascinating to see how the shape of the landscape can change and, given reasonable weather, you should take home with you some truly memorable pictures.

The entire picture is structured around that strip of light clipping the edge of the hillside, which enhances the undulation. Without it there would have been no photograph. I didn't have to wait long for this, but then the sky that day was perfect; clouds were constantly rolling by, away from the camera and into the photograph. It was relatively simple to watch as the shadow crept towards the edge of the hill, and release the shutter just as the band of light was at its narrowest.

Sometimes a photograph will compose itself quite naturally. There will be only one viewpoint and one arrangement worth considering. Lighting will then be the sole object of the photographer's attention. At other times there may be an element of thought required and a degree of re-arrangement necessary, but there is still just one outcome, one composition that works – ultimately, there is no question or debate about the final arrangement.

Occasionally, however, the photographer will be faced with a choice. There may be two or more alternative compositions which, although quite different, work equally well. When this happens – and if they really are equal – then don't make a choice, take both photographs. If a subject is visually strong it can often be successfully photographed in a number of different ways and it is always interesting, after the event, to compare the results of the various compositions.

Of the two pictures here I much prefer the one on the right, but this is because of the sky. In the photograph below it is terribly weak. It could have been improved by using a stronger graduated filter but even then it would have lacked character. I hope to return one day and realize the full potential of this alternative composition. It could, under the right conditions, make a very striking image.

Cloud cover, if not too thin, can also be an effective means of preventing lens flare.

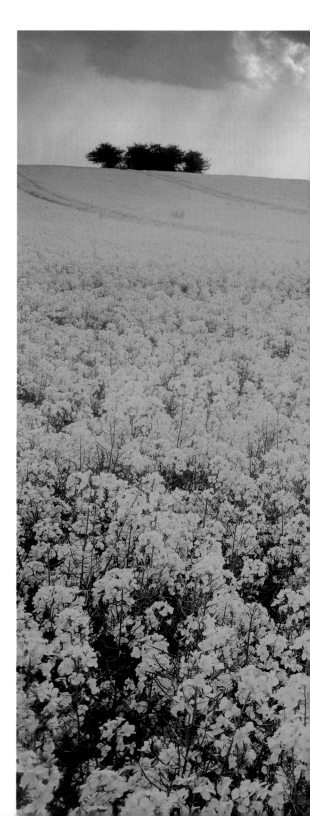

Bromfield, Shropshire
Tachihara 5 x 4in with 150mm lens, Fuji Velvia [ISO 50], 1sec at f/32, 81C and 0.3 grey grad

Bromfield, Shropshire
Tachihara 5 x 4in with wideangle lens, Fuji Velvia [ISO 50], 1/2sec at f/32, 81C and 0.6 grey grad

may

This is a rewarding month for making dawn expeditions into the countryside. Although daybreak occurs around 5am, it is worth making the effort to rise early – the photographs you take should be ample reward for your endeavours. Layers of mist (the result of rapid changes between day and night temperatures) and the first light of day can combine to spectacular effect. Photographs taken in such conditions will have an intrinsic quality unique to this time of day and year. May is also the month to search the woodlands for natural displays of wild flowers, which can, of course, be photographed at more civilized times of day.

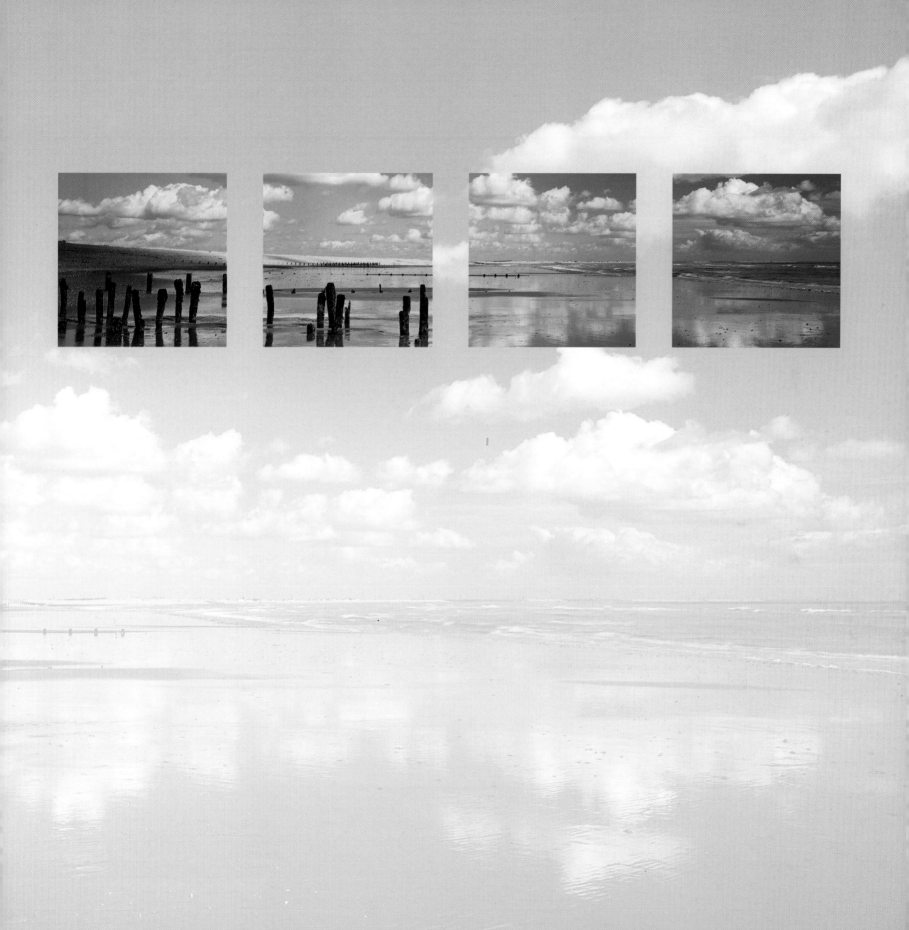

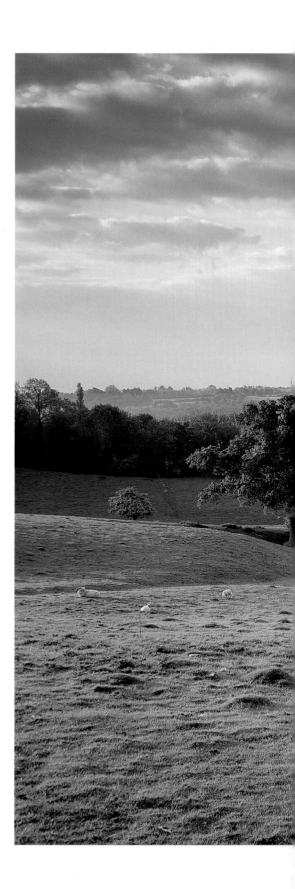

To photograph in what is generally considered to be the best light of day it is necessary to rise early (very early in the summer). Bathed in warm, soft, directional sunlight, the dawn landscape almost glows with beauty – but of course, the sun doesn't always shine.

The variable nature of our weather can, unfortunately, dampen one's enthusiasm for rising in the early hours, but weather forecasts are now fairly reliable, especially if taken one day at a time. An evening forecast will usually provide an accurate indication of what to expect the following morning, so you can set your alarm clock with a degree of confidence. A scene which may appear quite ordinary during the day can be completely transformed by dawn. Witness such a transformation just once and any disappointments you may have experienced previously will be immediately forgotten.

In this photograph the low position of the sun produces a highlight on the small building to the right. This acts as a focal point which gives the picture a sense of scale and depth. The hint of mist in the distance provides a dawn atmosphere and also strengthens the impression of depth. The sky completes the picture, being visually interesting but not to the extent that it dominates the landscape below. All these key elements would not, indeed could not, be present together at any other time of day.

When the right conditions seem likely, it really is worth making the effort to get an early start.

If grazing animals are included in the picture, and you are using a slow shutter speed, wait for them to be perfectly still, if possible. Blurred sheep or cattle would be a distraction. Also, avoid animals being cut in half at the edge of the frame. This would look careless in the finished picture.

Unlike evening, the misty, evanescent light of dawn can quickly lose its sparkle. Ensure that you are there before daybreak so as not to miss the golden moment.

Goudhurst, Kent
*Tachihara 5 x 4in with 150mm lens,
Fuji Provia [ISO 100], 1/2sec at f/22½, 81C,
0.3 grey grad and polarizer (half polarized)*

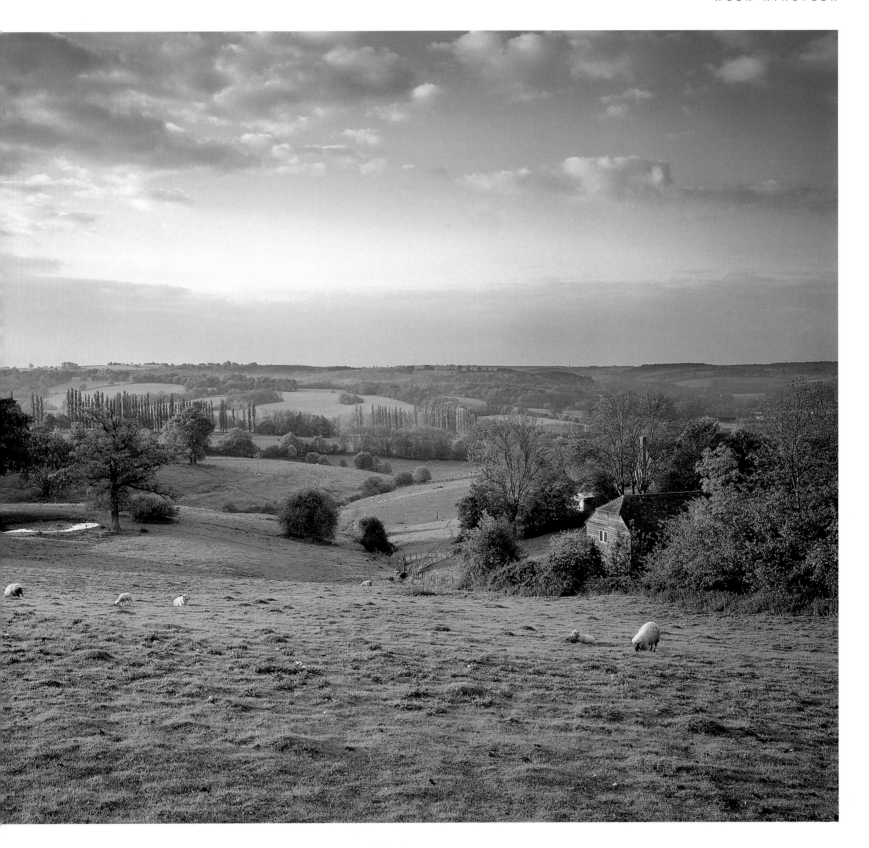

The time of year and the weather dictate events and the surprise element is never far away. This means that no two days are the same but I do endeavour to establish a routine. I will often start several days, weeks, sometimes months earlier when, with the aid of a map, I tour an area and produce a list of potential photographs. Using the map or a compass to determine the direction of each picture, I can envisage the lighting conditions at different times of day and this enables me to make a note of the time and preferred weather conditions for my return visit. In summer my day will be based around early morning and late evening with little in between. Autumn and winter are different; the working day can span all daylight hours.

This spring day I had planned two pictures (weather permitting which, initially, it did). This one could only be taken at dawn. With the north-facing view, low sidelighting from the rising sun would be perfect. Add a touch of morning mist hovering above the water's surface and you have the lake at its best. After dawn would have been too late: the show would have been over.

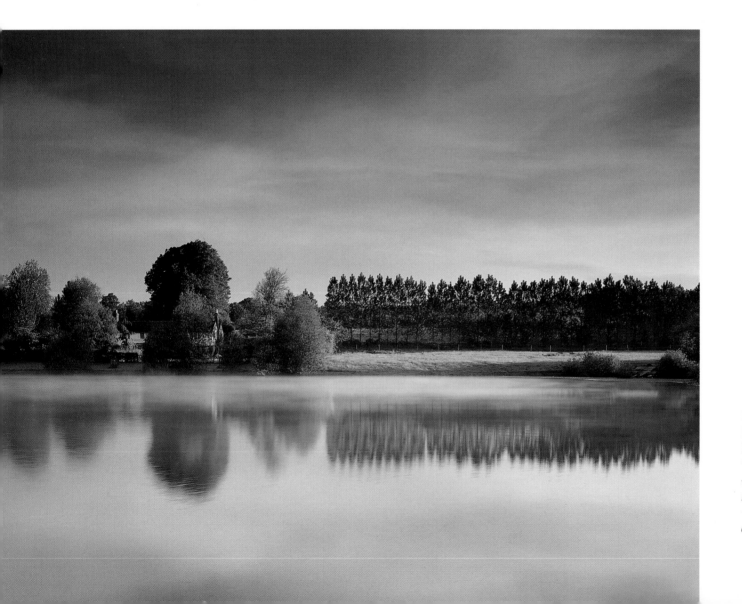

Bewl Water,
Kent/Sussex
border
*Tachihara 5 x 4in
with 150mm lens,
Fuji Provia [ISO 100],
1/15sec at f/22,
0.6 grey grad*

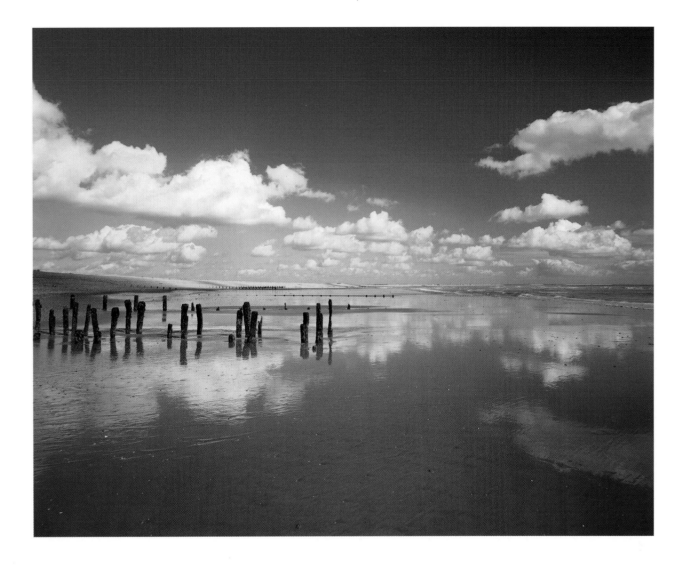

And that was it for the day. The sky clouded over, so I spent the next few hours revisiting several short-listed locations. (It is well worth doing this to keep abreast of the landscape's constantly changing appearance.) The sky remained dull so, having risen at 4am, I retired early.

Overnight the sky cleared, so bright and early, I made the short trip to the Sussex coast. It was not to be a wasted journey. By good fortune, rather than careful planning, my arrival was perfectly timed to catch those marvellous reflections in the wet sand of the ebbing tide. And at that early hour of the morning, I had the beach to myself. There were no people, dogs or footprints; just sand, sky and reflections. Perfect.

The day remained fine so I returned inland, back to the Weald. I took the photograph as planned but somehow, I much prefer the simplicity of this modest image of timeless coastal charm.

Winchelsea, Sussex
Tachihara 5 x 4in with wideangle lens, Fuji Provia [ISO 100], 1/8sec at f/32, 81B and polarizer

There is a quiet, understated symmetry in this picture. Apart from the repetition above and below the horizon, the clouds also produce an X-shaped uniformity across the photograph. The clouds were drifting to the right as I was taking the picture, so I had to hurry in order not to lose this balance.

I am often asked to explain how I choose what to photograph. This is not simple because there is no specific formula or system involved. In essence, it is a matter of observing the landscape and developing an awareness of how a particular scene might look when viewed as a photograph. Study the photographs in this and other publications. Look at individual pictures and imagine that you were the photographer. Would you have seen it? Would you, perhaps, have taken the picture in a different way?

The photographer's 'seeing eye' develops with practice and experience. Look with a critical eye at objects, or a piece of the landscape, in isolation from their surroundings and photographs will begin to reveal themselves.

Walking towards, and even through this gate, I had not realized the potential, but turning round and looking back in the direction I had travelled (and it is *always* worth doing this), the picture was immediately obvious.

Bewl Water, Kent/Sussex border
*Tachihara 5 x 4in with 150mm lens, Fuji Provia
[ISO 100], 1/15sec at f/22*

The simple photographs are often the most effective. Photography has a unique power – it can transform the mundane into the magnificent.

The sky was intentionally excluded. To succeed, the photograph has to consist of the gate and trees and nothing else.

Heading for somewhere else, I found myself driving through a pleasant area of rolling farmland which culminated in this marvellous little strip of horizon. From a distance I could see the tiny tree perched high above the fields and, without hesitation, I halted my journey and set up my camera.

Here – quite unexpectedly – was a photograph, but my excitement was short-lived. The reality was that on its own, the tree was not a sufficiently strong subject; the sky was also going to have to make a contribution.

I then witnessed a miracle (or so it seemed at the time). All around the sky was clear with not a cloud in sight, except for one. Drifting towards that tiny tree, in quite perfect position, was a solitary small cloud. It was gradually fading and losing shape but it held together just long enough for me to photograph it.

I couldn't believe my luck. I had stopped for no more than 30 minutes, taken the picture, then continued on my way. Looking back, this photograph still seems a minor miracle.

There are faint traces of cloud visible across the centre of the sky and these prevent the picture from being perfect. The isolated tree should be accompanied by an equally isolated cloud.

A polarizing filter has improved the contrast of the cloud and blue sky which was, at the time, a little hazy.

Near Nebo, Gwynedd
Tachihara 5 x 4in with 150mm lens, Fuji Provia [ISO 100], 1/15sec at f/22, polarizer

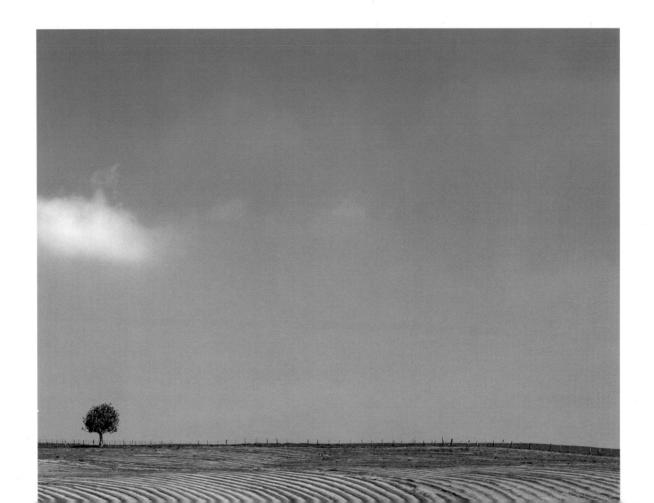

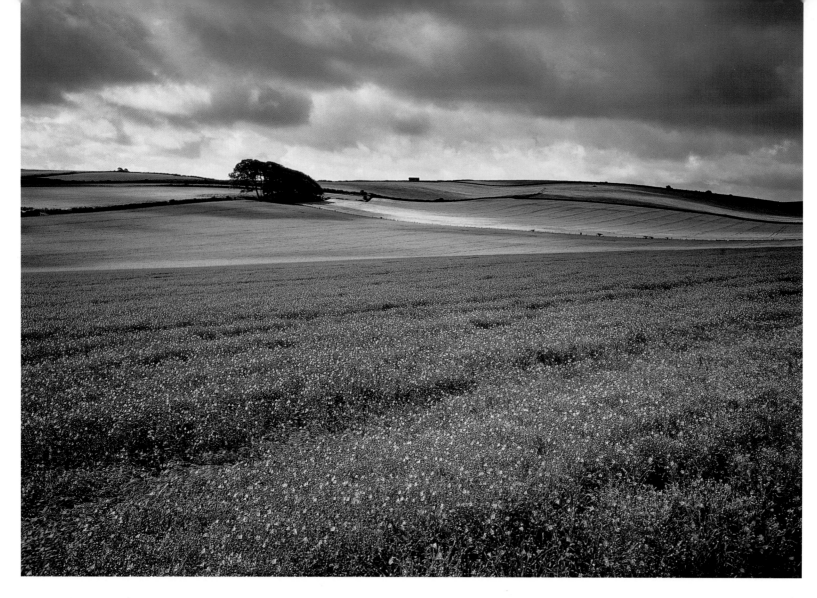

Near Weymouth, Dorset

Tachihara 5 x 4in with wideangle lens, Fuji Provia [ISO 100], 1/2sec at f/16½, 0.3 grey grad

Colour in the landscape, other than the ubiquitous green, is a rich vein of photographic opportunity. If you discover a field devoted to the growing of wild flowers or colourful crops then you have before you the basis of a fine photograph.

The colours here are a delicate, pastel shade so soft, subdued lighting was required to reflect their tone. A light, innocuous sky was also preferable. A bright blue stripe splashed across the top of the picture would have dominated the landscape beneath it and the subtlety in the photograph would have then been lost.

You might imagine that this lovely blue expanse was hidden away in the Dorset backwaters, its discovery being the result of days of painstaking, exploratory excursions. But no, it was next to a busy roundabout on the outskirts of Weymouth, a little piece of rural paradise surrounded by an endless flow of frantic holiday traffic. I was there for three days, on and off, and not once did anybody stop

to photograph, or even admire the scene. This, I have found, is one of the joys of photography. As photographers we look, we absorb, and we appreciate. We see what others don't. We then photograph what we see and, hey presto, other people admire the picture of the view! And this, the creation of something to be appreciated by others, epitomizes, I believe, photography as an art form.

I often spend hours walking through woodland and forest. Photographically, such excursions can be highly rewarding but also, I am afraid, very frustrating.

Every forest holds hidden secrets. Some reveal themselves willingly to the observant eye, while others are so well hidden – sometimes, for example, masquerading as a shapeless clump of trees – that they need to be painstakingly sought out.

It is sad but true that more often than not, hours of foraging will produce nothing. Despite one's efforts, no pattern of nature will emerge from the undergrowth; nothing of any shape or form will reveal itself in the naturally chaotic beauty of the forest interior. With a little research and forward planning, however, it is possible to greatly improve the chances of finding a photograph. For example, deciduous forests with streams and waterfalls always hold potential. At this time of year wild

flowers are there to be found and can make attractive subjects, while autumn, of course, provides its very own kaleidoscope of colour.

This pleasant piece of woodland reminds me of the stage of a theatre. I can visualize the stage brightly lit with the curtains set to rise (albeit for an audience of one). That was my first, and has proved to be my lasting, impression as I stood before the wall of trees.

The orderly structure you see here was, in fact, the exception to the general disorder all around. By moving in close and using a 150mm lens, the surroundings have been excluded and only those simple but strong graphic elements retained.

These finer details are always present, they just take a degree of seeking out and isolating. Practise and experiment and you will soon be seeing features which previously, you would not have noticed.

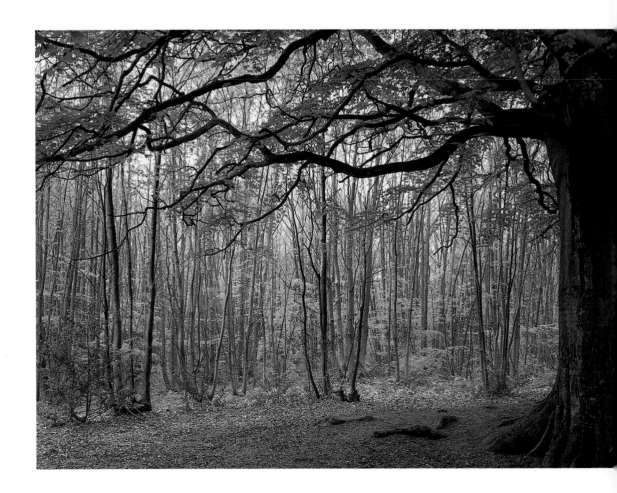

Burgh Wood, East Sussex
Tachihara 5 x 4in with 150mm lens, Fuji Provia
[ISO 100], 2 seconds at f/32

East of Froncysyllte, Clwyd

Tachihara 5 x 4in with semi-wideangle lens, Fuji Provia [ISO 100], 4 seconds at f/32

The sky was overcast, with little prospect of improvement, so rather than waste the day, I headed for a remote, wooded area which I had previously discovered and which I knew had attractive displays of wild flowers. These can be photographed in flat lighting and indeed, in most cases, this is preferable.

The journey was an hour by car, followed by a hike of 30 minutes, but it was worth it – I had found a hidden garden.

These woods are way off the beaten track. I doubt if many people visit them or even know of their existence. What I find so encouraging is that all over the country there are many more floral displays, buried deep and flourishing in woodlands, and the majority have yet to be photographed. Looking for these floral oases takes time and patience but I would encourage you to go in search of them. They are an absolute joy to discover, and once found they are relatively easy to photograph.

Avoid including the sky in this type of photograph. Here the only highlights should be the flowers you are photographing.

White flowers should remain white when photographed, so use warm-up filters with caution. An 81A should be sufficient to compensate for any blue cast which may be present.

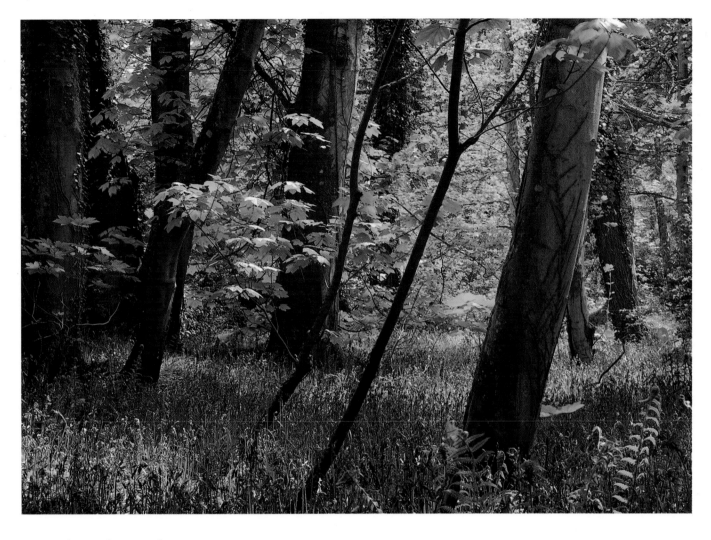

Near Llangefni, Anglesey
Tachihara 5 x 4in with short telephoto lens, Fuji Velvia [ISO 50], 1sec at f/64, 81B and soft focus

Bluebells flourish in the spring climate of the British Isles. Find a wooded hillside adorned with them and you will find a landscape which oozes colour and charm.

Having discovered this fine display I decided, after some deliberation, to add a soft-focus filter. I rarely use these filters but they can, on occasion, produce pleasing results. Pictures of flora and fauna, for example, will sometimes benefit. The delicate edges of leaves and petals can, if softened, produce a tranquil, dreamlike image. Still water benefits too; reflections of highlights appear as tiny, sparkling jewels glittering on the water's surface.

It is worth experimenting by taking photographs both with and without the filter. Needless to say, it should be used at all times with care and sensitivity. In particular, beware of highlights which can easily flare, especially when you are using backlighting.

Soft focus does not mean out of focus. The picture must be critically sharp for the effect to succeed.

If a slow shutter speed is used, ensure there is no breeze as this will blur any leaves, and would also spoil the soft-focus effect.

The use of an 81B warm-up filter was a mistake: it has created a yellow cast which spoils the picture.

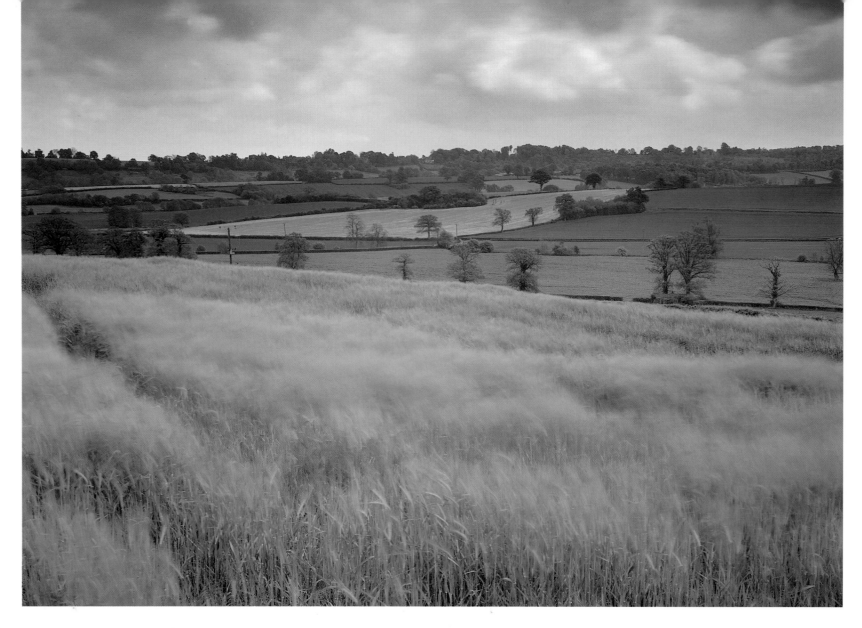

North of Mayfield, East Sussex
Tachihara 5 x 4in with 150mm lens, Fuji Provia [ISO 100], 4 seconds at f/45, 0.6 grey grad

The distant fields are the only still part of this landscape, sandwiched between wind-blown grasses and equally wind-blown clouds. Allowing these mobile elements to express themselves as such has the effect of drawing attention to the only sharp, clearly defined part of the picture – those far-off fields and, in particular, the yellow oil-seed rape field. Creating a contrast between still and moving objects is an effective way of placing emphasis on a particular part of the landscape; an isolated barn surrounded by a sea of swirling grass will always look striking, even in flat lighting.

It is often preferable to exclude the sky from this type of photograph but if it is included, it should also express movement in some way.

To blur a field of swaying grasses, an exposure of several seconds will normally be necessary. Use the smallest possible aperture and, if necessary, either a polarizer or a neutral-density filter (not a graduated filter). This will absorb light and increase the exposure required.

Do ensure that you use a sturdy tripod. A flimsy and lightweight one will introduce more camera shake than it will eliminate.

Those vivid sun rays bursting through the heavy, rain-filled clouds are the essential ingredient in this western Highland landscape. Indeed, it was because of the sky that I decided to stop and search for the rest of the photograph.

Wishing to reinforce the theme of dynamic motion established by the sky, I looked for a flowing, preferably gushing, stream. This, I hoped, would provide the perfect mobile foreground and would repeat the movement of the flowing storm clouds above.

It wasn't long before I found what I was looking for – a mountain tributary swollen by days of incessant rain. This was now crashing and tumbling towards the river. Nature's forces were balanced both on and above the landscape.

I wasted no time taking the picture. Rain was in the air and the heavy clouds suggested its arrival was imminent. Minutes later a flash of lighting confirmed this. A 5ft (1.5m) metal tripod offers no protection in a thunderstorm so, picture taken, I was quickly on my way.

South of Dunoon, The Cowal Peninsula
Tachihara 5 x 4in with wideangle lens, Fuji Provia [ISO 100], 1/2sec at f/32, 81C and 0.9 grey grad

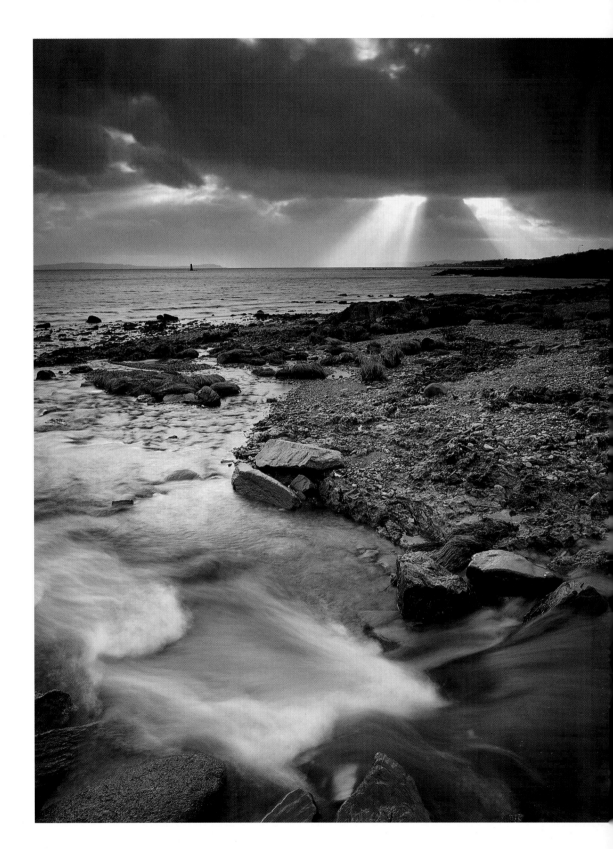

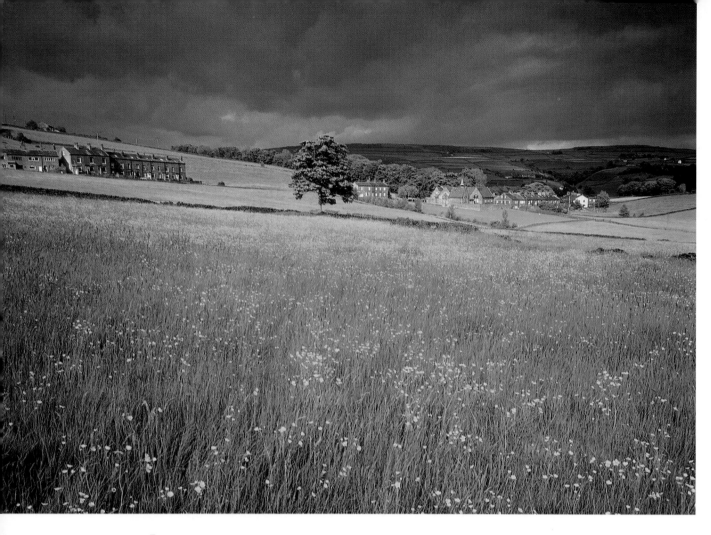

North of Halifax, West Yorkshire

Tachihara 5 x 4in with wideangle lens, Fuji Velvia [ISO 50], 1sec at f/32, 81B and 0.6 grey grad

The restricted and harmonious colour combination of yellow, green and neutral grey accentuates the rugged beauty of this part of Yorkshire.

The bold, grey, abstractly patterned sky is essential to the success of this photograph. A blue sky would have completely changed the mood of the picture and would not have worked.

The introduction of any other colours (for example, tiny specks of blue or red flowers in the foreground) would have weakened the image. Any foreign colour should always be excluded.

Colour in a photograph is a potent force. When viewing a picture, one's perception of the image will be affected instinctively by its colour. Any other elements will be eclipsed if colour is not treated with care and sensitivity. Consequently, an awareness and understanding of the effects of colour are essential if the landscape is to be photographed in a way which will enable its true character to be portrayed to the viewer.

Colours can produce feelings of warmth, coolness, tranquillity and vitality. Pleasing

colour combinations can be harmonious or complementary and each will produce a different effect in a photograph.

Consider the colours of a rainbow – red, orange, yellow, green, blue, indigo, violet – in a circle. Adjacent colours are harmonious, opposites are complementary.

Harmonious colours tend to produce feelings of calm and tranquillity while complementary colours which contrast strongly with each other are visually more striking and dynamic. Because these

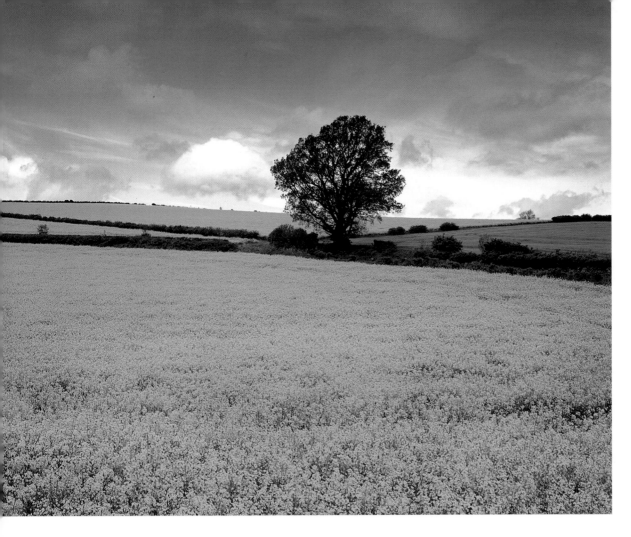

East of Leintwardine, Herefordshire
Tachihara 5 x 4in with semi-wideangle lens, Fuji Velvia [ISO 50], 1/4sec at f/32, 81B, 0.3 grey grad and polarizer

contrasts create a strong and dominant visual presence, they have the effect of obscuring any subtle elements which may exist in a photograph. For this reason, more pleasing results are often obtained when colours are used in harmony.

Colours also create illusions; bright, warm colours – reds, oranges and yellows – give an impression of advancing forwards whilst the cooler colours, at the blue end of the spectrum, appear to recede. Photograph a bright red balloon against a blue sky and this property will become

immediately apparent. If bold, contrasting colours are to be the theme of the photograph, keep the arrangement simple. Distinct, solid blocks will be more striking than a scattered myriad of colours, which can often degenerate into little more than an eyesore.

A polarizing filter comes into its own when you wish to emphasize colour. It can have a dramatic effect on a single, solid expanse and can be used in any lighting conditions – it will always bring an improvement to an image.

Here grey clouds are replaced by a typically British blue sky which, in the context of this landscape, is fine. A grey sky would have been too heavy and brought too serious a tone to the picture.

A cloudless sky would, however, have been preferable as simplicity and saturation of colour is the theme here: the expanses of yellow and green in the fields and of blue in the sky should, ideally, be equally pure and unblemished. The picture still works reasonably well because the sky is not unattractive but there is no doubt that, without the clouds, it would be improved.

june

Evening photography comes into its own during the midsummer months. Given reasonable weather conditions (you don't need a cloudless blue sky), the evening will provide a good four hours of lighting of a quality which can greatly enhance the appearance of the landscape.

Look at the effects produced by long shadows, notice how undulations and textures, invisible at other times of day, reveal themselves under the scrutiny of the searching evening sunlight.

Take advantage of these long days but leave sunsets for other times of year. This month it is sunlight, not the setting sun, which will provide the majority of your picture-taking opportunities.

Six months of waiting preceded this photograph. In midwinter I saw a hint of what was to come. Three months later the arrival of spring brought with it the landscape I wanted, but it needed to be properly lit, with warm, gentle sunlight creeping across the undulating hillside. As a consequence of the north-westerly outlook, I was going to have to return in June or July when the sun was at its widest arc.

I duly returned and am very satisfied with the result but this is, I'm afraid, one of those almost, but not quite pictures. Almost everything about it is just as I would have arranged if I had control over the landscape; the rise and fall of the hillside, the right-of-centre position of the solitary farmhouse, the surrounding group of marvellous trees (which nature has grown in such perfect balance), and then there is that lovely evening sky, warm but not overdone. Finally, add to all of this that most special ingredient, which is, of course, a splash of quality lighting, and together they produce a most appealing and satisfying photograph. But it is, unfortunately, flawed.

The group of trees at the bottom of the picture just shouldn't be there; cover them up and you will see how the structure of the picture becomes immediately clear. You can straight away see what I saw, what compelled me to take the photograph.

I didn't want to include those bottom trees but there was no acceptable alternative. Excluding them by lowering the horizon would have placed too much emphasis on the sky and would have weakened the picture. I could have used a longer lens but this would have excluded too much sky and would also have framed the group of trees too tightly. The remote isolation of the farm and the feeling of open space would then have been lost. So, on balance, those bottom trees had to stay.

It still works well and remains a very pleasing picture. It just isn't perfect.

Use an 81B or C warm-up filter to enhance early evening sunlight but beware of overwarming, particularly in the last hour of daylight.

Always be prepared to wait for the essential quality lighting.

East of Macclesfield, Cheshire
Tachihara 5 x 4in with 150mm lens, Fuji Provia [ISO 100], 1sec at f/16, 81B, 0.6 grey grad and polarizer

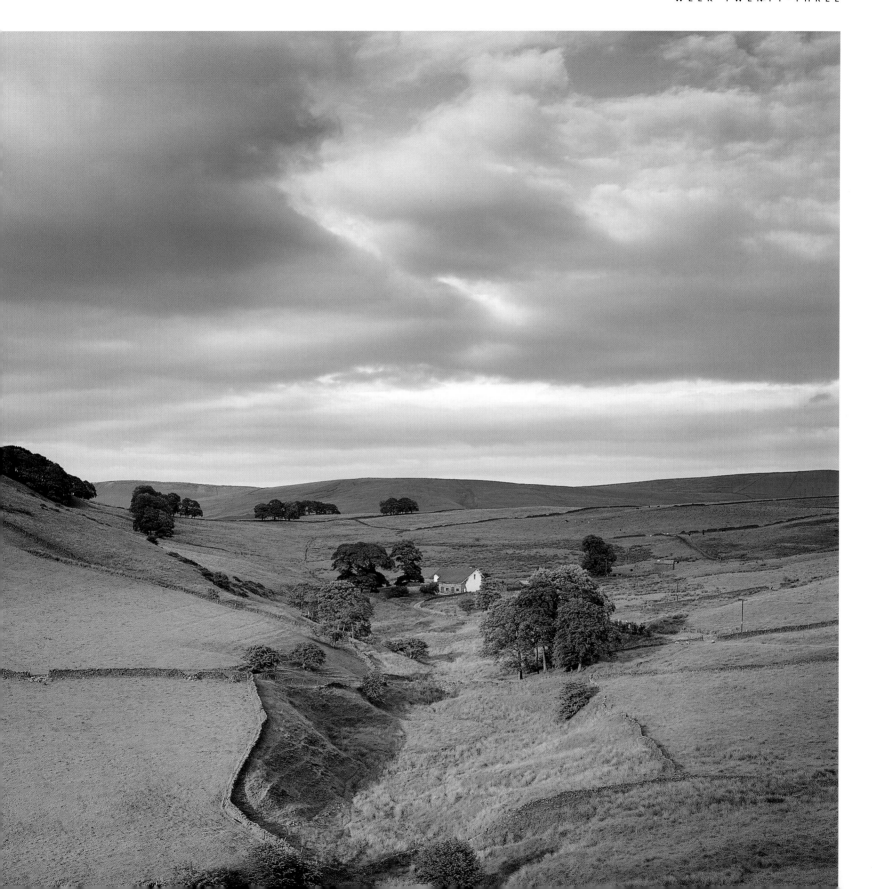

Trees are a photographer's friend. Whether they are given star billing or merely used in a supporting role, the contribution trees make to a picture is invaluable. It might be an isolated specimen, the jewel in the crown of a rolling hillside, or a group arranged perfectly by nature into a ready-made photograph. You may discover a regimented row of conifers within which lies a repeated, and consequently visually strong pattern of nature, or a sprawling, ancient forest. The scope is endless.

Driving along the edge of the Tanat Valley, I was attracted by this striped field in front of the farmhouse. It was some distance away when I first noticed the farm but even from afar the potential could be seen. The flowing lines of the mowed field are the focal point of the landscape but the role of the trees should not be underestimated; they bring scale and shape to the picture. Indeed, without them the photograph would be reduced to a rather boring and flat study of a field surrounded by a somewhat featureless terrain. There would, in fact, have been nothing to photograph.

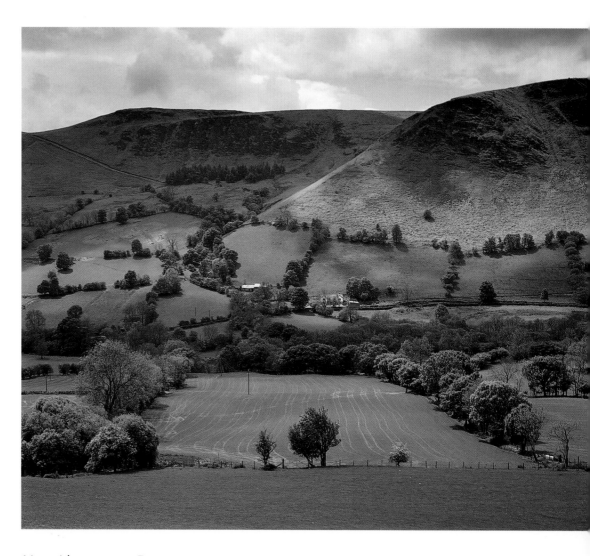

Near Llangynog, Powys
Tachihara 5 x 4in with 150mm lens, Fuji Provia [ISO 100], 1/30sec at f/16¹/₂, 0.6 grey grad

In addition to their aesthetic appeal, trees are an excellent means of bringing a perception of scale to a picture by creating a feeling of depth and distance. They will also delineate and bring the contours of the landscape graphically into a photograph.

This picture would have benefited from low sidelighting but it is facing west, so the sun would never have been in the desired position. When you find yourself in such a situation, and inevitably you will, there is always a solution. Here, broken cloud was used to create interesting lighting.

Gwydyr is situated on the northern edge of Snowdonia. It covers a vast area, contains both evergreen and deciduous trees, and has numerous footpaths and streams. The forest's peace and serenity are in marked contrast to the bustling activity of the nearby town of Betws-y-Coed. It is a joy to visit and there is always something new to photograph. This picture was taken near the edge of the forest, close to the busy road which leads into the town. I saw the tree glowing as I drove past – it was, literally, a shining example of the power of light – and I wasted no time in stopping and setting up my camera.

In this forest there are steep slopes which can create high levels of contrast in sunny weather. This is not always desirable but can sometimes be used to advantage. Backlit leaves can look stunning when photographed against a dark background, and steep or hilly forests provide the perfect setting for this type of picture; do beware of lens flare when the sun is shining towards the camera. A lens hood will not prevent flare in such situations. An umbrella is useful, but make sure it doesn't protrude into your picture.

Gwydyr Forest, Snowdonia
Tachihara 5 x 4in with 150mm lens, Fuji Provia [ISO 100], 1/30sec at f/11

There was a breeze blowing when I took this photograph. To avoid the leaves blurring I was forced to use a shutter speed of 1/30 second and, consequently, a relatively large aperture (f/11). This reduced the depth of field which has resulted in some leaves being slightly out of focus. Normally this should be avoided at all costs but in this case I felt it would be less intrusive than blurred leaves.

I should have excluded the fern at the bottom left of the picture. There should have been no highlights other than the leaves on the trees.

The position of the sun is critical when using backlighting. A movement of just a few degrees can have a noticeable effect on your photograph, so work as quickly as you can without cutting corners.

Backlit leaves look exquisite in the autumn. I will return, one day, to photograph this tree again.

The Dee Estuary, The Wirral Peninsula
Tachihara 5 x 4in with 150mm lens, Fuji Provia [ISO 100], 1/2sec at f/45, 81C and polarizer

The landscape consists of many graphic elements. At a glance they remain hidden but under scrutiny they leap from their surroundings and become, in themselves, the strongest visual feature.

Isolate these elements – patterned surfaces, repetitions, flowing lines, textures – and you can create dynamic and attractive abstract compositions. Use a telephoto lens to isolate specific details and also to compress distance. This alone will emphasize any graphic qualities that are present.

Sand or pebble beaches provide an abundant source of intriguing graphic images, but they often go unnoticed. Looking for the bigger view, I stumbled across this lovely combination of colour, texture and pattern. It is an image of utter simplicity, flawless, but by no means unique. Observe the landscape and it will respond.

To record texture and surface detail, low, oblique sidelighting is essential. No other lighting will reveal such intricacies.

Care needed to be taken to ensure that nothing else, particularly anything green, strayed into the picture. In this type of photograph it is imperative that the image remains clean and uncluttered. Here this means yellow sand and a green rock and absolutely nothing else.

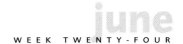

In this photograph, the emphasis has been placed on the surface pattern of the sand and those glorious curving lines in the centre of the picture. The angle of lighting is of critical importance. The sun is just out of view near the top left corner; it was close to the horizon and rapidly losing its strength. The gentle backlighting this creates is the essential element around which the photograph is structured. This is perfect natural beauty. Quite exquisite. To have let it go would have been a sin.

The polarizing filter has taken the glare off the water's surface and enhanced the flowing lines by deepening the shadows.

The distraction-free, restricted colour range accentuates the graphic theme. This is perhaps a subliminal, but nevertheless essential, element in the picture.

The Dee Estuary, The Wirral Peninsula
Tachihara 5 x 4in with wideangle lens, Fuji Provia [ISO 100], 1sec at f/45, 81C and polarizer

Leaton, Shropshire
Tachihara 5 x 4in with 150mm lens, Fuji Velvia [ISO 50], 1/4sec at f/22, polarizer

Occasionally the landscape will obligingly provide you with a ready-made picture: a composition which requires no seeking out or rearrangement. It's there, you can see it, the perfect photograph. But is it really perfect? Is it complete?

In this picture three groups of trees embrace the depth and width of the image. They step back progressively into the distance, to the point where the furthest trees begin to dip below the horizon. Such an arrangement illustrates depth and space, but on its own is incomplete. However, the sky can help.

Where a spatial relationship exists between a group of objects, the photograph will be improved if this relationship is emphasized (or at least confirmed) by other elements in the picture, and in this case the only other element available is the sky. In this photograph there are three cloud groups which, as with the trees, span both the depth and width of the picture to produce a three-dimensional sky. Again (and this is an essential detail), the clouds stretch beyond and below the horizon, repeating the positions of the groups of trees. With the aid of this cloud arrangement, the photograph becomes complete.

Ideally, the clouds at the top left should not be there. Had this been the case, this would have been a perfectly symmetrical photograph.

It would have been wrong to use a warm-up filter. In a predominantly green landscape the colour should, in most circumstances, be allowed to remain just as you find it.

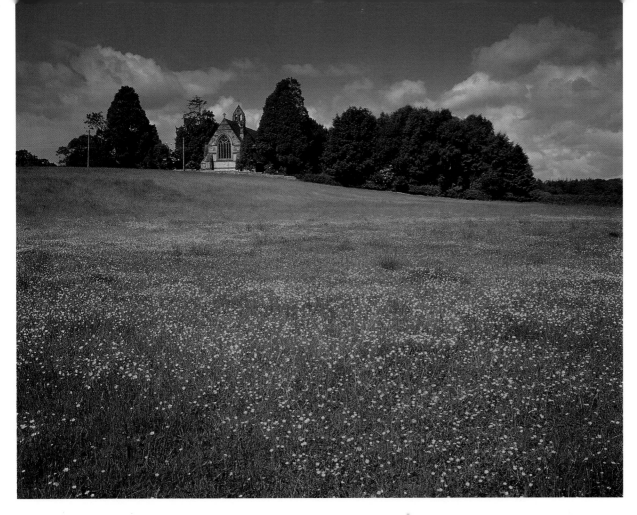

Lyneal, Shropshire

Tachihara 5 x 4in with wideangle lens, Fuji Provia [ISO 100], 1/8sec at f/22, 81B and 0.6 grey grad

Rural churches are often worth a detour as they are normally attractive buildings and naturally photogenic. That said, it was the lake opposite this church which had originally attracted me to this particular location. As soon as I arrived, however, I knew it was going to be the isolated church, overlooking that lovely field of buttercups and sitting on an attractive, gently sloping hillside, which would provide the photograph.

It was late afternoon and the sun was behind the church, shining towards me, so I planned an early-morning visit for my return. I came back a few days later in sunny but somewhat breezy weather. The wind was a little stronger than I would have preferred, but it did at least ensure that the clouds rolled quickly by, which encouraged me to wait in hope for the perfect formation. After an hour or so of sky watching, the pattern I had been praying for began to materialize. The perfect arrangement appeared, fleetingly, but long enough to take the picture.

It was worth the wait. Without those clouds, which help to produce a visually interesting horizon across the width of the picture, the buttercup field would have been too dominant. The sequence of cloud/trees/church/trees/cloud brings a balance to both parts of the picture.

Always imagine what the 'perfect' sky might look like, then persevere and wait to capture it.

A yellow field will normally benefit from the use of an 81B or C filter, which will greatly improve colour saturation. A polarizing filter would have improved this picture but would have required a shutter speed of 1/2 second (the equivalent of an increase of two stops in exposure). A long exposure would have blurred the buttercups, which were constantly swaying in the breeze, and I felt that was an unacceptable price to pay for stronger colours.

Llanberis Pass, Snowdonia
Tachihara 5 x 4in with wideangle lens, Fuji Velvia [ISO 50], 1/2sec at f/32, 81B

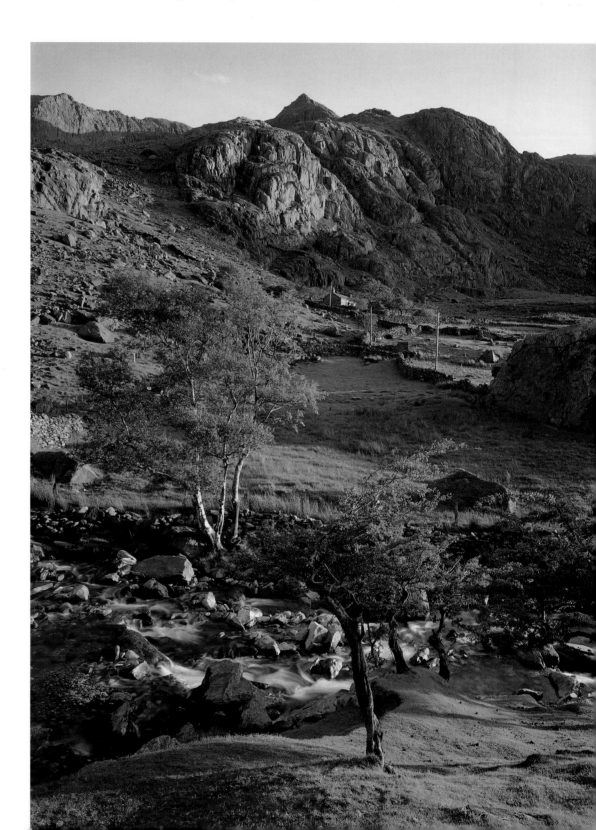

The lighting I wanted was elusive and I had to wait several weeks before I could take my planned picture of the dramatic Llanberis Pass. I suppose, having waited so long, I should not have been surprised when, eventually, two photographs came along together. But a surprise it was as the setting sun provided a quite unexpected bonus, particularly as just 30 minutes and no more than half a dozen paces separate these two pictures.

I had travelled to the pass knowing that a fine midsummer's evening was the only time when the sun would be in the required position – low and to the west.

The sidelighting this provides is essential in bringing the craggy rock face of this steep, imposing valley into the picture. At other times of day or year the sun is either above or behind the surrounding mountains and does not provide the lighting in which to photograph the valley.

I used an 81B filter, which was a mistake: the light was sufficiently warm and needed no further enhancement. The over-warming has produced a yellow cast, which is particularly noticeable on the grass, and this spoils the picture slightly.

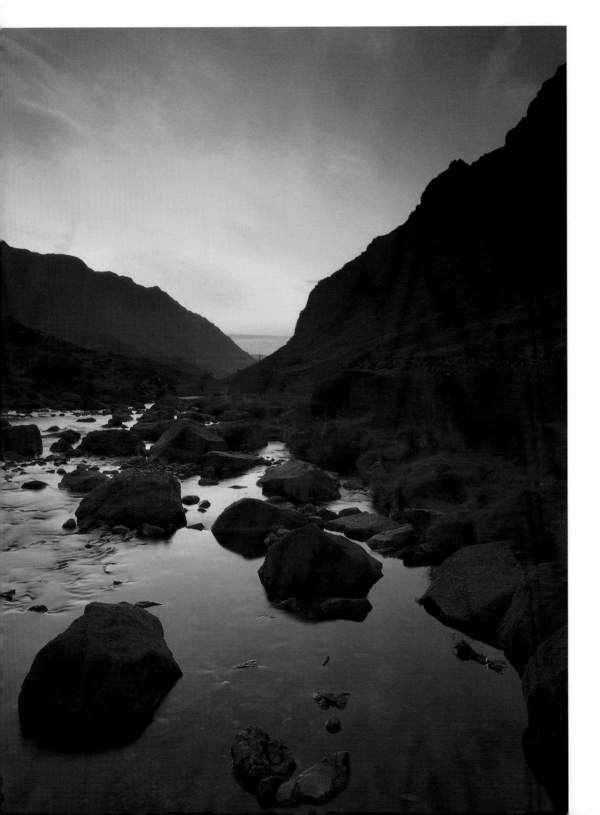

I had not anticipated this second picture and therefore, unlike the photograph on page 88, it was completely unplanned. I turned the camera 90°, walked forward a few feet, changed filters, and waited for the glowing sky to intensify.

Find yourself in the right place at the right time and there is often more than one photograph to be taken. Always seek, and then seize the opportunity.

Llanberis Pass, Snowdonia
Tachihara 5 x 4in with wideangle lens,
Fuji Velvia [ISO 50], 2 seconds at f/32, 81C
and 0.9 grey grad

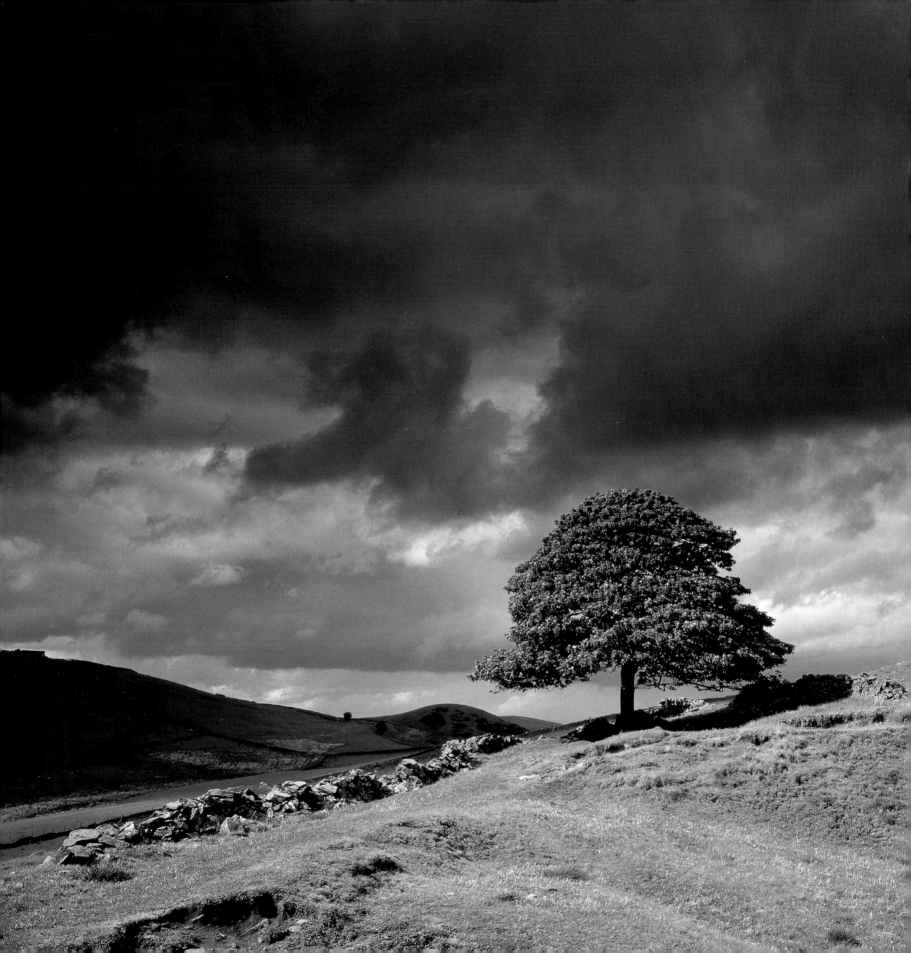

I am always attracted by the solitary. It may be a tree, a building, a mountain, even a cloud. It could be almost anything. What matters is not what the subject is, but rather, the extent of its visual appeal when photographed.

You will discover that there is a natural beauty in solitude. Isolate any single object and it immediately becomes visually stronger. If the image you have created can then be further strengthened by other complementary and supportive elements, or of course by lighting (or both), you will have the makings of a fine and distinguished photograph.

The importance of the sky should not be underestimated: it can be used to very strong effect. A threatening, stormy sky will add a sense of vulnerability to anything isolated, and this can be a very dramatic combination.

Avoid placing the subject in the middle of the picture. Even a marginal movement to the left or right will produce a more balanced composition. A right-of-centre position is, in most cases, a little stronger than a left-of-centre one.

When photographing a single tree, choose one with an attractive shape. Damaged or misshapen trees do not photograph well.

West of Buxton, The Peak District
Tachihara 5 x 4in with 150mm lens, Fuji Provia [ISO 100], 1/2sec at f/45, 0.6 grey grad

A bridge, a stream, a mountain and a farmhouse, the elements of the quintessential Highland landscape, all together, in place, and needing no creative rearrangement or manipulation.

I discovered this combination from a large-scale map of the area, but maps alone cannot tell you everything. They can entice you to many interesting and unusual places but there can be no guarantee that, having made the journey, you will then find anything of merit to photograph.

This time, however, I was lucky. That simple, wooden bridge, in gradual but graceful decay, is the essential element in this photograph, but it could so easily have been a concrete and metal affair. How grateful I am that the bridge has stood the test of time for so many years.

Because the view across the bridge was southerly, it was necessary to return on a fine evening, when the sun would be setting to the right. This would then produce the sidelighting needed to reveal the craggy surface of the mountain.

I was fortunate when, during a brief return to this part of Scotland a few weeks later, the perfect evening arose. There were no clouds threatening the light so my pace was decidedly leisurely. With everything ready, the only task that remained was the careful removal of some unsightly patches of dried mud from the front of the bridge.

If necessary, tidy the landscape before you photograph it.

The picture may have benefited from being taken a little later in the evening, when the light would have been slightly warmer.

Glen Masson, Argyllshire
Tachihara 5 x 4in with wideangle lens, Fuji Provia [ISO 100], 2 seconds at f/45, 81B and polarizer

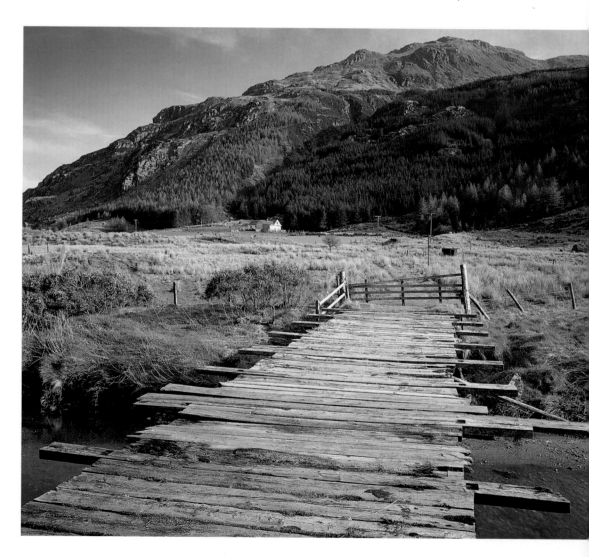

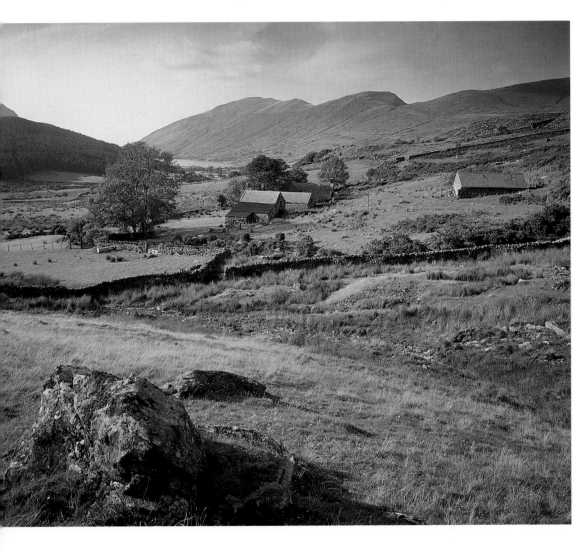

If you enjoy walking, Rhyd-Ddu is a good starting point for excursions into Snowdonia. The landscape there is fairly accessible, although long, sometimes steep treks on foot are still necessary to fully explore the area. But don't be deterred by this. Take either a leisurely stroll or an energetic hike; you will find both equally rewarding.

This photograph was taken from a position reached after a relatively short, and gentle, walk of 20 minutes. The picture has a certain appeal because of its completeness. Here Snowdonia is distilled into a single image; a foreground of rugged terrain, an isolated farm, a pine forest and the essential lake and mountain range. This is Wales. All that is missing is the sound of the choir, voices in unison echoing across the hills and valleys. Lose yourself in the photograph and you will hear the singing.

Rhyd-Ddu, Snowdonia
Tachihara 5 x 4in with wideangle lens, Fuji Velvia [ISO 50], 1/4sec at f/32, 81C and polarizer

Do not snatch at a picture. This was one of many options which had to be considered. It is the strongest composition but was not the most obvious. Always spend time walking around, investigating different vantage points.

july

Midsummer is the least favoured time of year for most photographers. This is because a bright sun, positioned high in a clear blue sky, produces flat, uninteresting lighting. Clouds, however, can help. In the right conditions (usually a mixture of sun and showers) look for changing, often dramatic, effects as light and shade play across the landscape. When sunshine does prevail, photograph in the early morning and late evening when the sun is low in the sky. This is a rewarding time of year to visit northern Scotland where the evenings (and mornings too, if you rise early) are exceptionally long. You can therefore enjoy many hours of potentially excellent lighting – perfect for capturing the unique splendour of the Scottish Highlands.

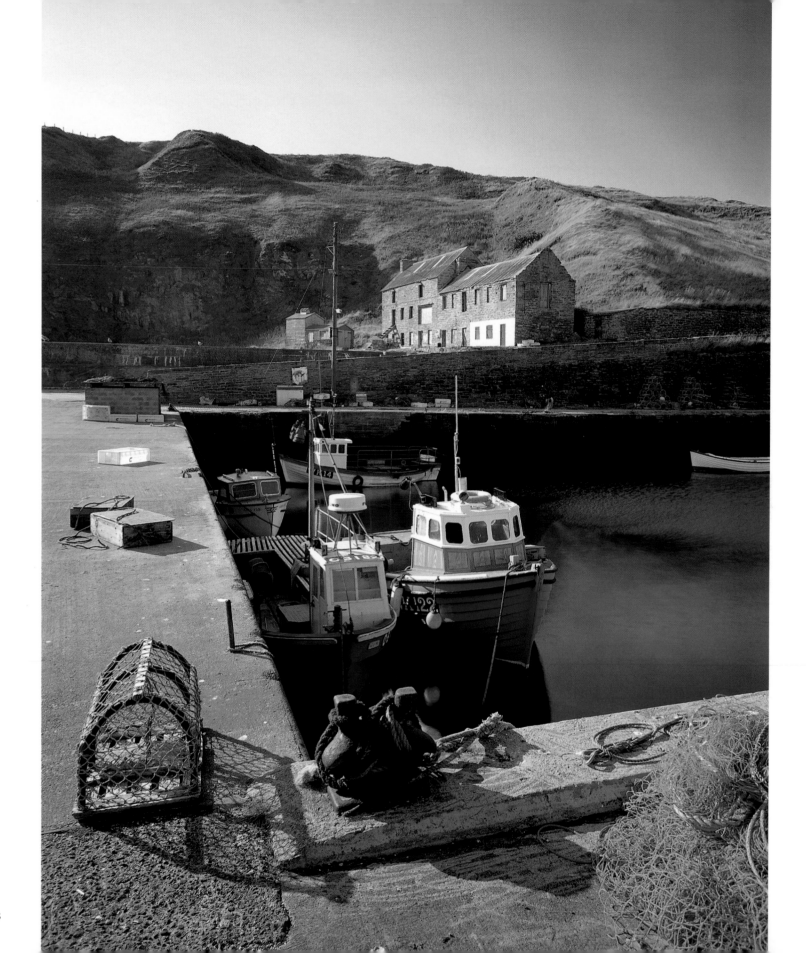

The remote north-east corner of Scotland is a somewhat neglected area. Its distance and anonymity deter many people from making the journey, which is a great pity. Inland it is certainly remote, with few roads and even fewer signs of habitation. A wilderness of peat moorland, the landscape demands, and also inspires, creative photography. The coast is more accessible. Unspoilt villages punctuate rolling farmland and sweeping sandy bays. There is an eternal beauty to the area which is enhanced by a surprisingly dry and sunny climate.

If you intend to visit northern Scotland specifically to photograph its landscape, the perfect time, I would suggest, is June or July. The nights are very short at this time of year and, if you are really keen, you could rest during the day and photograph in the magnificent light of both dusk and dawn (here darkness lasts for little more than three or four hours).

But of course, you don't need to restrict your photography to early morning and late evening. The landscape here has an intrinsic quality which will provide you with a wealth of picture-taking opportunities throughout the day. Indeed, in mountainous areas the sun can remain hidden behind high peaks and some photographs will only be possible when it is relatively high in the sky. This picture of Lybster Harbour, for example, was taken late in the morning, despite my arrival at 5am.

Make compositional use of the interesting shadows which occur in backlit photographs. They can be used to good effect in leading the viewer into the picture, but beware of lens flare.

The polarizer has reduced unwanted reflections on the water's surface.

Lybster Harbour, Caithness
Tachihara 5 x 4in with wideangle lens, Fuji Provia [ISO 100], 1/4sec at f/45, polarizer

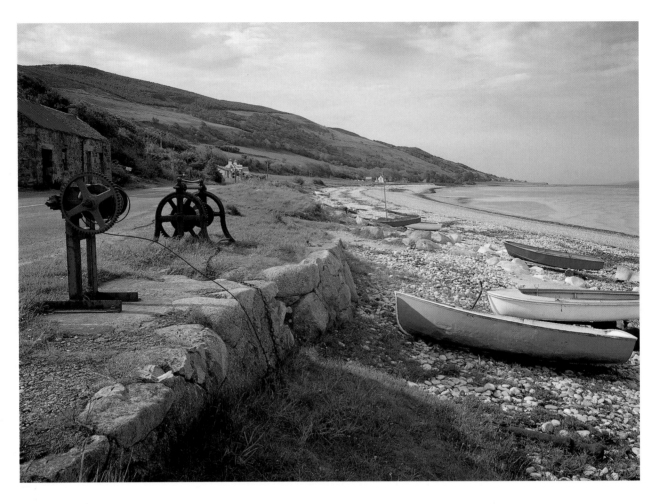

Pirnmill, Isle of Arran

Tachihara 5 x 4in with wideangle lens, Fuji Velvia [ISO 50], 1/4sec at f/45, 81A and polarizer

Britain has some of the world's finest and most dramatic coastline. It is also one of the most varied, providing endless photographic opportunities.

The meeting of sea and land – perpetual motion against the immovable – should itself be sufficient to inspire creativity. Add to this not only rugged, cavernous cliffs and mile after mile of beaches, often pebble-covered, but also spectacular sunsets, sunrises and dramatic, stormy weather and

it is not surprising that one begins to imagine the many exciting possibilities which abound along the coastline.

This photograph of Pirnmill, as you can see, boasts neither a sunrise/sunset nor stormy weather, but here that is not important: the shoreline is interesting and needs no dramatic lighting to enhance its appearance.

The use of a wideangle lens and a low camera position has emphasized the

foreground, but not to the extent that it dominates the picture. The sky and the coastline in the middle distance have also been allowed to have their say. The result of this composition is depth, with layers of visual interest present from the front through to the back of the photograph. This type of arrangement is the basis of a successful picture and can be very effectively used along the coastline where interesting foreground objects are relatively easy to find.

Pucks Glen, Benmore Forest, Argyll
Tachihara 5 x 4in with wideangle lens, Fuji Provia [ISO 100], 10 seconds at f/32, 81B

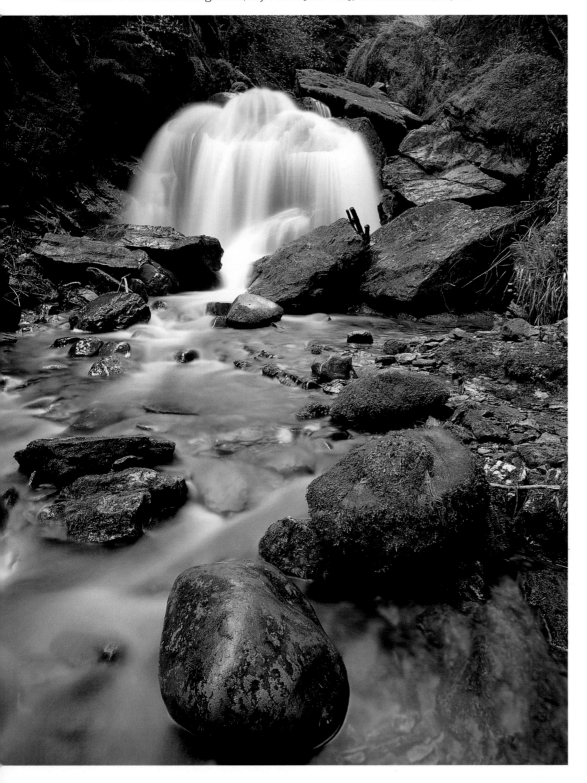

A stroll through Pucks Glen in the Benmore Forest, following the course of the meandering stream, is for anyone, a most pleasant experience. For the photographer it is much more. Places like this can be a paradise of opportunity; waterfalls, striking rock formations and vibrant plant life abound. With every twist and turn of the stream there is a photograph awaiting discovery.

Woodland areas like this are to be found all over the country. You can locate them using Ordnance Survey 1:50,000 Landranger maps. Look for forests with streams which flow over a contoured terrain (it need not be particularly steep); there you will find waterfalls and fast-flowing, visually dynamic water. With just a little effort and research, areas of quite captivating beauty can be discovered – and they can be the source of many memorable pictures.

Normally a 10-second exposure would lead to a complete loss of detail in moving water but here, the stream was gently flowing over the surface of the rocks. The very long exposure has rounded and improved the shape of the waterfall.

Triangular arrangements work well. I therefore had no hesitation in stopping when I approached this grouping of trees and farmhouse next to a remote road in the North Yorkshire Dales. I soon realized that here there was more than just three points of a triangle. In addition to the geometrical arrangement, there was a further symmetry within the landscape.

From the group of trees at the top to the brightly lit field in the foreground, there is a patterned patchwork. No two fields are the same, they all differ in both colour and texture. This feature has a quiet presence; it does not interfere with or weaken the picture's triangular theme, but the pattern nevertheless exists and has a role to play, as, of course, does lighting.

That patch of shadow between the two groups of trees is an essential detail. As well as strengthening the landscape's patterned appearance, the shadow (because of its position) has created a highlight on the top group of trees and has also produced a dark background behind the lower group, which accentuates their presence. The overall result is a landscape which is more than green fields; it is alive, growing, changing. There is a purpose to the landscape which has been brought into the picture by light.

And this – the bringing together of light and land – is the role of the photographer. It is an essential role. It is, in fact, the very heart and soul of landscape photography.

Make it a habit, every time you consider taking a photograph, to absorb every detail of what you see before you. Consider carefully the type of lighting which will most effectively contribute to the final picture.

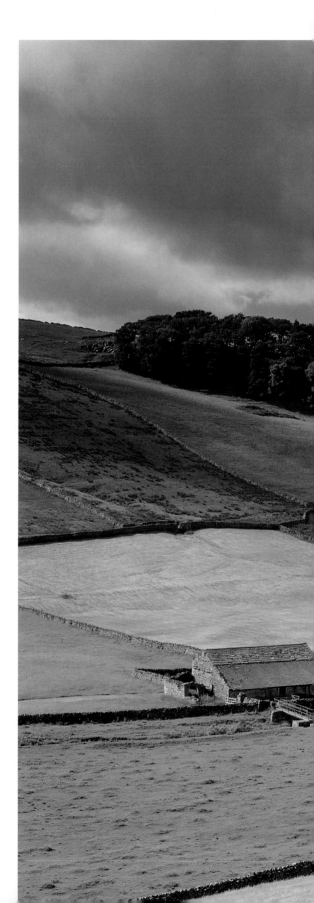

Near Hawes, Yorkshire Dales
Tachihara 5 x 4in with short telephoto lens, Fuji Provia [ISO 100], 1/8sec at f/22, polarizer

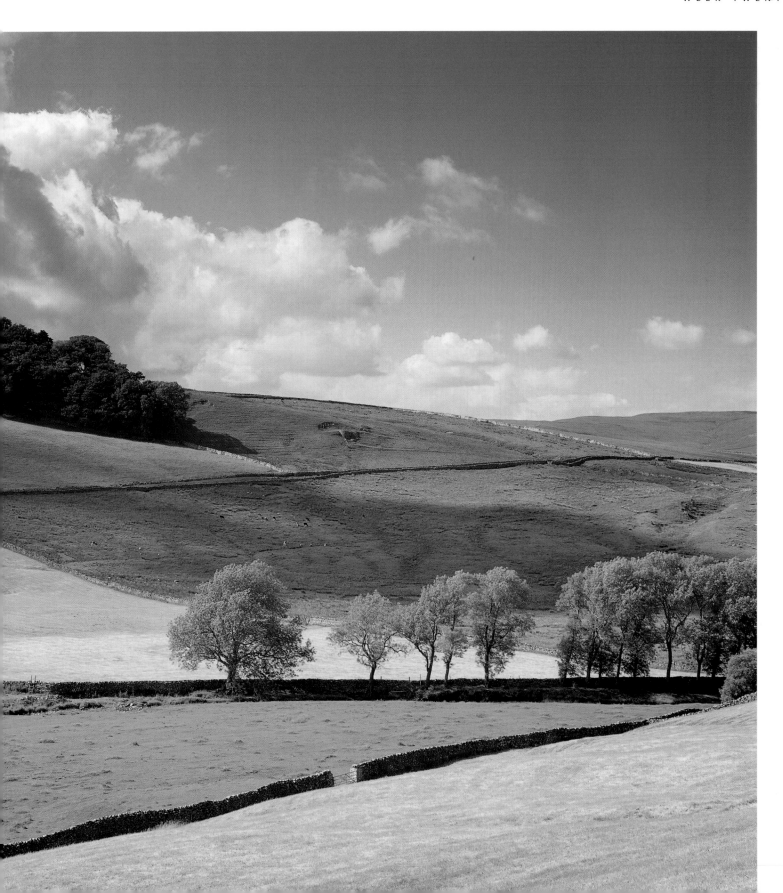

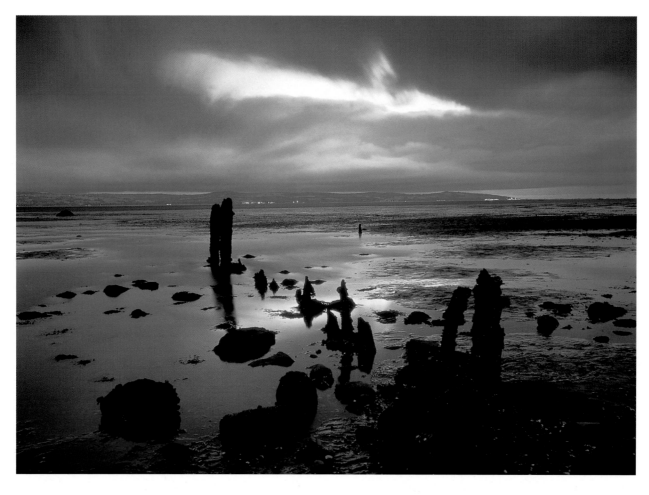

Caldy Beach, The Wirral Peninsula
Tachihara 5 x 4in with wideangle lens, Fuji Provia [ISO 100], 2 minutes at f/32, 0.6 grey grad

Photography is sometimes referred to as painting with light. This is a reasonable comparison, as a photographer uses light in the way a painter uses paint. But there is a difference – light and film are not the photographer's only materials. Time – it might be just a fraction of a second or several minutes or more – can also be used to great advantage in many areas of photography, including landscape.

This picture of Caldy Beach was taken at the end of a midsummer's day as the light was fading and the clouds slowly gathering. It was, however, a calm evening and not the stormy, dramatic night the photograph implies. The movement of light over a period of two minutes has created a storm where, in reality, only calm existed. Interesting results can be obtained by using long exposures with different types of sky and it is worth experimenting.

This picture also shows that it is not necessary to confine your photography to dramatic locations in order to achieve dramatic results. Here, a rather mundane pebbled beach provides the setting. It is the cloud, light and, most importantly, the passing of time which produce the stunning image.

The effect of time can transform a sky. The length of exposure required will be determined by the mobility of the sky and, of course, the mood that you wish to convey. The optimum exposure may be anything from a few seconds to several minutes. Experiment by using different exposures to become familiar with the effects of the passing of time.

There are times when, paradoxically, the less you include in a photograph the more you reveal about the subject, the *implied* being, on occasion, a more effective means of communication than the *shown*.

Moel Fammau rises to almost 2000ft (610m). Towering above the surrounding North Wales countryside, the view from the summit is breathtaking – a heavenly paradise for the photographer, one would assume. In reality, such big, open views are notoriously difficult to photograph.

If three dimensions are to be authentically condensed into two, the creation of an illusion of depth is required. This can only be achieved if the viewer is taken gradually through the photograph from front to back, hopping from object to object, stepping from foreground to mid-distance and eventually on to the far horizon. It might be a twisting, curving stream or possibly a row of trees – something which, through a diminution in size, gives the clear impression of receding into the distance. A view from a mountain summit rarely provides such visual stepping stones. The answer here was to simplify the arrangement and reduce the photograph in such a way that the viewer's imagination, rather than the image itself, creates the illusion.

Attention to detail, as always, is of paramount importance in a simple arrangement. The footpath beyond the gate, leading over the hill, is a small but important element in the photograph. It takes the viewer beyond the hill and on into the unknown, into the imagined.

A strong, grey graduated filter was necessary to prevent the sky from being grossly overexposed.

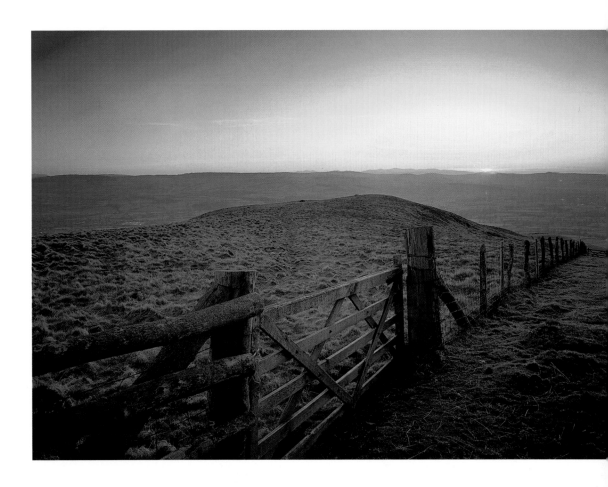

Moel Fammau, Clwyd
Tachihara 5 x 4in with wideangle lens, Fuji Provia [ISO 100], 1/4sec at f/32, 81B and 0.9 grey grad

august

Make the best of the weather when sunny days and blue skies prevail. Although a little lacking in creative opportunity, this type of lighting can, in some situations, produce attractive pictures and should not be completely dismissed. Look, for example, for reflections on still water; a reflected blue sky always looks attractive – often better than the sky itself – and can provide a marvellous foreground in a photograph. Architecture is also an excellent subject in sunny weather. Look closely at the direction of the sunlight and study its effect as it falls on different parts of a building. Use shadows created by oblique sunlight to reveal shapes and architectural features.

Possibly, with the exception of light itself, still water is the photographer's most valuable natural aid. This is because it is capable of producing a mirror image of an object. This might be a mountain, a tree or a building, something which even on its own would make a worthy subject. When an opportunity to duplicate a subject, to double its visual presence and, importantly, to create repetition in a photograph arises, that opportunity should never be missed.

It is not necessary, I assure you, to travel to the Lake District or the Scottish Highlands to find such pictures. The expanse of water need be neither large nor deep to produce an image of quite captivating beauty. All over Britain there are lakes (many quite tiny) which are hidden away, often in quite charming and sheltered locations. They receive few visitors and, despite regular displays of visual grandeur, even fewer photographers.

Llyn Cwm Bychan lies adjacent to the Rhinogs, an untouched mountainous hinterland accessible only by foot. The lake itself, however, can be easily reached by taking the narrow but delightful road which follows the course of the River Artro.

I will always remember the moment I was greeted by the sight of this lake. Suddenly I had entered another world, a world devoid of sound or movement. I was now in an imaginary, photographic world which consisted only of light, land and water. These are the rewarding occasions which make the pre-dawn rises so worthwhile.

A polarizer was used to reduce the surface reflection on the lake. It has brought the absolute clarity of the water graphically into the picture. (You can see the stones in the foreground almost as clearly below the water as you can above it.) However, this was at the expense of some detail in the reflection of the mountain. In such circumstances there can be no hard and fast rule; at the time the decision can only be made by viewing the scene through the rotating filter and choosing between none, half or a fully polarized picture. In this case I think the loss of some detail in the reflection is an acceptable price to pay for the increased clarity in the foreground.

Still water is often calmest very early in the morning, as wind tends to drop during the night.

Llyn Cwm Bychan, Near Harlech, Gwynedd
Tachihara 5 x 4in with wideangle lens, Fuji Velvia [ISO 50], 1sec at f/45, polarizer

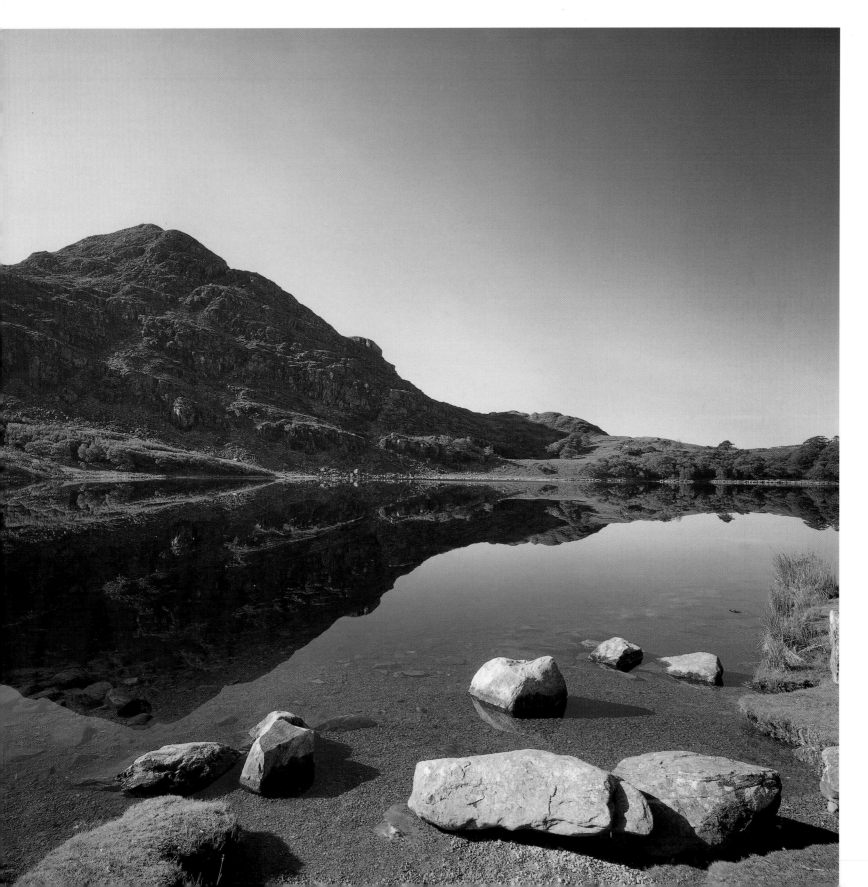

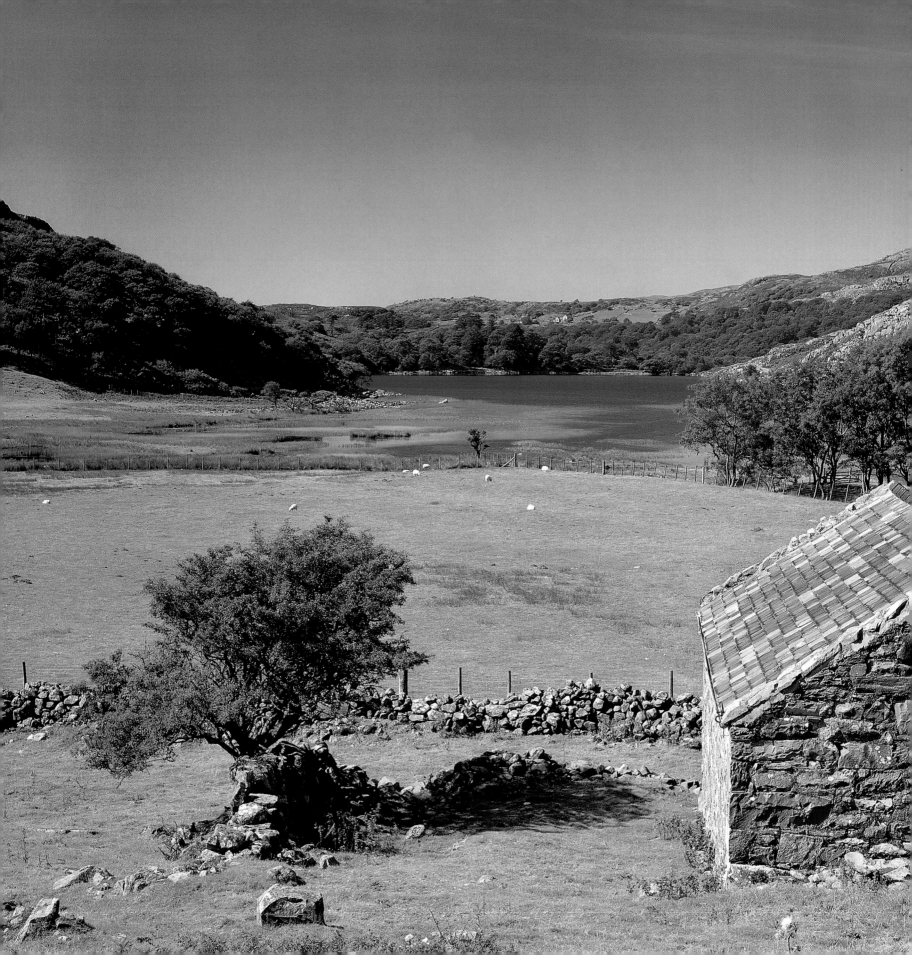

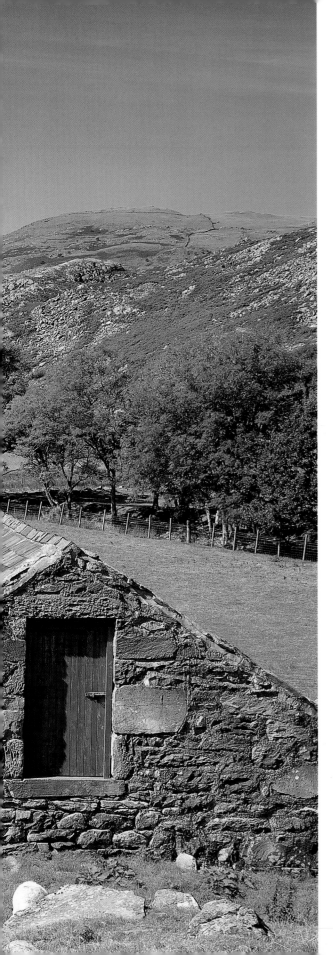

Like most photographers I tend to avoid postcard lighting. This is because the landscape can appear flat and one-dimensional when photographed under a high sun in a cloudless sky. But, as with any rule, there are exceptions, and it must be said that it is possible to produce creative images throughout the day, in every type of lighting. If the lighting is appropriate to the mood you wish to convey, if it depicts the landscape in a way you consider aesthetically satisfying, then ignore the time and take the photograph. Optimum conditions can occur at any time of day and year, particularly in Britain – and that includes midday in midsummer.

This picture was taken just before noon. The morning mist had cleared, the colour of the lake had deepened and the sun, in a position to the left (it didn't matter that it was high in the sky), was shining perfectly on the facing stone wall of the barn to reveal its craggy, textured surface. These were the factors which determined the timing of the photograph, not the hands of my watch.

Not surprisingly there were people strolling around the lake and I had to take care to ensure that they remained out of view when the picture was taken. You may not notice them at the time but any passers-by, once photographed, will stick out like a sore thumb.

Llyn Cwm Bychan, Near Harlech, Gwynedd
Tachihara 5 x 4in with 150mm lens, Fuji Velvia [ISO 50], 1/15sec at f/22$^{1}/_{2}$, polarizer (half polarized)

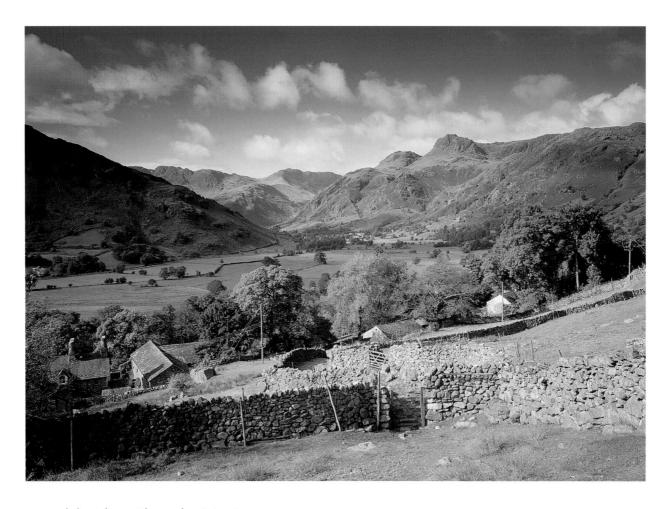

Langdale Pikes, The Lake District

Tachihara 5 x 4in with 150mm lens, Fuji Provia [ISO 100], 1/8sec at f/22, 0.3 grey grad and polarizer

Essentially, there are just three types of filter that I use with any degree of regularity. I have explained the grey graduated and warm-up filters I favour elsewhere; here I will describe the applications and effects of the versatile polarizing filter.

One useful property of a polarizer is its ability to darken a blue sky, particularly in the presence of white cloud, as it will deepen the blue yet have no effect on the brightness of the clouds. The effect is most pronounced when the sun is positioned to one side of the camera.

Beware, however, of uneven darkening: you may end up with an unnatural-looking dark corner of sky, particularly if you are using a wideangle lens. One way to avoid this is to wait for cloud to cover the area affected. Alternatively, you could half polarize by partly rotating the filter to reduce the polarizing effect.

The deepening of the shadows is noticeable on the white stone wall and distant mountain to the left. Here it is acceptable because the shaded areas are relatively small.

When using a polarizer, an increase in exposure of approximately 2 stops is required. Through-the-lens metering will automatically allow for this.

In addition to the polarizer, I quite wrongly used a grey graduated filter. Because of this the sky has become over-darkened, to the detriment of the picture.

Tremadog Bay, Gwynedd
Tachihara 5 x 4in with short telephoto lens, Fuji Provia [ISO 100], 1/8sec at f/22, polarizer

Polarized light has another, very useful property; it will reduce reflections from almost any surface, including water (but not, for some reason, metal).

Because of this, a polarizer will not only improve the clarity of water, it will also greatly increase colour saturation. Even on cloudy days the colour of foliage can be diluted by superfluous reflected light, particularly if there is surface moisture present. The filter will substantially reduce these highlights and the result will be enriched colours. There is one potential disadavantage to this – the darkening effect the filter has on shadows. This is acceptable (and sometimes desirable)

when the shaded areas are small but can cause larger shadows to look dull and lifeless, particularly in strong sunlight when contrast is high.

You can see all these effects, and the degree of improvement (or otherwise) they will bring to your photograph, simply by viewing the scene through the filter and rotating it slowly.

I don't suggest that you make it a permanent attachment but a polarizer is an extremely useful accessory and should not be packed away and forgotten about. Used correctly it will improve many photographs discernibly.

A polarizer will always improve this type of picture. It has increased the contrast between the blue sky and clouds and removed reflections from the water's surface. Without the polarizer, the sea would have produced undesirable highlights. Here, the only bright spots I wanted were the clouds, which should be as white and pronounced as possible.

This picture was taken with frontal lighting (the sun was behind the camera). Normally such lighting is undesirable but for this type of photograph there is nothing to be gained by using angled lighting. In fact, this should be avoided because there is a possibility that the sky would become unevenly bright if sidelighting was used.

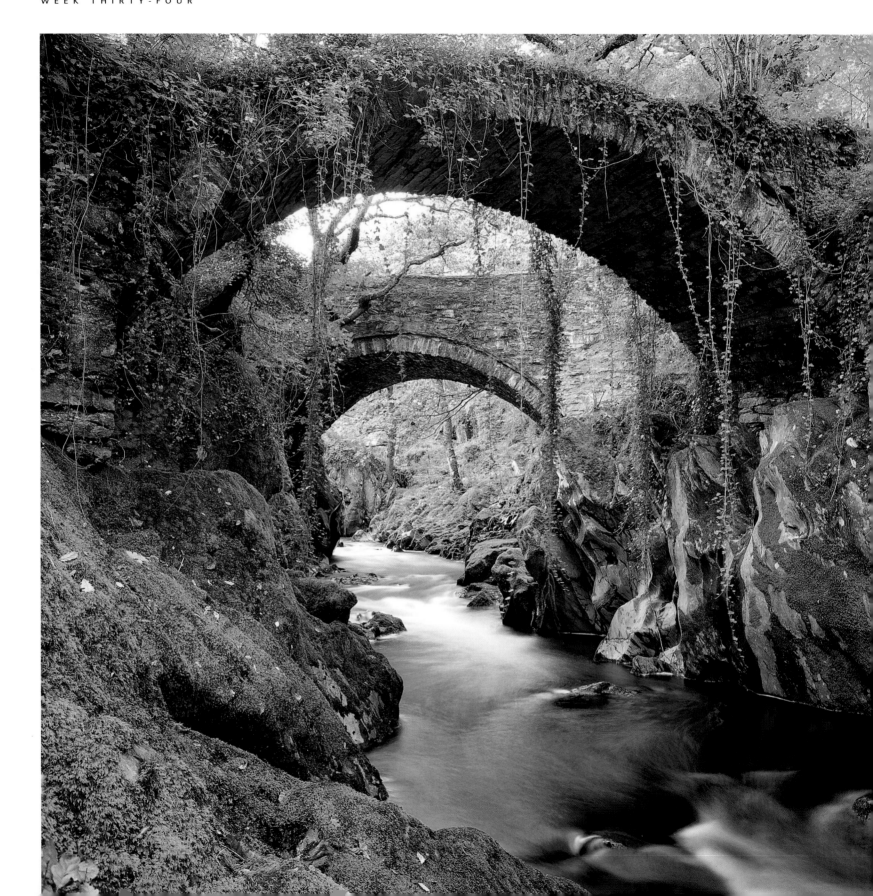

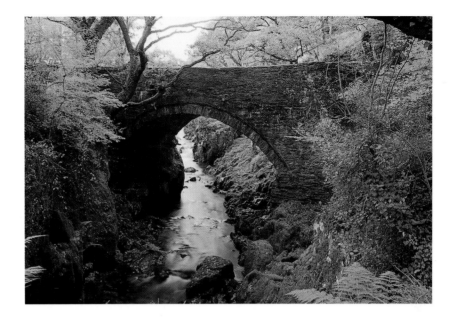

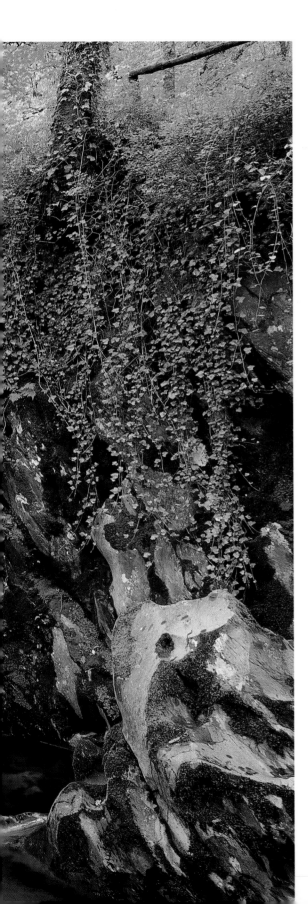

I had read about the two Roman bridges which span the River Machno in the tiny village of Penmachno – their description prompted me to make the journey to see them for myself.

On arrival my initial reaction was one of disappointment. How, I wondered, could I make an interesting composition of what lay before me? There seemed to be no way to include both bridges in a single photograph. This was difficult to accept:

I had made a long journey and there was undoubtedly potential here. I scrambled around for an hour, eventually crossing one of the bridges and lodging myself precariously on the far, and almost inaccessible side of the river. After a little more scrambling, climbing and crawling, I eventually found the position which provided the elusive viewpoint I had been searching for. Getting wet in the process didn't matter because I had, after all, obtained the photograph I was seeking.

Don't give up if you feel somewhere has potential. The picture above is what I first saw. Thorough exploration of a place can pay dividends.

I was fortunate to have arrived on a calm day. Any breeze would have blurred the long ivy strands hanging from the bridge.

Soft, shadowless lighting reveals the delicate tonal variations of the bridge and river bank.

Penmachno, Gwynedd
Tachihara 5 x 4in with wideangle lens, Fuji Provia [ISO 100], 5 seconds at f/45

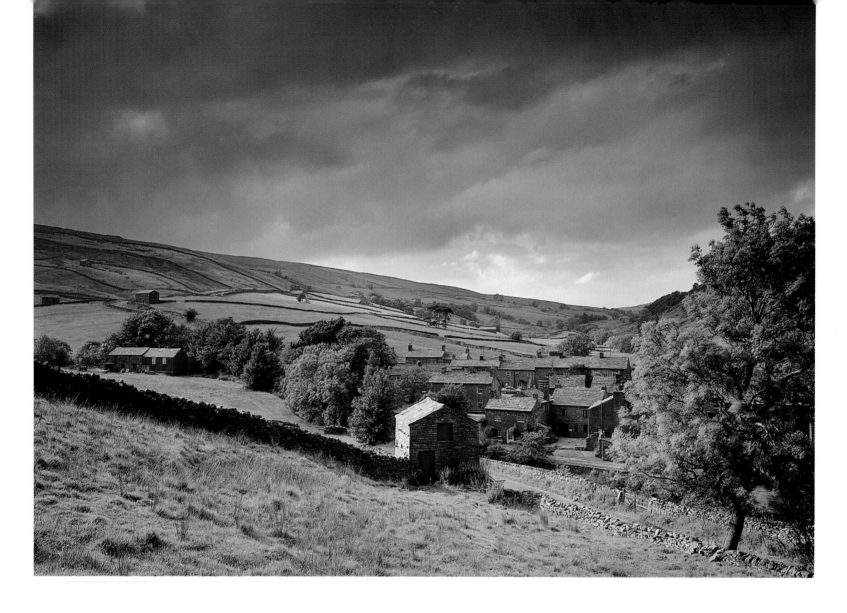

Thwaite, Yorkshire Dales

Tachihara 5 x 4in with 150mm lens, Fuji Provia [ISO 100], 1/8sec at f/22, 81C and 0.6 grey grad

When I arrived at this tiny North Yorkshire village, hidden deep in the Dales, the weather did not look promising. Storm clouds were gathering and the wind was strengthening. What should I do? Should I return another day or should I wait? I debated. I eventually chose the latter option which, on this occasion, proved to be the right decision. The brisk and steady breeze added momentum to the drifting clouds and within an hour of my arrival an occasional break in the cloud cover began to appear. I hoped for, and thankfully got, a shaft of sunlight which produced a highlight on the barn at the front of the village.

This highlight is essential. (Cover the barn with your finger to see just how important it is.) It brings the picture to life, adding drama, and contrasting with the menacing, stormy sky which it thus emphasizes.

Even dark skies can be brighter than the landscape above. Always meter sky and land separately and use a graduated filter as necessary; take a Polaroid to determine the precise extent to which the sky should be darkened.

My choice of viewpoint was compromised by parked cars in the village. Vehicles spoil pictures (they also date them) and should always be excluded if possible.

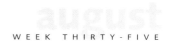

If you find a landscape with a rich, colourful texture, bring this into your photograph as graphically as you can. This will usually mean getting close to a strong foreground and using a wideangle lens. A low viewpoint will have the effect of bringing the foreground into touching distance, creating depth and great impact. To avoid your picture falling flat beyond the foreground, include a focal point in the middle distance or on the horizon. As always, a strong, well-structured sky will ensure that your picture has uniform appeal from top to bottom.

Pin-sharp definition is essential here. I used the smallest possible aperture and focused on the hyperfocal distance (see page 11). A long shutter speed may be necessary to compensate for the small aperture, so blurring of long grasses may occur if there is any breeze, but this is preferable to an out-of-focus foreground.

Strathy, Sutherland
Tachihara 5 x 4in with wideangle lens, Fuji Provia [ISO 100], 2 seconds at f/32½, 81C, 0.6 grey grad and polarizer

september

No other month surpasses September for variety of picture-taking opportunities. As the growing season reaches its peak, crop fields can make interesting subjects and provide scope for originality. Heather-clad hills and moorland produce natural displays of rich colour which can look very striking, particularly if photographed in stormy weather against a dark, threatening sky.

This is also the month when a nuance of autumn can be detected. A hint of what is to come is evident as leaves become speckled with yellows and browns. Use warm filters (81B or C) to accentuate these traces of colour.

Ben Loyal has been photographed countless times. A day doesn't pass without photographers and tourists stopping to capture a view of the mountain, in all types of weather and in every conceivable quality of light.

Thereis no need to avoid a subject because it is popular; a scene may have been photographed an untold number of times but this does not mean you should ignore it. However, your pictures will undoubtedly give you greater satisfaction, and will certainly be more enthusiastically received by others, if you attempt to photograph the subject in an original way. I don't suggest you use those gaudily coloured special-effect filters; instead, look for a different viewpoint or perhaps isolate one part of the subject and concentrate on a small detail which is normally overlooked.

This view of Ben Loyal is not the most obvious and, without the aid of a large-scale map, would be missed by most people. When I arrived I felt that, while the loch certainly strengthened the picture, the view still looked fairly ordinary. A circuitous walk around it took me to the little tree-clad island, which, with a degree of climbing and scrambling, I was able to incorporate in the middle distance. This, to my mind, completes the photograph. Heather, trees, the loch and the mountains all make a balanced contribution to the final image, and to me they all seem to say 'Scotland'.

The directional light in the photograph is not immediately obvious, but is perhaps the most important single element. Without sidelighting, the mountain's craggy surface would not have been brought into the picture and it would have become a flat, uninteresting mass. For a photograph to succeed, visual interest must be maintained from the foreground through to the distant horizon – without the detail in the mountains, the picture would have failed.

Ben Loyal, Sutherland
Tachihara 5 x 4in with 150mm lens, Fuji Provia [ISO 100], 1sec at f/32, 81B, 0.3 grey grad and polarizer

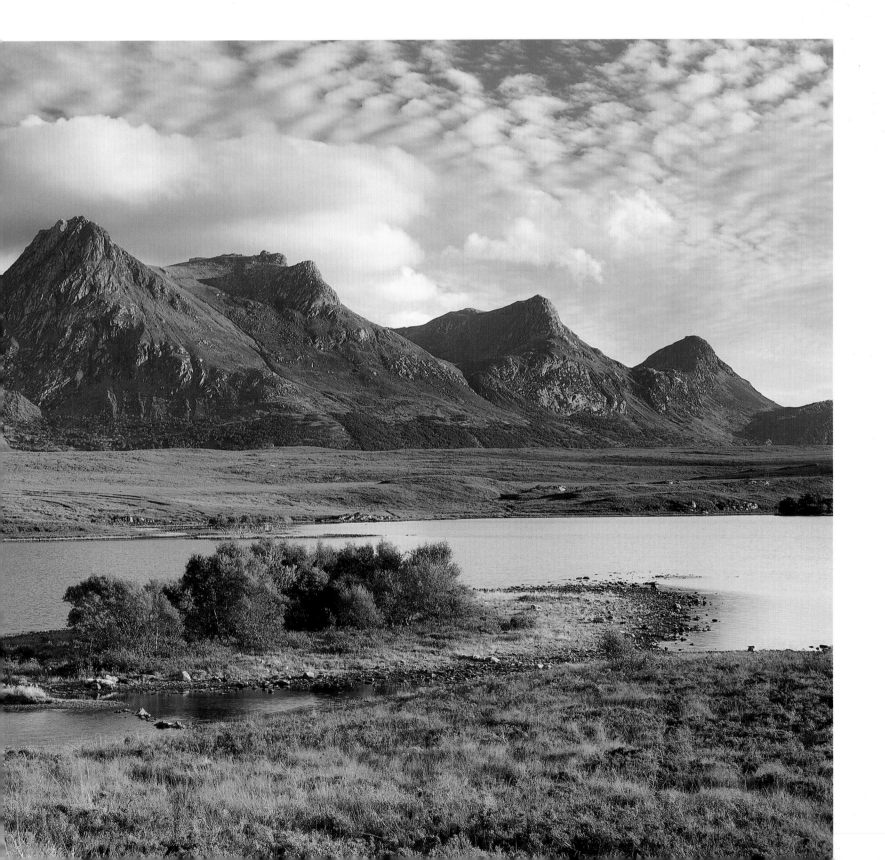

Near Llangollen, Clwyd

Tachihara 5 x 4in with wideangle lens, Fuji Provia [ISO 100], 1/8sec at f/45, 0.6 grey grad

What a day this was. There are times – and this was one of them – when single-minded, stubborn determination is the quality required for picture-taking rather than perceptual skills or creativity.

I had discovered this lovely, heather-clad mountain a week earlier. My initial thought then was to concentrate on the fence and heather and exclude the surrounding landscape, but I was also attracted by the curve of the fence and its repetition in the contour of the hillside, which led on to the bowl-shaped valley and beyond to the distant mountains. I concluded that the big view was the picture to take.

However, this type of landscape, which contains a foreground dominant both in mass and colour, but which also has within it other vital elements, is not easy to photograph successfully – it is a question of finding a balance. Each element should be allowed to make its contribution but not become dominant. Here, as is so often the case, balance could only be achieved through the appropriate use of light; the foreground would have to be in shadow while the valley would have to be strongly lit. Finally, the sky would have to contain a strong cloud formation (a postcard blue sky was most definitely not required here). All this was fine in theory but it had to be put into practice.

A few days later the weather forecast predicted a windy and showery day ahead – just the conditions that were needed. The forecast was not, I have to say, completely accurate. For reasons of brevity I will understate the weather that day and merely describe it as very windy and very showery.

It took an hour to set up and focus my camera (it is not, I must tell you, completely straightforward using a large-format camera in howling wind and rain). As I struggled against the elements it did, for a fleeting moment, occur to me that I might have to abandon my plans for the day but, quickly banishing such defeatist thoughts from my mind, I persevered. It was 8am, I had travelled a long way, and I was here to stay. If it took all day so be it. Come what may I was going to get that picture.

Success came several hours later, but it had hurt. The Siberian conditions, the constant covering and uncovering of my camera and tripod, the relentless watching and waiting, they had all taken their toll. Exhausted, I set off on the journey home.

At that point, if I had seen the most wonderful picture, that once in a lifetime opportunity, I couldn't have photographed it. I was drained. However, the physical discomfort I had endured that day would have been nothing compared with the mental anguish I would have suffered had I given up – that was never an option.

South of Stornoway, Isle of Lewis, Outer Hebrides
Tachihara 5 x 4in with wideangle lens, Fuji Velvia [ISO 50], 1½ seconds at f/45, 0.3 grey grad and polarizer

There may be times when you want to photograph the landscape to record a specific feature or regional characteristic. On such occasions the arrangement should be kept simple because there is nothing to be gained by including extraneous subject matter.

Prominent characteristics of the Hebridean landscape are the randomly scattered crofters' cottages and the peat cuttings – peat is still used as a fuel on the island. To record this traditional aspect of the islands, I searched for a simple composition which included both.

Although this was a relatively straight-forward photograph, it could not be taken at the first attempt because the sky was overcast and the diffused lighting gave the landscape an uninteresting, flat appearance. More importantly, it did not reveal the line of cut peat – an essential element in the photograph – sufficiently. Having taken a compass reading, I returned on a better day at a time when the sun was fairly low in the western sky, to the left of the camera. This created the line of deep shadow along the peat and gave prominence to this specific feature of the island's landscape.

Behind the distant cottage is a road which, surprisingly, was fairly busy. A passing car would have spoiled the picture so care had to be taken to avoid this.

Perhaps the picture would have benefited from a more restrained use of the polarizer. The line of shadow along the peat contains little detail and this would have been improved by using only half, or possibly no polarization.

This picture was a bonus. I had taken my intended photograph (of the cut peat) and thought I had finished for the day, but not knowing for certain when a day will end (or begin) comes with the job and as I emerged from the shadows of a mountain, I immediately knew that this particular day was not yet over. There was still work to be done.

There was no time to waste as the sun was sinking rapidly and in another half hour or so it would all have been over. Searching for a position I was happy with took a little longer than expected because of the boggy ground *and* a line of overhead power cables, which obviously had to be excluded from the picture. After 20 minutes of searching I found a good position and, without waiting, took the photograph. I wasn't sure at the time, but this proved to be the optimum moment: minutes later sky, land and water were brought together, this time not by the use of filters, but by a descending shroud of darkness. Now there was no doubt – the day was definitely over.

I would have preferred to record some detail in the mountains and the foreground instead of those solid black masses, but it was not possible. In order to reproduce the reflection on the water, exposure was based on this part of the picture and the sky darkened with a grey graduated filter, bringing its brightness down to that of the water. The effect of calculating exposure on the water's reflection is that the mountains and foreground stones appear as silhouettes. This was unavoidable and sometimes one has to accept and work within the constraints of the restricted latitude of colour reversal film.

Near Ardvourlie, Isle of Lewis, Outer Hebrides
Tachihara 5 x 4in with wideangle lens, Fuji Velvia [ISO 50], 1/4sec at f/45, 81C and 0.3 grey grad

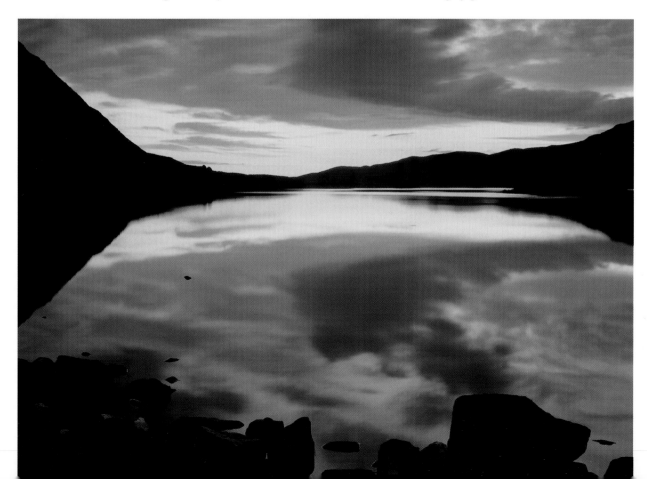

The past few days had been successful. I had no cause to complain of the offerings these lovely islands had given me but this was a photographer's evening. There was a gentle breeze, a warmly lit landscape and an attractive sky. I have to admit that, somewhat greedily perhaps, I hoped for just one more picture.

My hope soon turned to unexpected joy as I rounded yet another bend in the endlessly winding road and realized that my prayers had, to my astonishment, been answered. Here, right in front of me, was my yearned-for photograph. After seeing nothing for mile after mile I was suddenly greeted by this marvellous scene. It seemed that, by an act of divine intervention, it had been created solely for my benefit.

I don't know what that little building is in the middle distance but it is perfectly placed between the bridge and the far ridge of mountains. Its presence is essential. It acts as a visual magnet, drawing the eye right into the middle of the picture. Viewers are taken on a journey. They start by crossing the bridge, continue on to the hut, then finally embark on the long trek to those distant mountains, a trip of several miles travelled in as many seconds.

This picture concluded a brief but fruitful visit to the Hebrides. Luck contributed to my success, I will readily admit, but all photographers need an element of luck when photographing the landscape, particularly Britain's landscape. Without it we would either give up in sheer frustration or relocate to sunnier climes. When good fortune presents itself, don't hesitate to take advantage; it may, after all, be some time before it visits again.

The stones and rubble at the foot of the bridge are bordering on being intrusive. Always check foreground details very carefully: the seemingly insignificant will often assume leviathan proportions when photographed.

Ensure that the horizon remains intact wherever possible. Had the top of the bridge strayed above the mountains, the sense of distance and open space would have been greatly impaired.

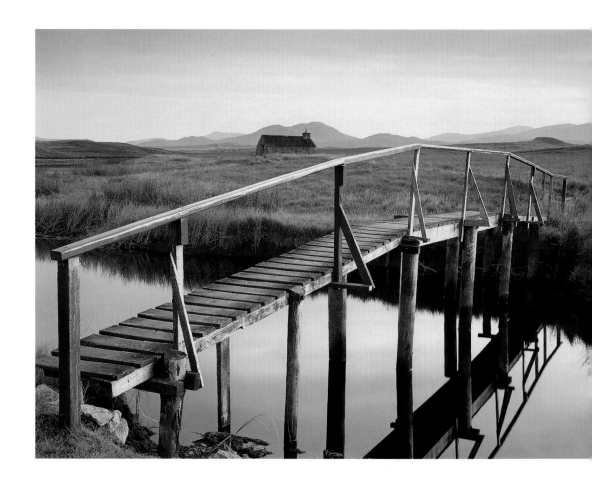

Near Tarbert, Isle of Harris, Outer Hebrides
Tachihara 5 x 4in with wideangle lens, Fuji Velvia [ISO 50], 2 seconds at f/45, 81B

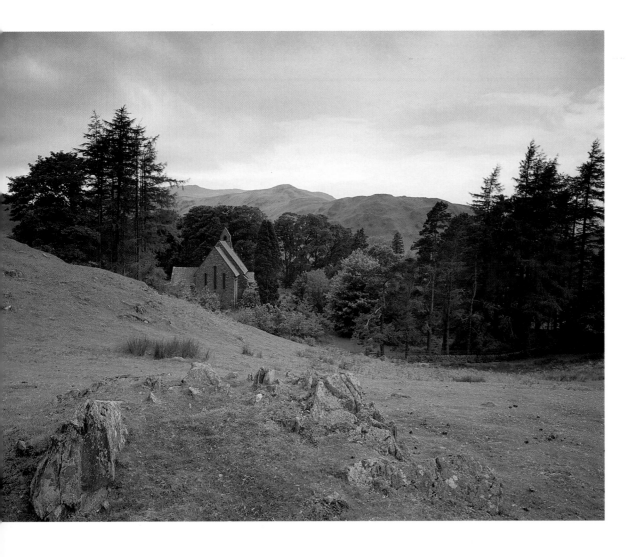

Martindale, Cumbria
Tachihara 5 x 4in with 150mm lens,
Fuji Provia [ISO 100], 1/8sec at f/22½

One of the greatest pleasures in photographing the countryside is the surprise encounter, that unexpected meeting of photographer and subject, that perfect piece of landscape which greets you as you turn a corner, climb a hill or cross a field.

At the southern end of Ullswater the land rises steeply, and nestling among the mountainous slopes at Martindale is an isolated church. I climbed to the top of a hill. It was a speculative ascent because I was, at the time, unsure of what lay beyond, but there it was: this lovely,

ready-made photograph. All I had to do was set up my camera and take the picture. Nothing needed adding, excluding or enhancing. Everything was quite perfect in its natural state. There was an interesting foreground, a sloping, undulating hillside and a framework of trees around the church which obligingly dipped below the horizon to provide a view of the distant mountains. This is an essential element in the photograph. As well as adding depth, it reveals the nature of the Cumbrian landscape and depicts the church in its wider environment.

The sky could have been improved by being a touch darker, but I felt compelled to take the picture just as it was, without the addition of any filters.

Big views usually require low, directional lighting, but here the diffuse lighting works well. There is sufficient tonal variation present in the picture to obviate the need for highlights and shadows.

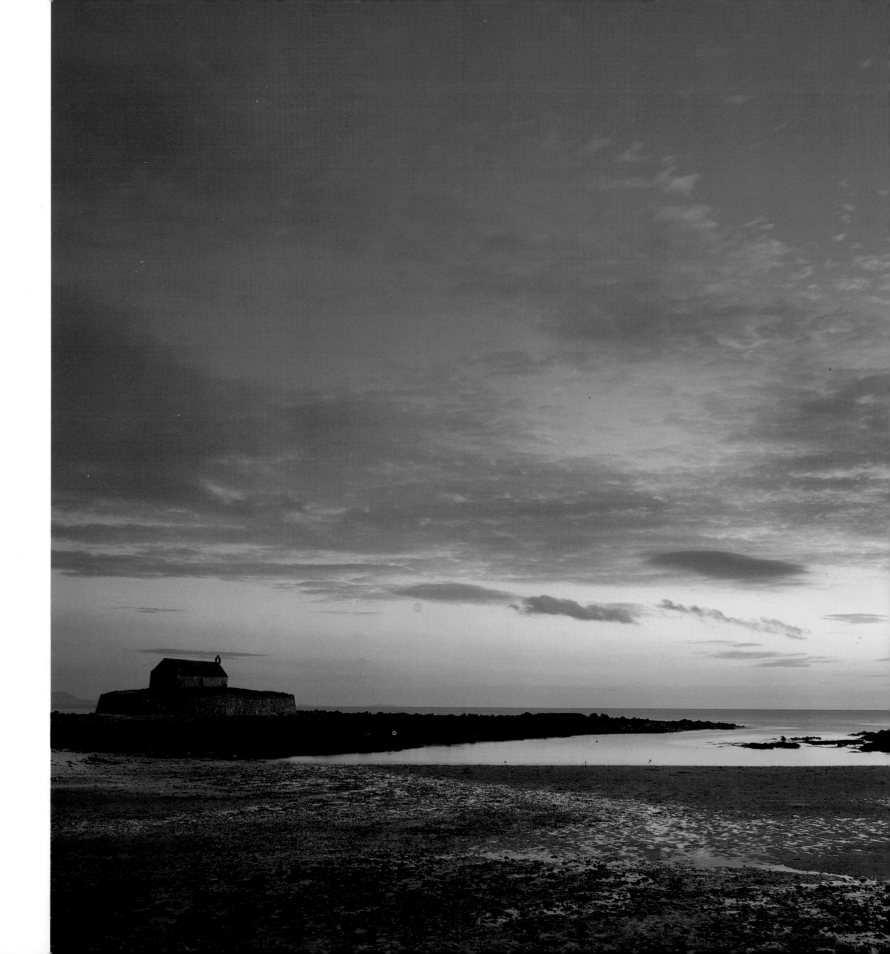

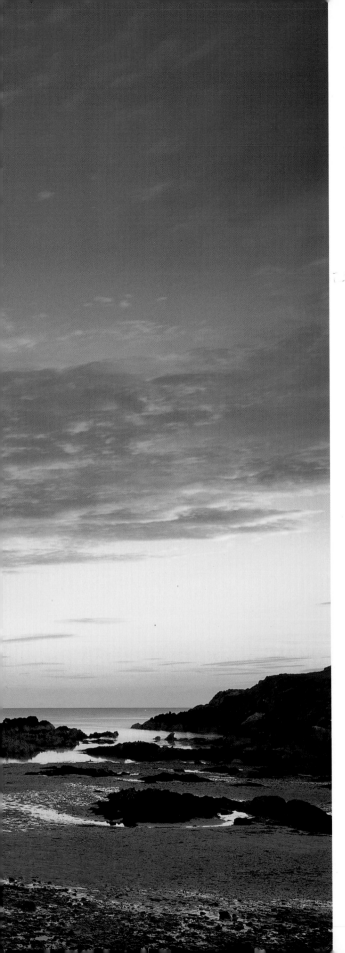

Nearing the end of a day of frustration (Anglesey, delightful as it is, is not, photographically speaking, the most accessible of places), I decided to head for a bay situated in the south-west corner of the island. I had visited the area previously and knew that it held potential. The sky looked promising and I sensed that the evening was going to end with a flourish. You can see that my day's frustrations were about to end.

The final hour of daylight can be a revelation and here the transformation was quite miraculous. Scenery, props and lighting were all changed in a matter of minutes. It was pure theatre. That evening will remain with me forever. It was a privilege, and indeed a humbling experience, to be there and capture a fleeting moment of perfection. It is one of a handful of precious moments which are so sublime that words become an inadequate means of communicating the euphoria I felt. I will therefore add no more and allow the power of photography to speak for me.

Aberffrawr, Anglesey
Tachihara 5 x 4in with 150mm lens, Fuji Provia [ISO 100], 3 seconds at f/45, 81C and 0.6 grey grad

There is more to photography than photographs. Well, certainly this is true in the case of landscape photography. The search for pictures will take you to places previously unheard of, places which are tucked away in Britain's hinterlands, blissfully free of visitors and traffic.

This is the Britain that tourists don't see. The timeless Britain which remains untouched by urban development. You won't find Mainstone in any tourist guide; outside of its locality it is unknown and ignored and, in this respect, Mainstone is by no means unique.

Britain is a land of surprises. Delve deep into its countryside; follow the minor, single track roads and you will embark on a journey of discovery. Use your map and follow your instincts. Investigate and explore. You will find yourself stepping back in time and you will see sights which will lift your heart.

South-west Shropshire is a somewhat anonymous area, but anonymity should never be confused with mediocrity. Here sparsely populated backwaters straddle Offa's Dyke Path, which marks the boundary between England and Wales. Rolling hills carry quiet lanes that rise and fall and twist and turn across a landscape which oozes character and photographic opportunity.

In this photograph, the combination of a wooded valley, a field of crops and a ramshackle shed produces an image evocative of an earlier age. There is nothing spectacular about this picture, it is merely a glimpse of time-honoured, traditional, rural life. That, in itself, is a worthy subject for the camera.

The position of the clouds is essential in preventing the picture falling away sharply to the left. It took some time for these clouds to appear but without them the photograph would have looked unbalanced. Cover them with your hand and you will see how important they are.

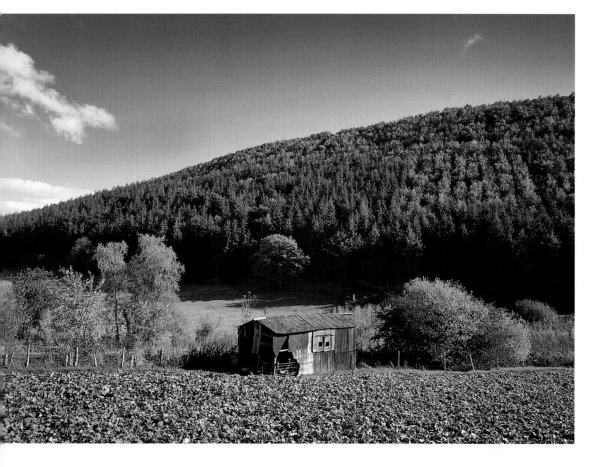

Mainstone, Shropshire
Tachihara 5 x 4in with wideangle lens, Fuji Provia [ISO 100], 1/4sec at f/22½, 81B, polarizer (half polarized) and 0.3 grey grad

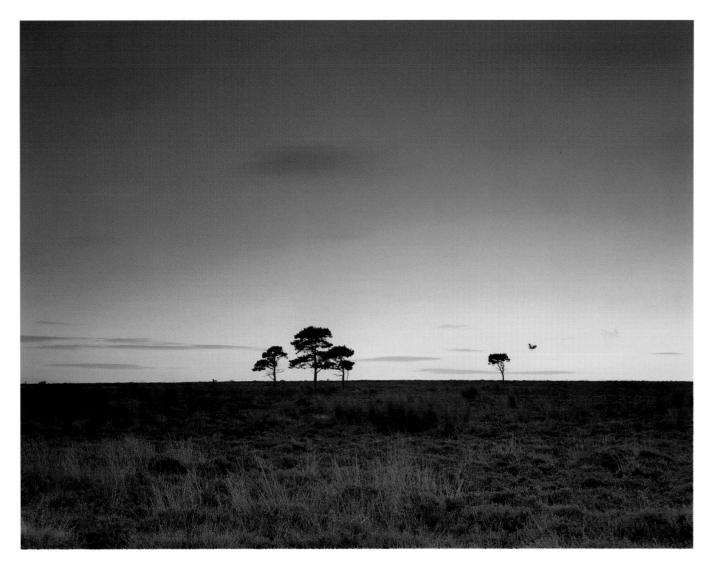

Fylingdales Moor, North Yorkshire

Tachihara 5 x 4in with 150mm lens, Fuji Provia [ISO 100], 5 seconds at f/32, 81C and 0.3 plus 0.9 grey grad

This atypically tropical moment on the Yorkshire Moors arose at the end of a wind- and rain-swept day (one of several in fact). Judging by the week I spent there, these moors must be one of the windiest places in Britain, but this can bring dividends. Wind and cloud bring with them ever-changing lighting conditions and it pays to remain both patient and aware of the photographs which can occur fleetingly at any moment.

You may expect me to say that the balmy evening depicted here was nothing of the kind and that in order to get the photograph, I had to battle against a freezing temperature and gale force winds. But surprisingly, this was not the case – just the opposite in fact. The winds had blown themselves out, the sky had cleared and it had become a warm and pleasant late-September evening. (This photograph was taken at 7.30pm.)

There was a difference of 4 stops between the exposure value of sky and land, despite the sun setting a few moments earlier. Therefore, two grey graduated filters were needed to reduce the brightness of the sky to a level which enabled the colour of the heather to be brought into the picture.

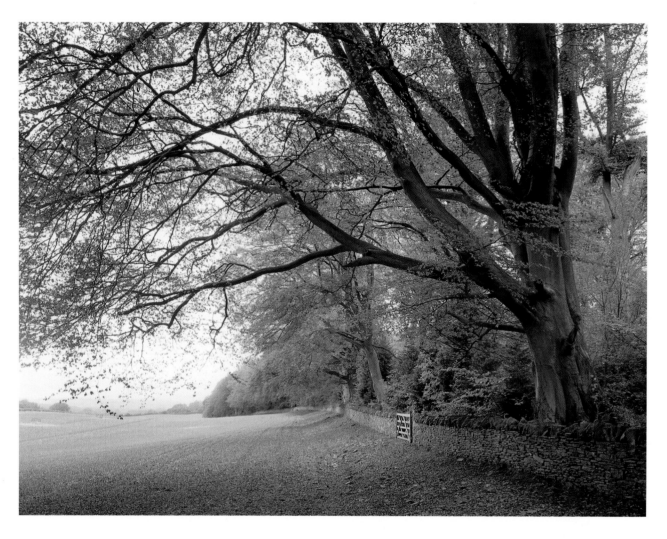

Near Naunton, Gloucestershire

Tachihara 5 x 4in with wideangle lens, Fuji Provia [ISO 100], 2 seconds at f/45, 81C

The existence (and position) of the gate is an important detail. It acts as a central focal point and gives depth to the picture.

Even with the dull, flat lighting there is a gradual brightening from front to back across the field. The highlights and shadows are within the exposure latitude of the film and are perfectly acceptable, indeed desirable. Stronger lighting would have created too much contrast and the picture would then have failed.

Driving along the Cotswold lanes and back-roads (to learn more about places which, until then, had simply been names on a map), I saw a long, undulating and colourful row of trees in the distance. Hoping to find a road running through this display of autumnal splendour, I took the first turning in their direction and, minutes later, I was driving through what could have been the inside of a kaleidoscope. Colourful as it was, I preferred the simplicity of the ploughed field and group of trees situated to one side of the lane. The flat lighting of the overcast sky enhanced the glorious tone of the recently turned soil which was in such perfect harmony with the overhanging, autumn-tinged branches. There was no vibrant colour here. It was subtle, quiet and understated but there is nothing wrong with that; autumn shouldn't always shout colour at you. Sometimes the intimacies of the landscape should be spoken in a soft, seductive whisper.

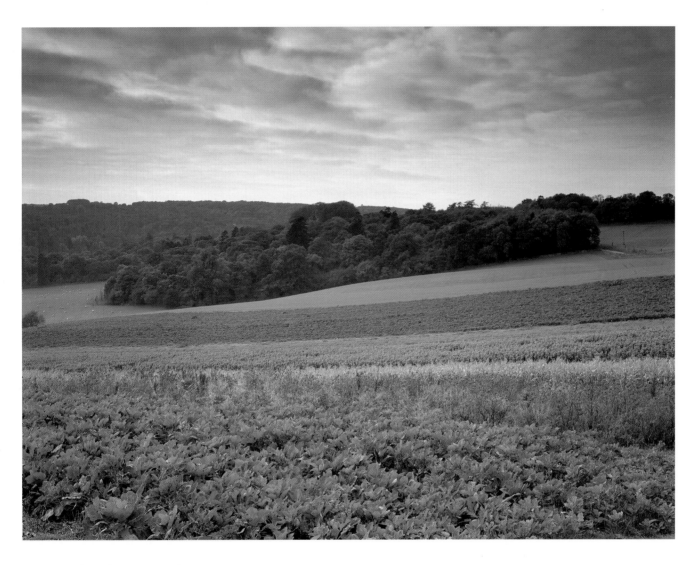

Yanworth, Gloucestershire
Tachihara 5 x 4in with 150mm lens, Fuji Provia [ISO 100], 5 seconds at f/45, 0.6 grey grad and polarizer

While no doubt unintentional, the farmer who planted this intriguing variety of crops should be congratulated for creating such a fine photogenic display. Had I designed it I could have brought no improvement to this rural landscape.

Once again, diffuse lighting is quite acceptable; the striped landscape speaks for itself without the need for highlights and shadows. This time the sky makes an important contribution to the photograph. The tonal qualities of the clouds, trees and crops are all very similar and produce a consistently textured surface across the picture. It took an hour or so for this sky to materialize, but it was worth the wait. Be patient with the sky and it will reward you.

The polarizer has reduced reflections on the slightly damp crop leaves, which has improved colour saturation.

No warm-up filter was used. The green crops would not benefit from any warming.

The long exposure has softened the clouds and this has brought the sky closer to the texture of the landscape below.

october

This is the month favoured by most photographers, and rightly so. Autumn leaves transform the countryside into a masterpiece of colour and create outstanding picture-taking opportunities which do not exist at other times of year. Search for suitable locations in advance, then return frequently to ensure the optimum moment is not missed. Beware of wind and frost: they can have a ruinous effect on fragile leaves.

Photograph in flat lighting to produce strong, saturated colours. Use a polarizing filter to reduce surface reflections, particularly in damp weather. On sunny days seek to use backlighting in forests and woodlands – its effect can be quite stunning.

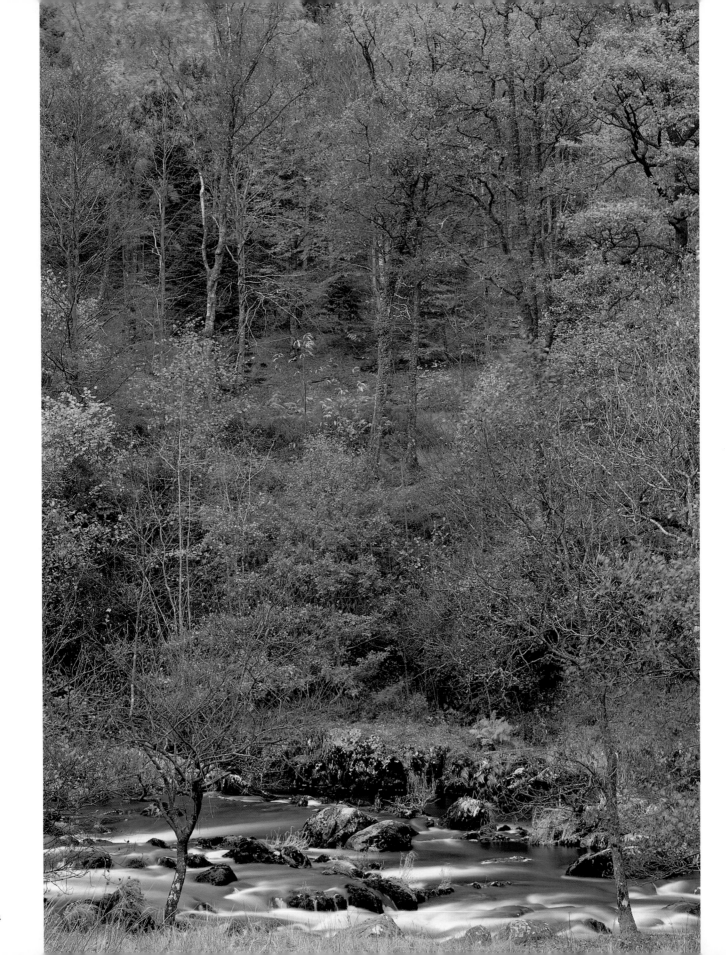

That trickling stream could be almost boiling couldn't it? It is a wonder that the water isn't evaporating in the inferno raging above it. This is the beauty of autumn. The green of summer gradually fades to be replaced, not by a single colour, but by a mixture of yellows, oranges, reds and browns. This is the time of year when colour forces itself onto the photographer. There is no escape. Shape, form, texture, and even lighting to a degree, take second place to the kaleidoscope which covers the landscape.

No two autumns are ever the same and it is impossible to predict when colours will reach their peak. Often the most successful approach is to search out a number of potential photographs during the summer and then monitor these locations as the autumn approaches.

Frost and wind can have a dramatic effect on leaves at this time of year so it is important to remain vigilant. The picture you have been waiting for might suddenly appear and then, just as suddenly, disappear a few days later.

There is no need to wait for a strong cloud formation: it is often preferable to exclude the sky when taking a 'treescape', particularly during autumn. Here, the sky has been omitted to ensure that the only highlight is the water.

Flat, shadowless lighting is normally preferable in a picture dominated by strong colour, although backlighting can also be effective in some situations.

Gwydyr Forest, Snowdonia
Tachihara 5 x 4in with short telephoto lens, Fuji Provia [ISO 100], 1sec at f/22½, 81C and polarizer

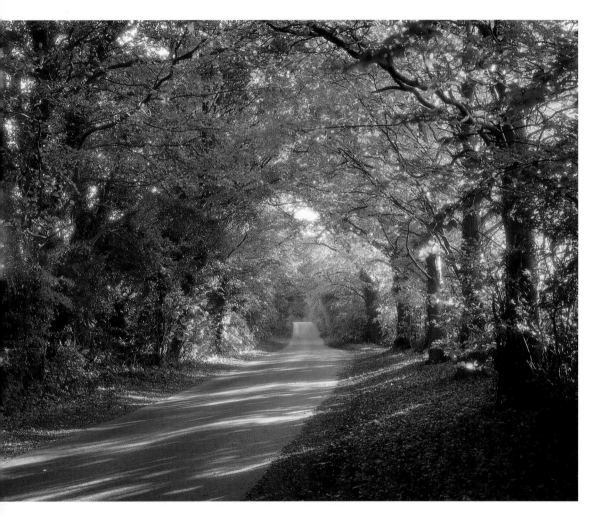

Near Stow-on-the-Wold, The Cotswolds
Tachihara 5 x 4in with semi-wideangle lens, Fuji Provia [ISO 100], 1/2sec at f/32½, soft focus

It had been an inauspicious start to the day. The weather was fine (too fine in fact because the sky was almost cloudless) but nothing had inspired me. Then this.

It was an unforgettable and elating experience rounding a bend in the lane to discover that the elusive showpiece, that sought-after moment of perfection, was, for the time being, no longer eluding me.

Why did I turn off the main road and drive two miles to this lane? I don't know. Perhaps it was luck, or maybe it was a sixth sense which guided me to this tranquil and beautiful example of Cotswold charm.

Everything here was right; the curve of the lane, the shape of the trees, the direction and quality of light. Individually they were attractive, collectively they were sublime. And they could so easily have gone unseen.

The fine, soft-focus filter gives the photograph an ethereal quality. It is subtle and not overdone. A coarser filter would have destroyed the picture's delicate charm.

Lens flare can all too easily occur in backlit pictures and it will be exacerbated by a soft-focus filter. Take extreme care to shade the camera lens. (A lens hood is unlikely to be effective in such situations.)

Always check for litter or any other unwanted objects. I should have removed the leaf in the bottom left corner. The light has caught it and it is slightly distracting.

Every photographer is affected by luck, many would say by a lack of it rather than a presence, but there is nothing to be gained by complaining. It is pointless to dwell on what might have been. Accept bad luck philosophically and take every advantage when good fortune does eventually present itself – and it will.

But for sheer good fortune you would not be looking at this photograph of Northumberland farmland. I first saw the field in the early morning but the light was behind me and had a flattening effect on the rows of hay. I calculated that the sun would be in the right position by late afternoon/early evening, so I returned at 5pm.

Everything was as I had envisaged and within minutes I had taken the picture. I had barely started to pack away my equipment when I heard the sound of an approaching engine. Seconds later an amiable farmer waved to me as he drove by, combining the recently cut hay and taking with him my foreground. I watched as the combine harvester drove backwards and forwards. Within minutes the field was transformed (from a photographer's point of view) into a desert. No, I will never complain of bad luck.

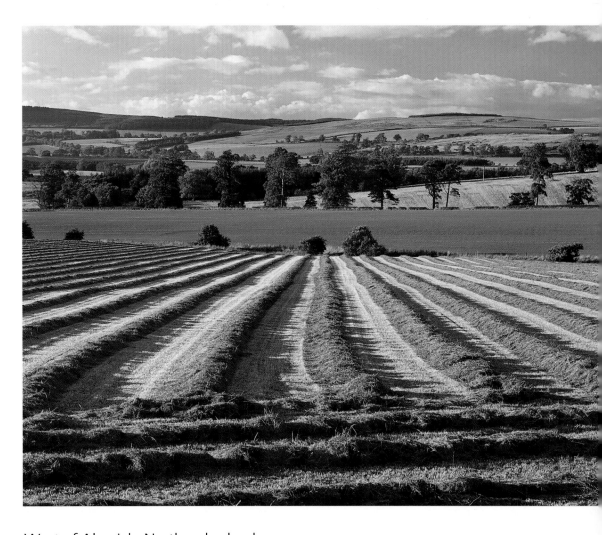

West of Alnwick, Northumberland
Tachihara 5 x 4in with short telephoto lens, Fuji Provia [ISO 100], 1sec at f/64, 81B

The position of the sun is critical here. It needs to be low to cast shadows on the raised rows of hay – a high sun could not have done this. The light source needs also to be slightly in front of the camera, because of the combination of both horizontal and vertical lines in the field. Shadows need to appear in both of these directions and only a combination of side and backlighting will produce this effect.

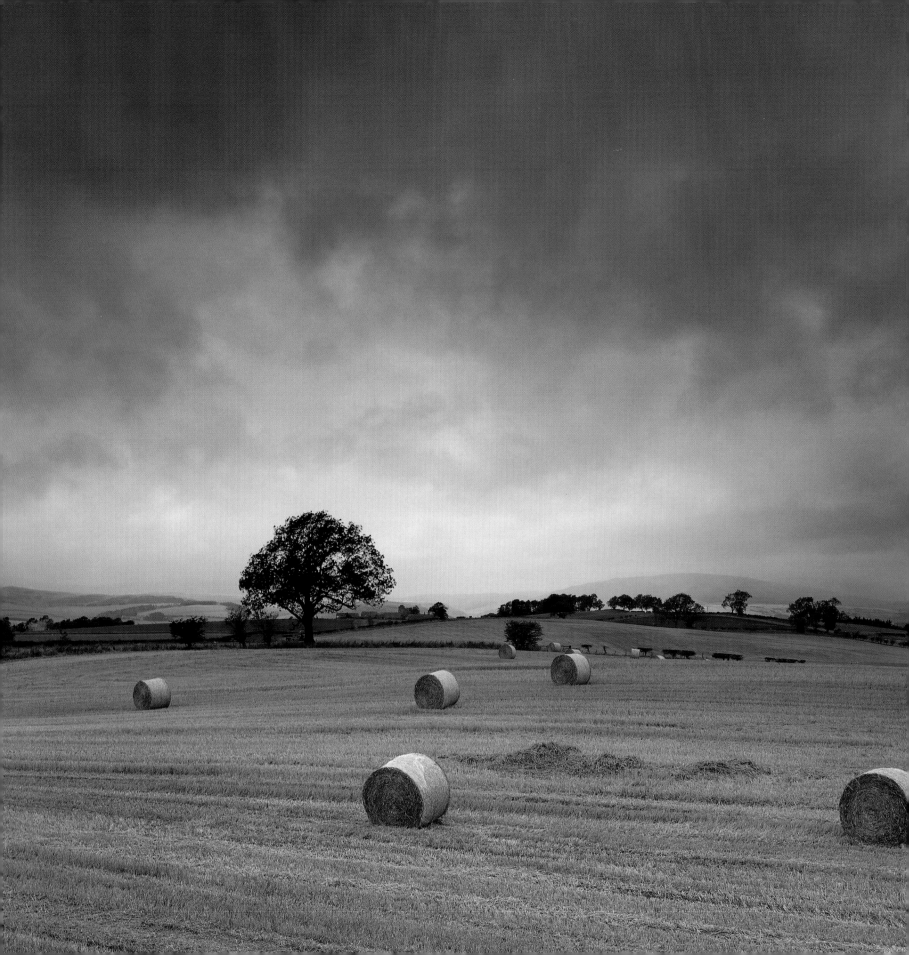

There are relatively few blue skies in this collection of photographs and, whilst this is partly a reflection of the British weather, it is also because I normally avoid taking photographs in such conditions. The main reason, apart from the lack of creative opportunity provided by the lighting of a high sun in a cloudless sky, is that clouds make skies so much more interesting. It may be a mackerel sky or a gathering storm, or perhaps just a few strategically placed clouds, but the presence of any type of cloud structure will, in most cases, improve the appearance of the sky.

Any hint of blue was the last thing I wanted in this picture so, having confidence in the forecast of rain later in the day, I waited for the clouds to gather. It was, as you can imagine, a windy day with clouds swirling by in constantly changing patterns. This type of weather always provides the photographer with a multitude of options and, if you are not to miss such opportunities, I would urge you to spend an hour or so sky watching in such conditions. It will never be time wasted.

My initial attempt at this picture produced a timid, featureless sky. Fortunately, this was a Polaroid so, with the benefit of hindsight, I was able, at the second attempt, to rectify the problem by using a stronger, graduated filter. Use a Polaroid to remove uncertainty and avoid disappointment.

Fields of hay will always benefit from the warming effect of an 81B or C filter.

Near Whittingham, Northumberland
Tachihara 5 x 4in with 150mm lens, Fuji Provia [ISO 100], 1/4sec at f/22, 81C and 0.6 grey grad

It was the abundance of castles which encouraged me to visit the north-eastern corner of England but, as I was soon to discover, castles are by no means this region's only attraction.

The landscape here is a curious blend of England and Scotland; typically English rolling hills mingle with heather-clad moorland. From these undulations flow meandering rivers which bring a rich fertility to the surrounding green and expansive valleys. Church steeples and castle turrets interrupt the sweeping horizon but are no match for the towering, solid mass of the Cheviots. And, as if this were not enough, there is, at the edge of it all, a coastline that is clean, unspoilt and timeless.

On the banks of the River Aln lies the ancient port of Alnmouth. It is an attractive, unspoilt village which overlooks several miles of bracing but impressive shoreline. I spent a grey and drizzly afternoon searching for a vantage point which would provide a wide view of the coast. I favoured a position on the opposite side of the bay, south-west of Alnmouth (the camera would be pointing north-east): this would be perfect, weather permitting, for a dawn photograph. Fortunately, the weather did permit. Conditions improved overnight and the morning dawned crisp and bright. The interesting cloud structure I had hoped for had not materialized, but this was not a disappointment because a fine, almost imperceptible mist had given the sky an ethereal luminescence. Quite charming but, not surprisingly, it was short-lived. The

sun soon crept above the horizon, lit up the coastline and, as it took on a more everyday appearance, abruptly brought the landscape back to earth.

Thankfully, dawn had lingered long enough for me to capture the moment.

To take the guesswork out of calculating exposure, this type of picture should be spot metered.

For this photograph the reading taken was of the row of buildings only. Including sky and water in the reading would have caused the picture to be underexposed.

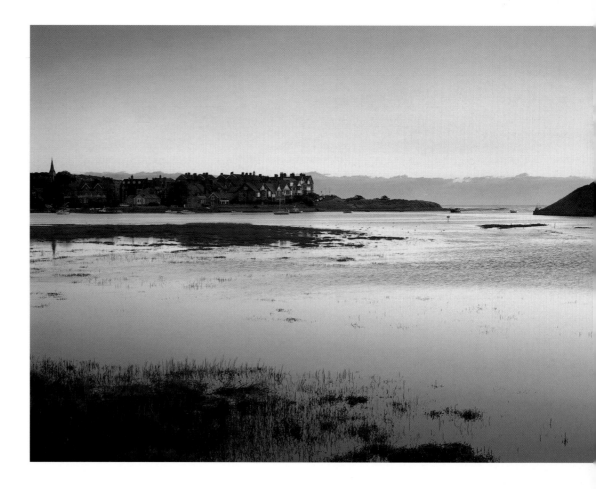

Alnmouth, Northumberland
Tachihara 5 x 4in with 150mm lens, Fuji Provia [ISO 100], 1/4sec at f/32½

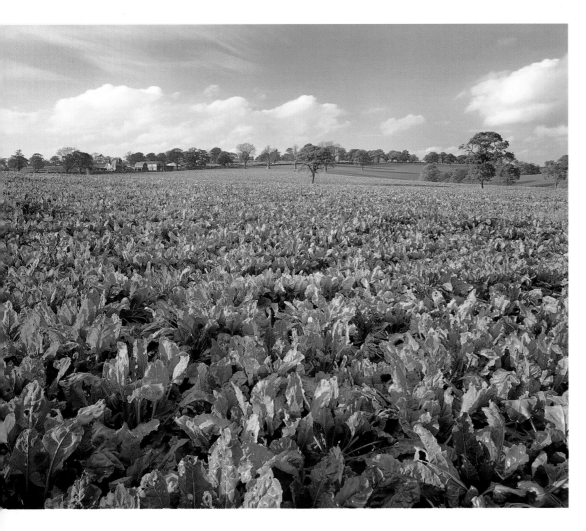

Harthill, Cheshire
Tachihara 5 x 4in with wideangle lens, Fuji Provia [ISO 100], 1/2sec at f/45

Any expanse of a consistent pattern, texture or colour will always have impact when seen as a photograph. Fields of crops, because of their repetitive, identical rows of vegetation, have a pronounced graphic quality. They can, on their own, produce very strong images and should not be ignored.

A polarizer should not be used in strong sunlight because it may create an unwelcome degree of contrast in the shaded areas where as much detail as possible should be retained.

I wouldn't photograph a turnip on its own (well, not as a landscape) but put hundreds of them together in a field and the beauty of nature becomes apparent – suddenly you have the makings of a fine picture.

Fields of crops are naturally photogenic and often produce strong, graphic images. Use a wideangle lens to emphasize the expanse of a field and place the horizon near the top of the photograph. (The sky has only a minor role to play in this type of picture and can, if necessary, be omitted.) It will be essential to photograph with maximum depth of field, which can be achieved by focusing on the hyperfocal distance and using the smallest possible aperture. It is therefore likely that you will be forced to use a slow shutter speed. If this is the case, there should be no breeze when the photograph is taken or the result will be a partially blurred image, particularly if the crops have tall stems.

Low sidelighting is normally preferable, either from early morning, late afternoon or early evening sun: this will reveal the patterns and textures of the crops most effectively. A backlit picture may also be worth considering as this can create a translucent effect and look quite striking, but beware of lens flare.

If strong, contrasting colour is present then flat, shadowless lighting could be used instead to enhance this; the effect could be further improved by using a polarizing filter.

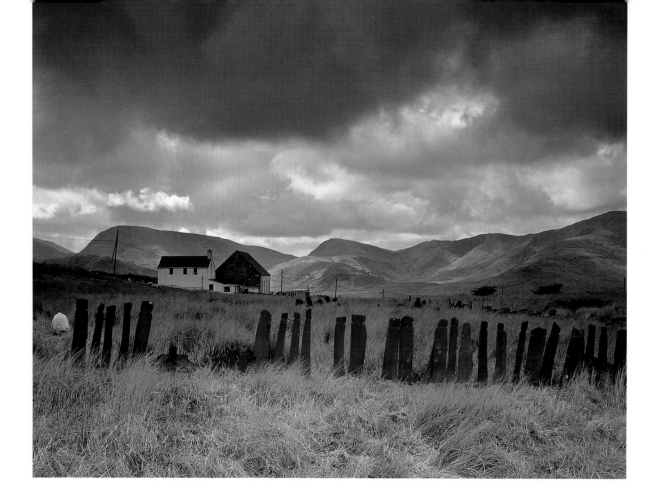

Near Deiniolen, Gwynedd

Tachihara 5 x 4in with semi-wideangle lens, Fuji Provia [ISO 100], 1/15sec at f/22¹/₂, 81B and 0.6 grey grad

When composing a picture, landscape photographers (in common with all photographers) need to have at their disposal a number of options. It may sometimes be desirable to exclude extraneous detail from the picture; equally, there are likely to be occasions when it is essential that as much information as possible is included. A single lens of a fixed focal length gives no such flexibility and is therefore impractical, being too restrictive in the compositional choices it provides.

Consequently, it is necessary to use either a number of lenses of different focal lengths or the ubiquitous zoom lens. I prefer the former solution (in fact I have no choice, as variable focal length lenses are not practical with large-format cameras). I do not, however, criticize the use of zoom lenses; they provide an infinite number of options which can act as a catalyst to the photographer's thinking process – and a thinking photographer is a creative photographer. But beware. It is all too easy to use a zoom lens as a tool of convenience. It is not, I should emphasize, a replacement for your legs. Standing in one position and varying the image by zooming forwards and backwards is not the same as using a range of fixed lenses from different positions.

This picture is structured around three distinct elements: the foreground fence, the farm building in the middle distance and the background mountain range. For the photograph to succeed, there is a fine balance which must exist between these elements. This can only be achieved by undertaking a meticulous examination of the scene and assessing the picture from different positions, through different lenses. Choosing a random viewpoint and then using a lens to suit that viewpoint is not the way to do it. This would give no satisfaction and is a recipe for mediocrity.

I would have preferred the sheep not to have been there but the problem was that it wasn't a sheep, it was a ram – one of several in fact. I therefore considered it prudent not to pursue any territorial claims or jeopardize, in any way, the prevailing spirit of peaceful co-existence.

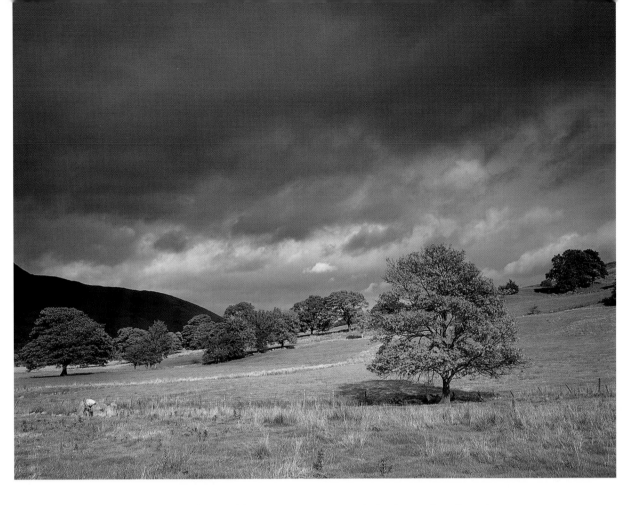

**South of Threlkeld,
The Lake District**

*Tachihara 5 x 4in with
150mm lens, Fuji Provia
[ISO 100], 1sec at f/32½,
81B and 0.6 grey grad*

Focal length affects not only the width and height of the image but also the depth; the longer the focal length, the flatter the picture. Viewed through a telephoto lens, background objects will appear bigger in relation to objects closer to the camera. Conversely, a wideangle lens (a lens with a short focal length) will give greater emphasis to the foreground, with distant objects appearing relatively smaller. Any change of emphasis in the relationship between foreground and background will have a fundamental effect on your picture.

Do not discard your zoom lens if you have one but remember that the perspective, balance, theme, and ultimately, the success of your photograph will be affected by the focal length of the lens you use.

The success of this picture depended on two factors: how the trees were lit and how, as a group, they were arranged.

It was important that the trees were spotlit against the dark sky and mountains. Achieving this effect was just a matter of time because the play of light was constantly moving across the landscape. The arrangement of the photograph, however, with one tree given prominence but also retaining an association with the main group, took some time to configure. Arriving at this composition would not have been possible had a zoom lens been used from a stationary position.

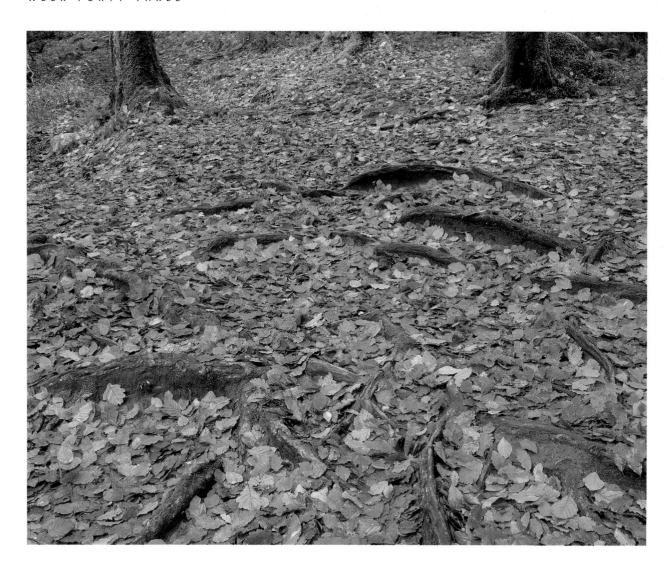

Delamere Forest, Cheshire

Tachihara 5 x 4in with wideangle lens, Fuji Provia [ISO 100], 6 seconds at f/45, 85A and polarizer

Here, autumn has been reduced to an abstract pattern – well, almost. It isn't a complete abstract because you know straight away what it is you are looking at.

The simplification of the landscape into a graphic design has, to a degree, been compromised by the foliage and bushes surrounding the tree trunks at the top of the picture. Now in principle there is no problem with that, indeed a hint of reality can be helpful in depicting an isolated image in its true environment. The photograph would have been stronger, and its graphic quality more pronounced, however, if the fallen leaves had replaced the greenery and extended beyond the trees to stretch all the way to the top of the frame. This would have brought a purity of design and produced a cleaner, stronger image. The picture still works on a basic level but there is no escaping the fact that those green leaves do intrude.

Autumn is all embracing. Opportunities are limited only by imagination.

Compare the effect of the 85A filter in this picture to the 81C used in the photograph on page 134. The 85A is the strongest filter I would recommend. The more pronounced effects of stronger filters can begin to appear artificial.

Birkenhead Park,
The Wirral Peninsula

*Tachihara 5 x 4in with 150mm
lens, Fuji Velvia [ISO 50],
1/2sec at f/32½, 81C and
polarizer (half polarized)*

It is too easy to ignore the familiar. The commonplace, something seen every day, is often taken for granted and provides no inspiration for the creation of a photograph. This can mean a lost opportunity.

A local building, forest, beach or lake (or any other feature), can be just as interesting as that renowned, more distant, attraction. I would, therefore, encourage you not to make long, speculative journeys until you have explored and exhausted your local

landscape. Moreover, the 'when not what' principle can only be applied, realistically, if fairly short distances are involved.

Having visited Birkenhead Park many times, I knew the lake looked particularly attractive in the autumn. As the leaves began to turn it was simply a question of waiting in hope for the appropriate lighting. After several days of weather watching, the photograph was taken early one fine morning when the sun was in the right position to shine obliquely on the boat house.

So, right time of year, right time of day and right lighting conditions; these are the factors which make a successful photograph and, without the need to travel, they are that much easier to obtain.

It was necessary to scatter a few more fallen leaves onto the foreground: without them it may have looked a little bare.

This photograph could also have been taken successfully in mist with completely flat lighting.

Because I use a large-format camera, I also need to use a hand-held exposure meter (these cameras having no built-in meter). This is, however, a positive advantage. Through-the-lens metering is ideal for the casual user, but not for the serious photographer.

The calculation of exposure, or more precisely the measurement of light, should be undertaken independently of,

and after, all other aspects of preparation have been completed. The picture has first to be conceived, the choice of lens made, the camera and tripod set up, and the use of filters considered. These are the essential, creative steps in the making of the photograph; the exposure meter can, for the time being, wait. Once everything is ready I calculate exposure using a spot meter and I strongly recommend their use. They are not a

gimmick. Indeed, the ability to measure light reflected off different parts of the landscape becomes, in some situations, a virtual necessity.

In addition to accurate light measurement, spot metering will tell you what level of contrast will be in the finished photograph and enable you to measure the brightness of the sky so that you can decide by how much (if at all) it should be darkened.

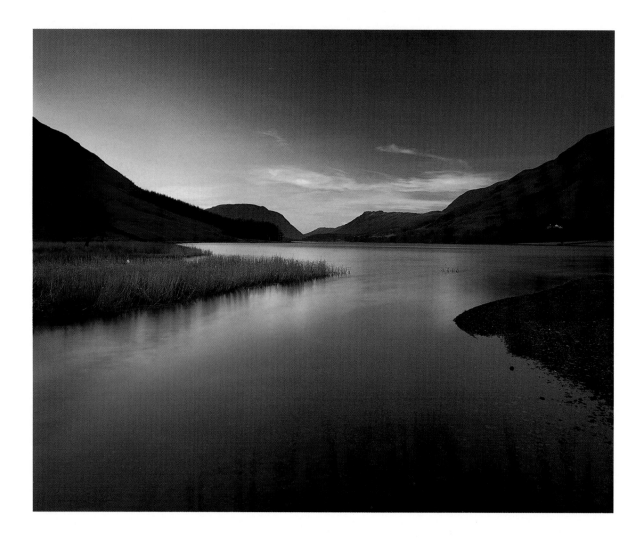

**Buttermere,
The Lake District**
*Tachihara 5 x 4in with wide-
angle lens, Fuji Provia [ISO 100],
3 seconds at f/32, 81C
and 0.6 grey grad*

In this picture of Buttermere, the unique beauty of the Lake District could so easily have been lost through inaccurate exposure. The lighting had (and deserved) to be caressed with the care one would give to a newborn baby. Nothing less than precision spot metering of the highlights, shadows and mid-range tones would have enabled the moment to be captured in all its glory. If this photograph of Derwent Water had been taken using TTL metering, it would have been underexposed. The reading would have produced an 18% grey image (or its colour equivalent) and the highlights in the sky and water would therefore have been rendered too dark. As a result, the boat would have been reduced to a near silhouette. A reading of the light reflected off the boat, and nothing else, gave the correct exposure and the result is an accurate reproduction of the misty scene.

This type of photograph does not require a polarizer. The reflections on the water's surface are critical to the success of the picture and should not be reduced in any way.

Warm-up filters are also unnecessary. Adding warmth to the misty blueness would spoil the picture's atmosphere.

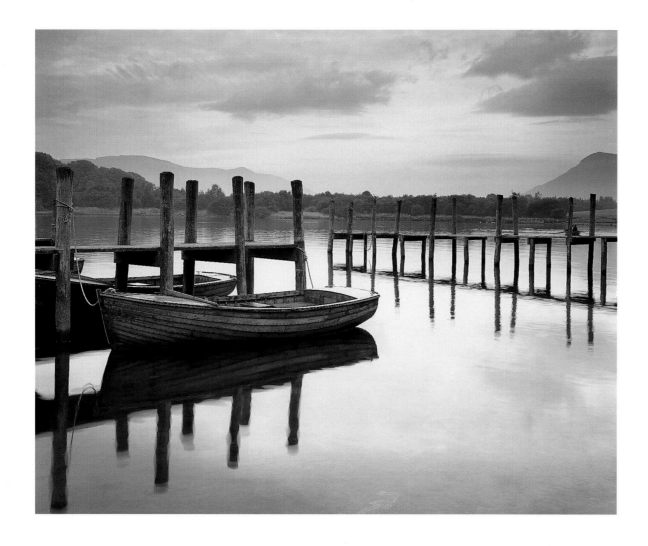

Derwent Water,
The Lake District
Tachihara 5 x 4in with 150mm lens, Fuji Velvia [ISO 50], 1/2sec at f/22½, 0.3 grey grad

The debate has persisted for years. Just what is photography? Is it science or is it art? I like to describe it as painting with light, creatively and aesthetically. This is the art of photography. The application of light to film is as much an artform as the application of paint to canvas. A flick of a brush or a click of a shutter – do the tools really matter? It is the skill and imagination of the painter or photographer which produces a consciously formed, unique image, preserved for others to see.

This photograph of the Mamore Forest, in the Scottish Highlands, has been mistaken for a painting on more than one occasion.

I think its painterly qualities have something to do with the blurring of the swaying leaves and the softly textured ferns. This gives an (unintentional) hint of Impressionism to the picture, which I find alluring. The soft colours and lack of directional light also suggest paint rather than film so the overall effect is that of an image which has been created by indeterminate means.

And there's nothing wrong with that; a picture's uncertain origins should not detract from its aesthetic appeal. A picture should, after all, be looked at as a picture, not as a collection of halides or pigments.

The telephoto lens has exaggerated the blurring of the leaves. When using a long lens, the only way to avoid this is to wait, if you can, for complete stillness. The slightest movement will become enlarged by the magnifying effect of the lens.

Had this been a painting, the artist would not have included the white stone in the foreground. It is distracting and adds nothing to the picture. Being a photograph and not a painting, however, the immovable stone had to remain. Who said photography was the easy option?

Mamore Forest, Kinlochleven,
The Scottish Highlands
Tachihara 5 x 4in with short telephoto lens, Fuji Provia [ISO 100], 1sec at f/22½

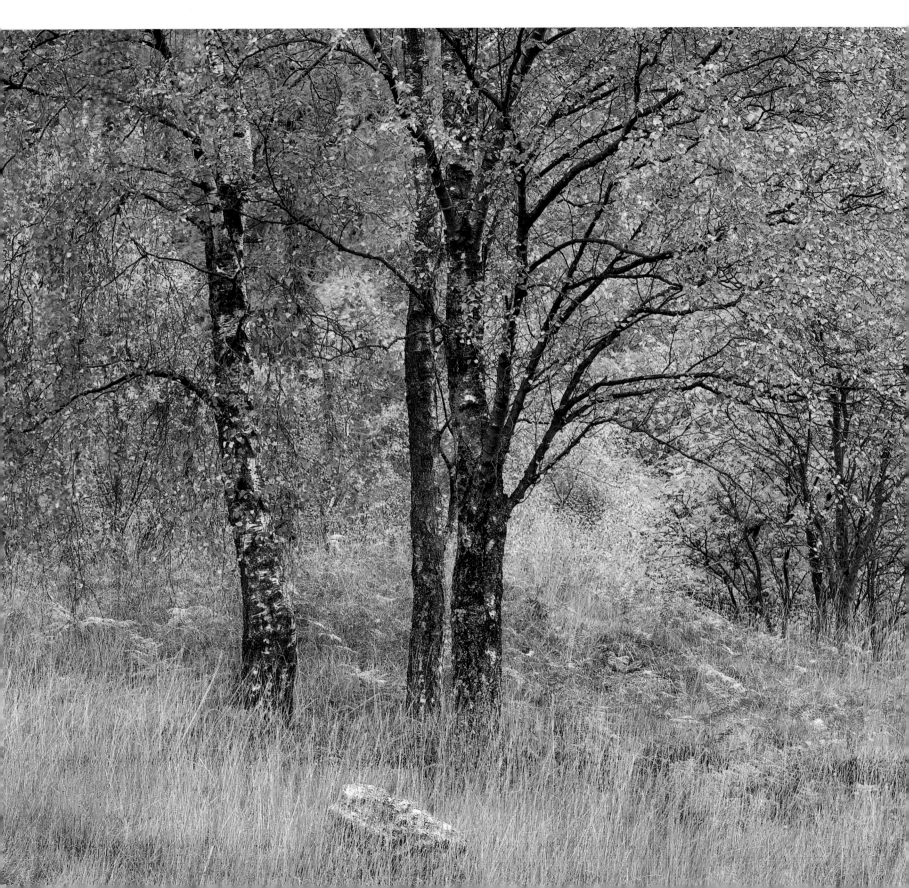

november

Autumn colour begins to fade as frost and mist become increasingly prevalent. Warm reds and browns are replaced by cooler colours as the landscape becomes tinged with silvery blues and greys. Use mist to create mood and atmosphere. Warm-up filters should normally not be used in such conditions: the mood you are endeavouring to create may be dependent upon a cool blue cast.

Fallen leaves carpet the ground in colour and a stroll through deciduous forests and woodland can be rewarding. Simple arrangements, such as tree roots protruding through a layer of orange and brown, can provide opportunities for creative photography.

I have to thank my wife for discovering this fine example of woodland fungi. Her description of it sounded too good to be true so I wasted no time in visiting the woods and taking a look for myself. With the aid of accurate directions, I soon discovered the fungi-covered tree and I was not disappointed; they were clean, undamaged and well developed, the best example I had seen for some time.

The photographing of fungi is, in most cases, quite straightforward. Delicate backlighting is usually not required because most species have no translucent qualities to be enhanced by such lighting – shaded conditions are usually preferable.

Because I was photographing both the tops and the undersides of these mushroom caps, I used a reflecting surface to brighten the stalks and bottoms: this helped to retain detail in the shaded areas. On this occasion I used a white card resting at an angle, close to the base of the tree. An alternative to a reflecting surface would have been fill-in flash. This is not a method I favour because I like to see the precise lighting effect before I take the photograph, but it can be useful in certain situations, particularly in areas where contrast is high. However, beware of losing the subtle tonal qualities, which are a welcome by-product of subdued lighting.

When photographing at close distance, always use the smallest possible aperture to create maximum depth of field.

Ensure that the camera is perfectly parallel with the subject. Any deviation will increase the effective depth of the subject and may result in a loss of sharpness. It may also cause the image to look distorted.

Caldy Woods, The Wirral Peninsula
Tachihara 5 x 4in with 150mm lens, Fuji Provia [ISO 100], 15 seconds at f/64, 81B

My original intention was to take only the one picture. Having previously visited this gothic folly, perched on a hill top in an imposing, elevated position, I had decided to photograph the ancient building as a silhouette against a twilit sky. I very rarely record a subject as a complete silhouette. My decision on this occasion was influenced by the monument's interesting outline, its arches and windows, and also its high, westerly outlook which would enable me to photograph the building against an evening sky, at sunset.

Fortunately, the perfect lighting conditions eventually materialized at the right time of year, with the sun and moon in precisely the positions I had hoped for. Arriving in good time (approximately two hours before sunset), I was able to contemplate the scene, evaluate my choice of picture, and consider any other possibilities.

Strolling around the hill top, I began to realize that there was a second photograph to be taken, quite different, but in its own way just as effective as the one above. The best position, as always, required an energetic scramble over difficult and steep terrain, followed by a somewhat ambitious and quite precarious balancing act. As I cautiously set up my camera, the evening sunlight gradually became more discriminating in its illumination of the landscape; as the light faded, the monument began to glow, with an ever-increasing intensity, against the darkening sky. As I gazed upon it, the

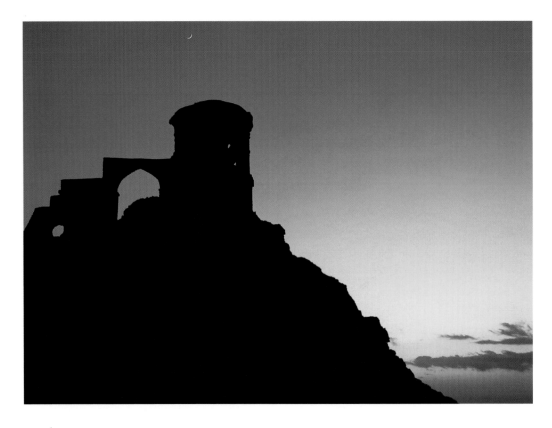

Mow Cop, Staffordshire
Tachihara 5 x 4in with wideangle lens, Fuji Velvia [ISO 50], 1/30sec at f/22

grey stone of the building appeared to be turning gold. It occurred to me that the ancient alchemists should not have been ridiculed for their vain attempts to create this precious element from mere base metal. At this moment I was witnessing a transformation every bit as miraculous, a piece of wizardry of which Merlin himself would have been proud. This, you will discover, is the power of light.

Having taken the photograph opposite, I changed position and moved behind the monument to look west and take the picture I had originally intended. What often surprises people is that these photographs were taken within 45 minutes of each other. Little wonder that most landscape photographers prefer early morning or late evening: they know that is when the power of light is at its strongest.

Whenever possible, arrive at a location early to give yourself thinking time – it is invaluable.

Mow Cop, Staffordshire
Tachihara 5 x 4in with wideangle lens, Fuji Velvia [ISO 50], 1sec at f/45, 81C and 0.6 grey grad

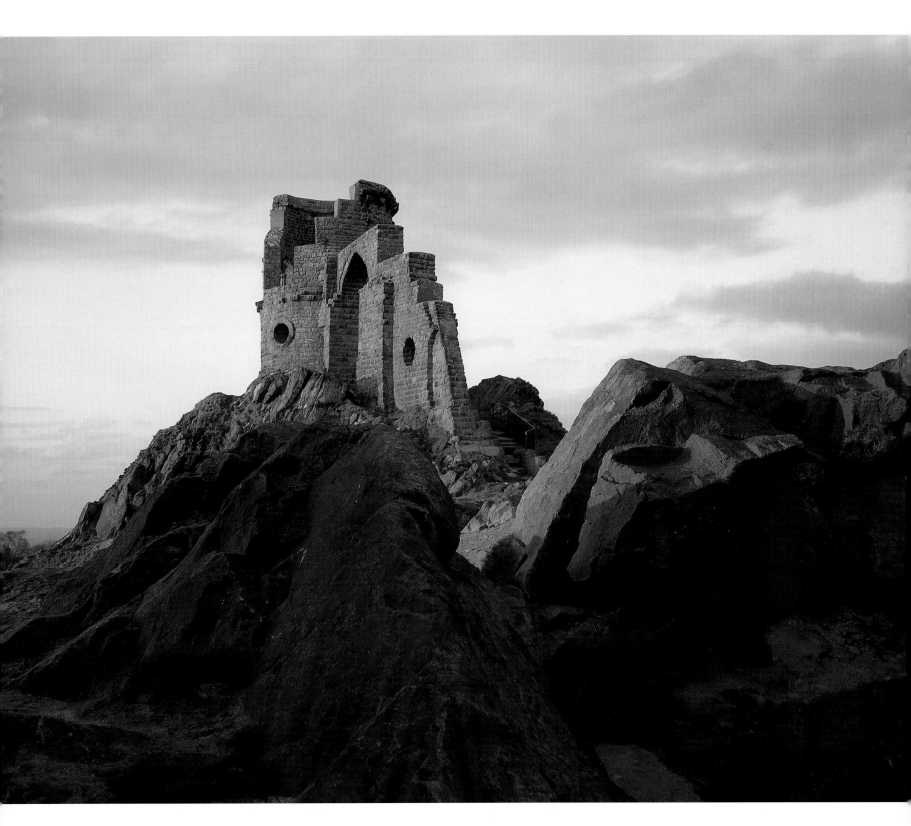

The River Llugwy flows through the Gwydyr forest, past Betws-y-Coed, and continues on to the Snowdonian Mountains. Along this river are the Swallow Falls, a well-known attraction and a popular stopping place for coach parties. They are an impressive sight and must have been photographed countless times, but I have never felt the desire to join the crowds and take yet another picture of these cascading waters. This is because there are better photographs to be found away from the falls along the banks of the forest-clad river.

These pictures may be on a smaller scale but in their own way will be just as impressive, and of course, they will be original. This position will also give you the opportunity to be creative whereas standing from a distance, in front of a towering waterfall (no matter how grand a sight it may be), gives you scope for nothing.

This picture was taken midway between the falls and Betws-y-Coed. I was fortunate because there had just been several days of heavy rain which had raised the level of the river. Without the torrent of water in the foreground, the picture would not have been worth taking; it would have been mainly rocks with too little water.

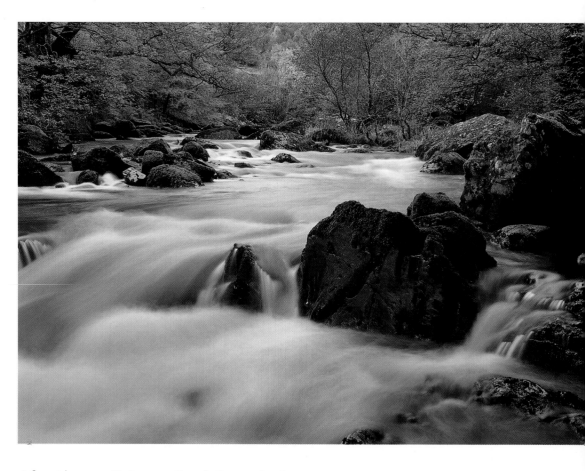

Afon Llugwy, Betws-y-Coed, Snowdonia
Tachihara 5 x 4in with 150mm lens, Fuji Provia [ISO 100], 1sec at f/45, 81B

Have a clear idea what the theme of your picture is and build the arrangement around it. Here the trees and rocks are important elements, but they have been restricted to playing a supporting role to the flowing river, which is the main theme of the photograph.

Unless there is good reason not to, keep the arrangement simple.

Again, the sky was intentionally excluded.

My intention was to photograph the nestling village of Martindale (and one day I will), but on this occasion I had stopped a quarter of a mile or so from my destination, my journey coming to an abrupt end the second this lovely hillside came into view.

Dismissing Martindale temporarily from my thoughts, I began the search for a suitable viewpoint. There was half an hour or so of daylight left with, I estimated, no more than a 50% chance of rain.

After a little scrambling around, I found a position I was happy with and took the photograph almost immediately. This was fortunate, because minutes later it did rain and Martindale remains, for the time being at least, unphotographed.

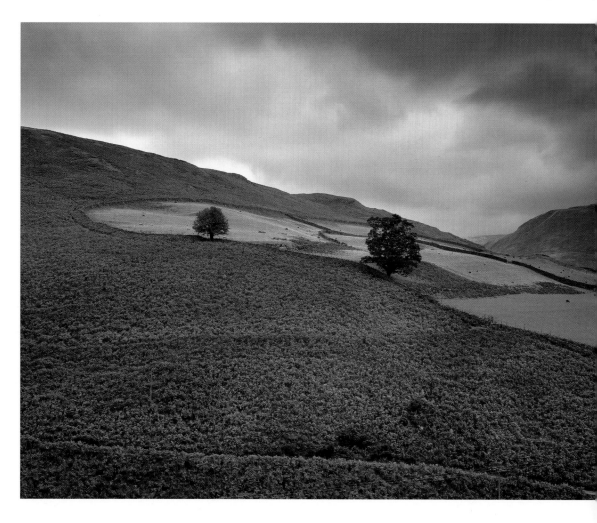

West of Martindale, The Lake District
Tachihara 5 x 4in with short telephoto lens, Fuji Velvia [ISO 50], 6 seconds at f/32, 81B and polarizer

In a landscape which exudes magnificence, it is easy to become immune to the underlying beauty which invariably also exists. Don't switch off when you are surrounded by visual splendour. Look beyond it: there is always a photograph waiting to be teased out of the landscape.

A high vantage point was used in order to prevent the two trees protruding above the top of the hillside. Had they done so, this would have become a photograph of two trees and not a fern-covered hillside.

The long exposure has improved the sky. Moving clouds can produce interesting effects if photographed for several seconds or more.

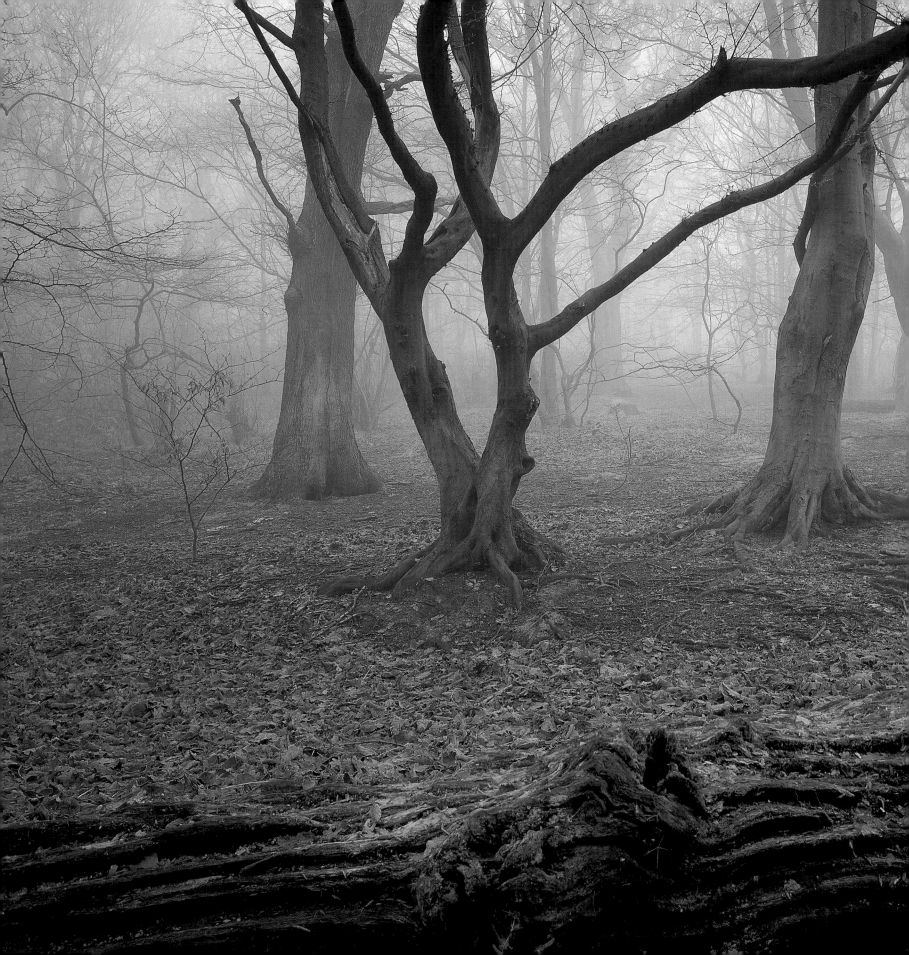

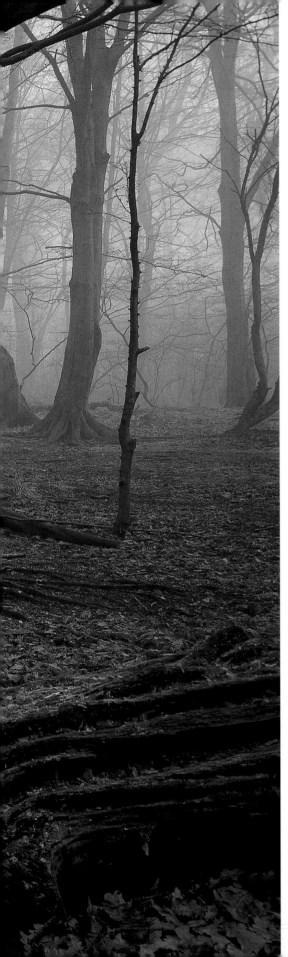

Dibbinsdale,
Bromborough, Merseyside
Tachihara 5 x 4in with wideangle lens,
Fuji Velvia [ISO 50], 15 seconds at f/45

The onset of less favourable weather conditions, such as mist, fog, frost or snow, brings with it the opportunity to produce interesting, often distinctive photographs; extremes of weather (when not too extreme) should not be ignored. However uninviting such days may seem, they hold far greater potential than those sunny days of cloudless blue skies. Pleasant as it is to be outdoors in fine weather, you will find that truly creative picture-taking opportunities arise with the greatest frequency in the most unfavourable conditions.

Mist can transform a woodland scene, creating a photograph where, normally, none would exist. Mood and atmosphere add a new dimension to the landscape and using mist can be an effective means of improving what would otherwise be a fairly mundane image.

Don't be deterred by dense fog. If you can drive safely to a woodland or forest then it is worth making the journey. You will find that fog usually doesn't penetrate a wooded area completely and once inside you will be able to photograph in misty, rather than foggy conditions.

No filters are required for this type of picture. The cold blue cast should be left just as it is. Warming it would spoil the atmospheric quality of the picture.

The dark, clearly visible foreground, which is further emphasized by the deteriorating visibility beyond, gives depth to the photograph.

Check continually that the lens of your camera remains clear. In misty conditions a hazy film can quickly form on its surface.

This photograph would be greatly diminished – probably to the point of failure – without the mist. Distance, mood and an enigmatic quality have been introduced to the landscape, simply through its presence.

The arrival of winter brings with it overcast days of flat, uninteresting lighting. This is not the quality of light for capturing those big, breathtaking views but, as we have seen on pages 36 and 37, all is not lost. Magnificence, you will discover, can also be found on a smaller scale.

Worthy though the pursuit may be, there is something to be said for not allowing yourself to become preoccupied with the search for the shot of a lifetime in that fleeting moment of perfection. This should always remain your objective, but do not allow it to obscure your appreciation of the many opportunities for creative photography which exist all around you. Interesting arrangements of colour, texture and pattern offer endless scope for artistic interpretations. Take a close look and use your imagination. Now is the time of year to make the most of these small-scale landscapes.

Sadly, these beach huts are now deserted. Perilously close to the eroding cliff's edge, the opportunity to photograph them will be short-lived, and dangerous. Fortunately, you don't have to travel far to find many examples of this combination of colour and pattern.

Skipsea, Humberside
Tachihara 5 x 4in with 150mm lens, Fuji Provia [ISO 100], 1sec at f/45

The doorstep is a little untidy and is a distraction. This picture would have been improved if I had removed some of the leaves and debris, but at the time I did not consider them to be intrusive.

Hawarden, Clwyd
Tachihara 5 x 4in with 150mm lens, Fuji Provia [ISO 100], 2 seconds at f/45

december

Despite being the darkest month of the year, with average daylight extending to just eight hours, December can, perhaps surprisingly, be a very rewarding time. Opportunities arise during midwinter because it is then that colours become soft and subdued, and at no other time of year are the landscape and sky so closely matched in colour and texture. Use a neutral, grey graduated filter to reveal the cloud structure and subtle tones of the winter sky, and add an 81B or C filter to bring warmth to the picture. Do not be deterred by inclement weather – it invariably produces the most dramatic lighting.

This picture demonstrates, I hope, that landscape photography is, without doubt, a year-round pursuit and not restricted to being a summertime hobby.

This wasn't my first visit to the fort. On previous occasions there had been too many people, or the tide was in, or the building was being renovated, or... Always there was something which prevented me from taking the photograph. But now it was December. It was cold, inhospitable and deserted. It was perfect. Late afternoon sun shows the fort at its best, wet sand produces a marvellous foreground, and an attractive sky completes the picture. If only the elements would combine like this to command. It is not apparent from the photograph but I was, at the time, battling against gale force winds. A consequence of this – and my own carelessness – is my footprint in the sand at the bottom left corner of the picture. 'Call yourself a photographer, Watson', I mutter every time I look at this picture, 'You should be ashamed of yourself.'

It is a constant reminder to me that one can never be too careful. Attention to detail and a cool presence of mind lie behind every successful photograph. It is a lesson that I, like many others, have learned the hard way.

It is often worth re-visiting a building on a sunny winter's day. The shorter arc of the sun will create a different pattern of shadow and will have a noticeable effect on the building's appearance. The sun sets behind this fort during summer so it is only possible to photograph it in this way, when both the building and foreground are bathed in low, oblique sunlight, in the winter.

Always check the edges of the frame for any unwanted intrusions (footprints or anything else) and take particular care when photographing sand: its delicate surface can be all too easily spoiled.

Fort Perch Rock, New Brighton, Merseyside
Tachihara 5 x 4in with wideangle lens, Fuji Provia [ISO 100], 1sec at f/32, 81C, 0.3 grey grad and polarizer

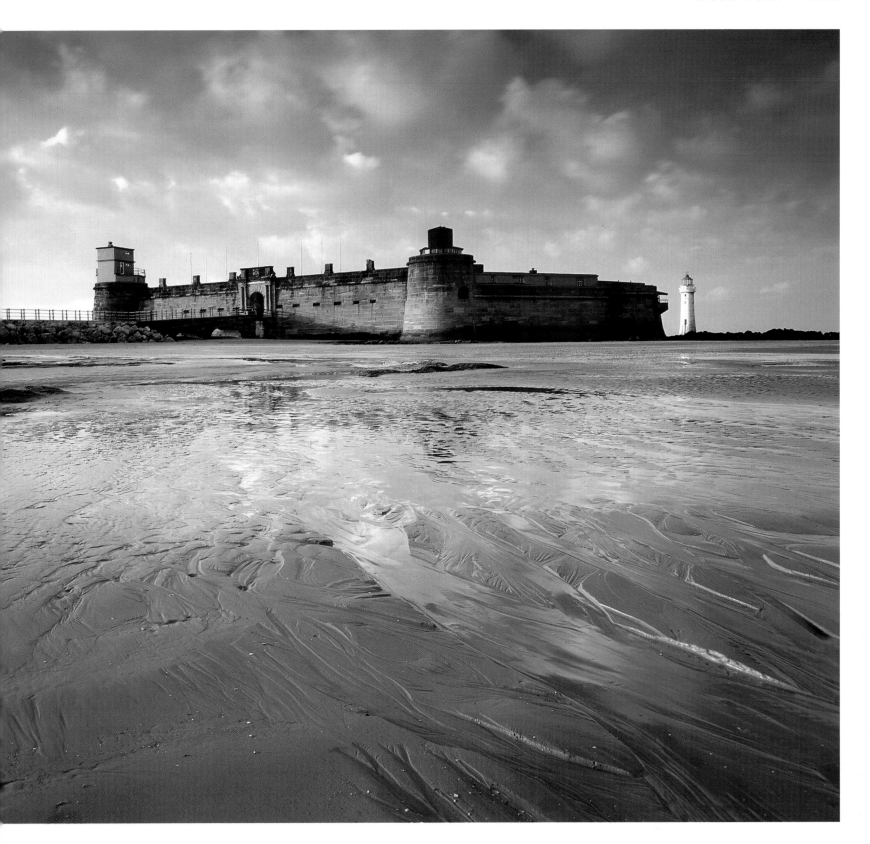

Check foreground detail with extreme care. Pebbles should all be natural, rounded shapes. It was necessary to remove small pieces of broken brick which were scattered amongst the stones. As you have already seen, it is important to avoid including your, or other people's, footprints in the foreground sand.

Use an 81B or C filter when photographing sand. They have a marvellous effect on its colour.

For many people, December is not a favourite month for taking a stroll beside the sea, and this is understandable. Biting winds and freezing temperatures deter all but a hardy few who seem to thrive in such bracing conditions. Photographers too will find a visit to the shoreline at this time of year a rewarding and invigorating experience, for there is no doubt that midwinter is the season for coastal photography.

Short days, a low sun, and deserted beaches are the perfect combination and offer a guaranteed recipe for photographic success.

Throughout the day, from dawn to dusk, lighting conditions *par excellence* can prevail. There is no need to rise in the early hours to capture the magic of first light because dawn occurs at a civilized 7.30am, or thereabouts. Sunsets too, can be photographed hours before dinner and in between you can enjoy several hours of perfect lighting – ideal for exploring mile after mile of deserted coastline.

This picture had been in my mind for some time: it was during the summer that I had first noticed, and been attracted by, those vivid, moss-covered walls, the bright splash of green being the perfect foil for the golden sand.

There was to be no subtlety here. Delicate lighting and soft shadows would have no role to play in this picture. It is all about colour, bright, bold and vibrant. An untouched, deserted beach was also going to be a necessity, so I decided to return early, on a cloudless winter's morning (and these do occur, even in December), when the sun would be shining directly onto the sea walls.

Egremont, River Mersey
Tachihara 5 x 4in with wideangle lens, Fuji Velvia [ISO 50], 1sec at f/45, 81C and polarizer

Midwinter duly arrived but brought with it a stormy spell of weather. Fortunately, this ended the way storms so often do – with a clear sky and a calm day. My tide table told me that, luckily, low water was at 9am. Perfect. I hoped that by arriving at 7.30 I would have the beach to myself, with the sand undisturbed by man or dog, and I was not disappointed. It was an unseasonable morning; mild, a whisper of breeze and a clear sky. 'Is this really December? Is this really England?', I asked myself as I discarded unnecessary winter clothing. Having composed the photograph during my previous visit, the preparation did not take long, but I then had to wait for almost an hour for the sun to rise higher. The problem was the windows in the houses along the promenade which were reflecting the low morning sun. This would have created an unwanted bright spot and, more seriously, could also have produced lens flare. Waiting, however, was time well spent because it gave me the opportunity to plan this second picture (right) which, until that moment, I had not considered.

So, having taken the first photograph and composed the second, I returned later that afternoon. Buildings can sometimes look their best when photographed as a semi-silhouette. This emphasizes shape, suppresses (sometimes distracting) detail, and concentrates on outline. It is for these reasons that buildings often photograph well at dusk.

Again, I was fortunate with the weather. The sky had partially clouded over, which adds weight to the picture. A light sky would have created an imbalance; the dark, dusky theme had to be consistent throughout the photograph, starting with the dimly lit railings in the foreground and continuing all the way to the clouds at the very top of the picture. By 4.30pm I had taken the picture, packed away my equipment and was on my way home. I have to say that it is more demanding in the summer.

When photographing a semi-silhouette, take an exposure reading in the normal way (excluding the sky from the reading), then underexpose by 1 stop. Bracket 1/3 stop either way.

There should be no need to darken the sky with a graduated filter: by under-exposing the building, you should correctly expose the sky.

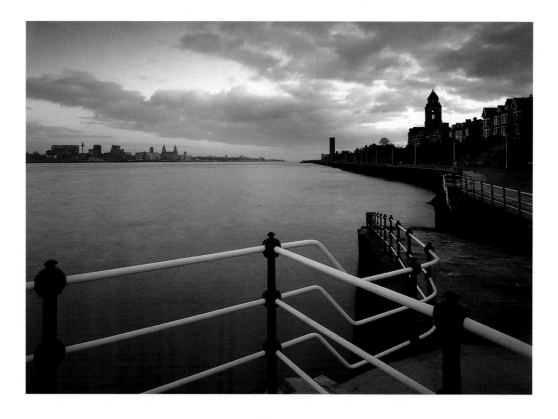

Egremont, River Mersey
Tachihara 5 x 4in with wideangle lens, Fuji Velvia [ISO 50], 8 seconds at f/45

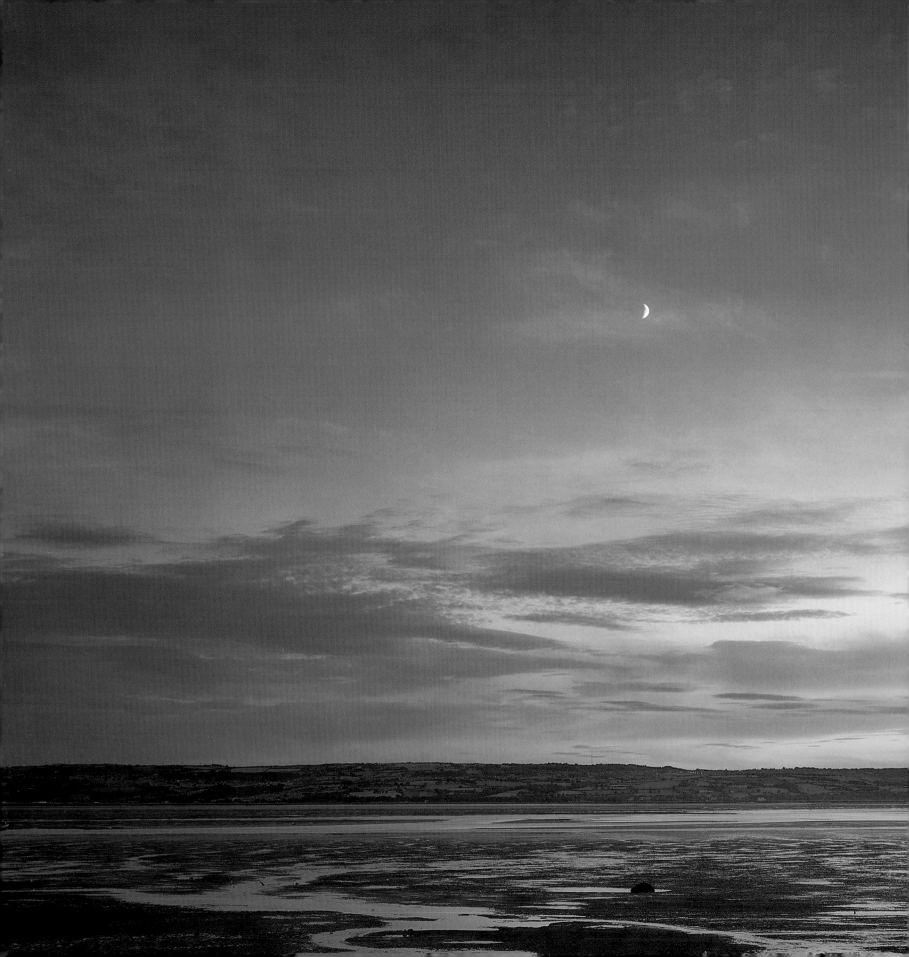

No book claiming to be a comprehensive guide to landscape photography would be complete without a sunset. Hackneyed though they may be, sunsets will always be popular and this is not surprising; they provide marvellous picture-taking opportunities and, if photographed with care, produce breathtaking, unforgettable images.

The secret to a successful sunset lies in the cloud formation. Ideally, you want a sky filled with a scattering of small white clouds. As the sun sets these will turn gold, pink and red and will contrast quite beautifully with the deepening blue background of the twilit sky. A clear sky, you can imagine, will not look as interesting, while one which is too cloudy, particularly near the horizon, will not produce the essential colourful display.

If possible, ensure that some detail is also retained in the landscape. A neutral, grey graduated filter (approximately 2 stops absorption is normally about right) and either an 81B or C are the only filters you should ever need. I urge you not to use those gaudy sunset filters: they look artificial and will destroy the sky's natural beauty. Once you have darkened the sky, take an exposure reading of the landscape and reduce the exposure by 1/2–1 stop. This will create a twilit, end-of-day appearance and, hopefully, a perfectly natural-looking sunset. Bracket exposure 1/2–1 stop either way, as you can never be certain which one will produce the best result.

To make the most of a glorious sky you can do no better than to include an area of calm water in the foreground. The presence of water, with its colourful reflections, adds a new dimension to a sunset. Find the right location and you could be striking gold.

Don't rush away once the sun has set: you may miss the best moment. This picture was taken a good 15 minutes after the sun had disappeared below the horizon. To be sure that you have seen the sky at its best, wait until the after-glow has completely faded before departing.

Meols, The Wirral Peninsula
Tachihara 5 x 4in with wideangle lens, Fuji Provia [ISO 100], 1/4sec at f/16, 81C and 0.9 grey grad

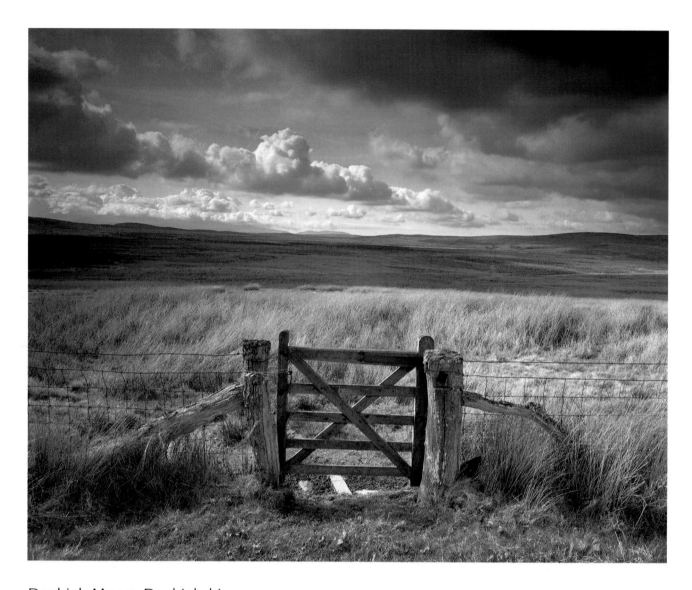

Denbigh Moors, Denbighshire
Tachihara 5 x 4in with 150mm lens, Fuji Provia [ISO 100], 1sec at f/32, 81B and polarizer

The light was fading rapidly as I drove through desolate moorland passing, along the way, a gate which led, apparently, from and to nowhere. Although its usefulness was no longer apparent, this did not detract from its appeal. When had it last been opened, I wondered? Setting aside such irrelevant thoughts, I stopped and lost no time in setting up my camera. Somebody might want a picture of a gate, I reasoned, in an attempt to justify my actions.

The simple photographs are often the most pleasing. This, to me, is one of those pictures which never loses its appeal. Again, there are countless photographs of this type scattered all over the landscape and most have yet to be taken. All that is required is observation.

The sky is as important as the gate and in fact, it was the quality of the cloud structure which prompted me to take the picture. When the sky excels itself, don't let it go to waste. Find something – anything – to complete the picture but don't let that sky go unphotographed!

Always remain vigilant. You may have just driven past the picture of a lifetime.

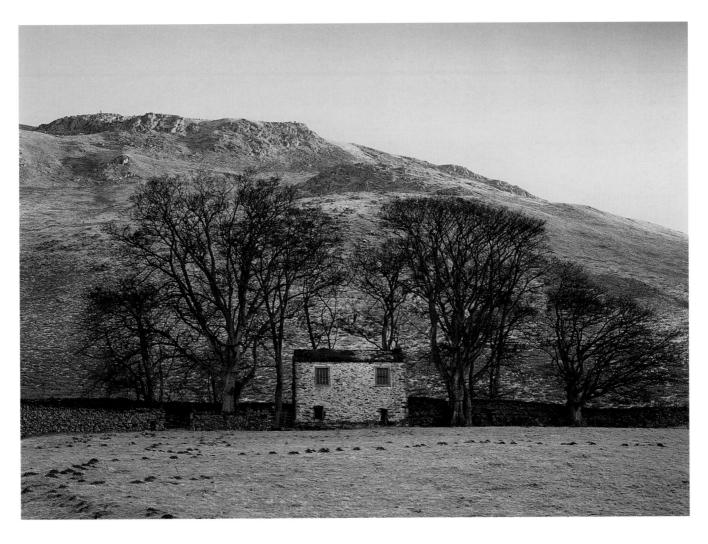

The Old School House, Howtown, Cumbria
Tachihara 5 x 4in with 150mm lens, Fuji Provia [ISO 100], 1/2sec at f/22½, 0.3 grey grad and polarizer

This delightful building was, in its early days, the local school. Perched up high on the hillside, it commands a breathtaking view of Ullswater. This, I should imagine, proved a constant distraction to the pupils and, no doubt, an equally constant source of irritation to the school teacher. But that was many years ago – the little house has obviously been empty and somewhat neglected for decades. Its charm, however, remains.

It seemed appropriate that the cottage should be photographed during winter; a redundant and lifeless building paired with an equally lifeless group of trees. What was also needed, inevitably, was the right lighting: warm, soft, partly diffuse, partly directional. The picture was therefore taken at the end of the day. You can see that the setting sun has brought the background mountain gently into the picture, and given a necessary warmth

to the scene. The fading light has also created a mood of calm and serenity which seemed appropriate to this pastoral study of winter quiescence.

I would normally photograph a building from an oblique angle in order to show it as a solid, three-dimensional object. In this case, however, I preferred the fairy-tale look obtained from a frontal position. Here, it is imagery rather than reality that is the theme.

Blaenau Ffestiniog, Gwynedd
Tachihara 5 x 4in with short telephoto lens, Fuji Provia [ISO 100], 2 seconds at f/64, 81C and polarizer

I never tire of looking at this picture. It is warm and reassuring. It reminds me how fortunate I am that I felt the lure of the landscape so strongly and chose to become a photographer. Had I not done so I would never have stood in this snow-covered valley in the depths of winter and that would have deprived me of one of life's enriching experiences. I was, and still am, captivated by its absolute stillness, its silence and its serenity. All around nothing moved or stirred. It could have been another planet. The photograph is as perfect and complete as any photograph can be, but I take no credit for it because, other than point the camera and release the shutter, I had virtually nothing to do.

I had originally visited the valley a few days earlier. It was during a spell of the most dreadful weather but, despite the gale-force winds and hailstones, the beauty of this remote corner of Wales prevailed. I imagined how it might appear in more favourable conditions but not, I must admit, in snow. I was thinking more in terms of a midsummer's evening. However, within a few days of my first visit, the combination of an overnight snowfall and a promising sky encouraged me to return. I am thankful that I did. The five-hour round trip was a small price to pay for the privilege of just being there.

Why do I see perfection in this picture? The light is warm and gentle yet at the same time directional. It is then diffused by the layer of snow, which acts as a natural reflecting surface. (Notice how the shadows on the walls of the farm are softened by the reflected light.) The warm-coloured grasses create an inviting foreground and the pine trees and farmhouse are a finely balanced group, idyllically placed in an attractive, hilly terrain. Finally, the sky, with its snow-like clouds, is in perfect tune with the landscape below.

Individually these elements are attractive, but it is only when they come together, either through careful planning or by stumbling across them as I did here, that they transcend simple visual appeal and combine to produce that elusive, transient, unpredictable – but complete – picture. And this is what makes it so worthwhile: the pursuit and capture of the complete picture.

Quixotic though the pursuit may occasionally be, I am delighted to say that I am a photographer and there is nothing on this earth I would rather do. The daily offerings of our landscape are a joy to photograph and, in a few short days, dawn will bring with it the start of another year...

The use of a telephoto lens has increased the size and proximity of the hillside. Use a longer lens to give greater emphasis to distant objects.

Sutherland

Caithness

The Scottish Highlands

Outer Hebrides

The Lake District

Northumberland

North Yorkshire

Humberside

INVERNESS

Western Isles

Scottish Highlands & Coast

The Cairngorms

Isle of Skye

The Pentland Hills

EDINBURGH

NEWCASTLE

The Peak District

Staffordshire

Island of Mull

The Trossachs

Scottish Borders

The Cheviots

North Pennines

Yorkshire Moors

Islay & Jura

GLASGOW

North Norfolk

Isle of Arran

Lake District

Yorkshire Dales

Peak District

LEEDS

Suffolk

Kent

Arran

Argyllshire

The Wirral Peninsula & Merseyside

LIVERPOOL

BIRMINGHAM

LONDON

Anglesey Coast

Anglesey

Snowdonia

Snowdonia & Denbighshire

Lleyn Peninsula

Long Mynd

The Cotswolds

South Downs

Cheshire & North Wales

Forest of Dean

Wiltshire Downs

New Forest

BRIGHTON

West Wales

Pembrokeshire Coast

Brecon Beacons

CARDIFF

BRISTOL

SOUTHAMPTON

Sussex

The Mendips

The Quantocks

Exmoor & District

Shropshire & Herefordshire

Gloucestershire

Cornwall

Dartmoor

EXETER

Dorset

PLYMOUTH

Devon

Cornwall Coast

locations

While the locations featured here are the larger, better-known areas, they are by no means the only places to visit: there is much more to Britain. Covering a relatively modest 93,800 sq m (243,000 sq km), Britain consists of approximately 150 inhabited islands, 7,500m (12,000km) of coastline, mainly undeveloped, and 8,000 sq m (21,000 sq km) of areas of outstanding natural beauty. And all of this on a landscape which is 48% meadow and pasture, 29% arable farmland and 9% forest and woodland. When photographing in Britain you are, literally, spoiled for choice.

To find specific areas, use the Ordnance Survey Landranger maps (1:50,000). They will tell you everything, and are indispensable for research and planning. Their key feature is contour lines; these, more than anything, reveal the nature of the landscape. Look for areas of rolling hills or mountains and valleys (the closer the contour lines, the steeper the terrain). Search also for long, isolated, minor roads which take you deep into the countryside. Sprawling forests with rivers and waterfalls are worth visiting. The coastline also has great potential. Look for beaches, coves and cliffs, as this is where you will find the photographs.

References are to page numbers

further information

The following organizations will be of assistance to the continued development of your photographic skills

Societies
The Royal Photographic Society
This offers membership and tuition
www.rps.org

Magazines
Outdoor Photography is widely available from newsagents or by subscription

Outdoor Photography
166 High St
Lewes
East Sussex BN7 1XU
www.gmcmags.com

The organizations listed below will be of assistance with the research and planning of your photographic excursions

Maps
Ordnance Survey
Maps of the UK can be obtained from the Ordnance Survey. They are widely available from retailers
www.ordsvy.gov.uk

Multimap
Multimap enables you to locate or preview specific areas
www.multimap.com

Woodland and forests
Details of forests and woodland with public access can be obtained from the Woodland Trust and the Forestry Commission
www.woodland-trust.org.uk
www.forestry.gov.uk

Other places of interest
The National Trust owns open land, parks, gardens, houses and stately homes
England and Wales
www.nationaltrust.org.uk
Scotland
www.nts.org.uk

Weather
www.meto.gov.uk
www.bbc.co.uk

Tide tables
www.digiserve.co.uk/ukfr/gbtide

Access
Landscape photographers, not surprisingly, respect the landscape and depend upon the co-operation of landowners. Guidance concerning access to privately owned land should be obtained from the Rambler's Association website
www.ramblers.org.uk

about the author

Peter Watson took up photography as a teenager, concentrating on black-and-white landscapes, and doing his own developing and printing in a home-made darkroom. He sold his pictures in a local art shop, and this early success encouraged him to pursue the hobby more seriously. He began to photograph in colour, still specializing in landscapes, and became a professional photographer in 1988, using large-format equipment (5 x 4in).

Peter is a contributing photographer with Images Colour Library, and his work appears in books, magazines, travel guides, and calendars, on greetings cards, on record, CD and video covers, in exhibitions and in print and television advertising. As well as landscapes, Peter undertakes commissioned work for clients, primarily architectural photography, as well as some studio work.

This book is the result of three years touring Britain, taking a variety of pictures showing all aspects of the landscape, throughout the year.

Peter is married with two daughters.

index

Page numbers in **bold** refer to illustrations

TITLES AVAILABLE FROM
GMC Publications
BOOKS

WOODCARVING

The Art of the Woodcarver	GMC Publications
Carving Architectural Detail in Wood: The Classical Tradition	Frederick Wilbur
Carving Birds & Beasts	GMC Publications
Carving the Human Figure: Studies in Wood and Stone	Dick Onians
Carving Nature: Wildlife Studies in Wood	Frank Fox-Wilson
Carving Realistic Birds	David Tippey
Decorative Woodcarving	Jeremy Williams
Elements of Woodcarving	Chris Pye
Essential Woodcarving Techniques	Dick Onians
Further Useful Tips for Woodcarvers	GMC Publications
Lettercarving in Wood: A Practical Course	Chris Pye
Making & Using Working Drawings for Realistic Model Animals	Basil F. Fordham
Power Tools for Woodcarving	David Tippey
Practical Tips for Turners & Carvers	GMC Publications
Relief Carving in Wood: A Practical Introduction	Chris Pye
Understanding Woodcarving	GMC Publications
Understanding Woodcarving in the Round	GMC Publications
Useful Techniques for Woodcarvers	GMC Publications
Wildfowl Carving – Volume 1	Jim Pearce
Wildfowl Carving – Volume 2	Jim Pearce
Woodcarving: A Complete Course	Ron Butterfield
Woodcarving: A Foundation Course	Zoë Gertner
Woodcarving for Beginners	GMC Publications
Woodcarving Tools & Equipment Test Reports	GMC Publications
Woodcarving Tools, Materials & Equipment	Chris Pye

WOODTURNING

Adventures in Woodturning	David Springett
Bert Marsh: Woodturner	Bert Marsh
Bowl Turning Techniques Masterclass	Tony Boase
Colouring Techniques for Woodturners	Jan Sanders
Contemporary Turned Wood: New Perspectives in a Rich Tradition	Ray Leier, Jan Peters & Kevin Wallace
The Craftsman Woodturner	Peter Child
Decorative Techniques for Woodturners	Hilary Bowen
Fun at the Lathe	R.C. Bell
Illustrated Woodturning Techniques	John Hunnex
Intermediate Woodturning Projects	GMC Publications
Keith Rowley's Woodturning Projects	Keith Rowley
Practical Tips for Turners & Carvers	GMC Publications
Turning Green Wood	Michael O'Donnell
Turning Miniatures in Wood	John Sainsbury
Turning Pens and Pencils	Kip Christensen & Rex Burningham
Understanding Woodturning	Ann & Bob Phillips
Useful Techniques for Woodturners	GMC Publications

Useful Woodturning Projects	GMC Publications
Woodturning: Bowls, Platters, Hollow Forms, Vases, Vessels, Bottles, Flasks, Tankards, Plates	GMC Publications
Woodturning: A Foundation Course (New Edition)	Keith Rowley
Woodturning: A Fresh Approach	Robert Chapman
Woodturning: An Individual Approach	Dave Regester
Woodturning: A Source Book of Shapes	John Hunnex
Woodturning Jewellery	Hilary Bowen
Woodturning Masterclass	Tony Boase
Woodturning Techniques	GMC Publications
Woodturning Tools & Equipment Test Reports	GMC Publications
Woodturning Wizardry	David Springett

WOODWORKING

Advanced Scrollsaw Projects	GMC Publications
Bird Boxes and Feeders for the Garden	Dave Mackenzie
Complete Woodfinishing	Ian Hosker
David Charlesworth's Furniture-Making Techniques	David Charlesworth
The Encyclopedia of Joint Making	Terrie Noll
Furniture & Cabinetmaking Projects	GMC Publications
Furniture-Making Projects for the Wood Craftsman	GMC Publications
Furniture-Making Techniques for the Wood Craftsman	GMC Publications
Furniture Projects	Rod Wales
Furniture Restoration (Practical Crafts)	Kevin Jan Bonner
Furniture Restoration and Repair for Beginners	Kevin Jan Bonner
Furniture Restoration Workshop	Kevin Jan Bonner
Green Woodwork	Mike Abbott
Kevin Ley's Furniture Projects	Kevin Ley
Making & Modifying Woodworking Tools	Jim Kingshott
Making Chairs and Tables	GMC Publications
Making Classic English Furniture	Paul Richardson
Making Little Boxes from Wood	John Bennett
Making Screw Threads in Wood	Fred Holder
Making Shaker Furniture	Barry Jackson
Making Woodwork Aids and Devices	Robert Wearing
Mastering the Router	Ron Fox
Minidrill: Fifteen Projects	John Everett
Pine Furniture Projects for the Home	Dave Mackenzie
Practical Scrollsaw Patterns	John Everett
Router Magic: Jigs, Fixtures and Tricks to Unleash your Router's Full Potential	Bill Hylton
Routing for Beginners	Anthony Bailey
The Scrollsaw: Twenty Projects	John Everett
Sharpening: The Complete Guide	Jim Kingshott
Sharpening Pocket Reference Book	Jim Kingshott
Simple Scrollsaw Projects	GMC Publications
Space-Saving Furniture Projects	Dave Mackenzie
Stickmaking: A Complete Course	Andrew Jones & Clive George

Tassel Making for Beginners — *Enid Taylor*
Tatting Collage — *Lindsay Rogers*
Temari: A Traditional Japanese Embroidery Technique — *Margaret Ludlow*
Theatre Models in Paper and Card — *Robert Burgess*
Trip Around the World: 25 Patchwork, Quilting
and Appliqué Projects — *Gail Lawther*
Trompe l'Oeil: Techniques and Projects — *Jan Lee Johnson*
Wool Embroidery and Design — *Lee Lockheed*

GARDENING

Auriculas for Everyone: How to Grow
and Show Perfect Plants — *Mary Robinson*
Beginners' Guide to Herb Gardening — *Yvonne Cuthbertson*
Bird Boxes and Feeders for the Garden — *Dave Mackenzie*
The Birdwatcher's Garden — *Hazel & Pamela Johnson*
Broad-Leaved Evergreens — *Stephen G. Haw*
Companions to Clematis: Growing Clematis
with Other Plants — *Marigold Badcock*
Creating Contrast with Dark Plants — *Freya Martin*
Creating Small Habitats for Wildlife in your Garden — *Josie Briggs*
Gardening with Wild Plants — *Julian Slatcher*
Growing Cacti and Other Succulents in the
Conservatory and Indoors — *Shirley-Anne Bell*
Growing Cacti and Other Succulents in the Garden — *Shirley Anne Bell*
Hardy Perennials: A Beginner's Guide — *Eric Sawford*
The Living Tropical Greenhouse: Creating
a Haven for Butterflies — *John & Maureen Tampion*
Orchids are Easy: A Beginner's Guide to their Care and Cultivation — *Tom Gilland*
Plant Alert: A Garden Guide for Parents — *Catherine Collins*

Planting Plans for Your Garden — *Jenny Shukman*
Plants that Span the Seasons — *Roger Wilson*
Sink and Container Gardening
Using Dwarf Hardy Plants — *Chris & Valerie Wheeler*

PHOTOGRAPHY

An Essential Guide to Bird Photography — *Steve Young*
Light in the Landscape: A Photographer's Year — *Peter Watson*

VIDEOS

Drop-in and Pinstuffed Seats — *David James*
Stuffover Upholstery — *David James*
Elliptical Turning — *David Springett*
Woodturning Wizardry — *David Springett*
Turning Between Centres: The Basics — *Dennis White*
Turning Bowls — *Dennis White*
Boxes, Goblets and Screw Threads — *Dennis White*
Novelties and Projects — *Dennis White*
Classic Profiles — *Dennis White*
Twists and Advanced Turning — *Dennis White*
Sharpening the Professional Way — *Jim Kingshott*
Sharpening Turning & Carving Tools — *Jim Kingshott*
Bowl Turning — *John Jordan*
Hollow Turning — *John Jordan*
Woodturning: A Foundation Course — *Keith Rowley*
Carving a Figure: The Female Form — *Ray Gonzalez*
The Router: A Beginner's Guide — *Alan Goodsell*
The Scroll Saw: A Beginner's Guide — *John Burke*

MAGAZINES

WOODTURNING ◆ WOODCARVING ◆ FURNITURE & CABINETMAKING

THE ROUTER ◆ WOODWORKING

THE DOLLS' HOUSE MAGAZINE

WATER GARDENING ◆ EXOTIC GARDENING ◆ GARDEN CALENDAR

OUTDOOR PHOTOGRAPHY ◆ BLACK & WHITE PHOTOGRAPHY

BUSINESSMATTERS

The above represents a full list of all titles currently published or scheduled to be published.
All are available direct from the Publishers or through bookshops, newsagents and specialist retailers.
To place an order, or to obtain a complete catalogue, contact:

**GMC Publications,
Castle Place, 166 High Street, Lewes, East Sussex BN7 1XU, United Kingdom
Tel: 01273 488005 Fax: 01273 478606
E-mail: pubs@thegmcgroup.com**

Orders by credit card are accepted

WATERFORD CITY AND COUNTY
WITHDRAWN
LIBRARIES